PRAISE FOR ART MARKETING 101

I bought your book *Art Marketing 101* three months ago and have worn the pages out already! Excellent book. Very glad I found it. *Stacy Lord, MA*

I have about a dozen books on the business of art, and yours is by far the most useful and most complete. Thank you for writing this fine book. I will recommend it whenever the opportunity presents itself. *Frank Hoffman MT*

I don't know how any artist can run a business without you. *New York, NY*

I've been studying the book *Art Marketing 101* and have begun to implement many of the ideas and suggestions. It's my studio Bible! *Karen Henzey, MD*

I just finished reading, highlighting and taking notes on your book *Art Marketing 101*. I must tell you how much I have enjoyed and digested the vast information that was collected to form this book. Out of the 25 years that I have been a watercolorist/instructor, this has been one of the best books I have read. I plan on recommending it to my students and to the members of my art league.
Kathy Rathburn, IN

I just finished reading *Art Marketing 101* and loved it. Now I'm going back to start initiating what I've learned. I wish I'd known these things years ago. *Jenison, MI*

Art Marketing 101 is in ALA's library and mine. It's a great book and I'm learning lots I thought I already knew! *New Orleans, LA*

The best marketing book I've ever seen and I've read many! Clear, concise and organized.
Bala Cynwyd, PA

I love your book *Art Marketing 101*. Thank you for writing it. I've written to my artist friends that they must buy it. *St Croix, USVI*

Thank you for such an excellent book. I enjoyed the concise, straightforward way it was written.
Naperville, IL

I have just finished reading through *Art Marketing 101*. Thank you so much!!!! I love this book and it will be my pleasure to recommend it. I am trying to learn all I can and find my niche. Your book was so helpful. I am now starting to read *Art Licensing 101*. *Nashville, TN*

How much time, money and heartache could have been saved had I had a copy of *Art Marketing 101* years ago. At last the fog has lifted! *Long Beach, CA*

I highly recommend this book for beginning, emerging and established artists as a reference source for many different topics, as well as for an emotional support. *Los Angeles, CA*

Absolutely everything artists need to know in order to sell their creative work in today's competitive marketplace. Full of excellent tips, practical information and reference material. A must for every artist who wants to make more money. *Art marketing consultant*

Wow! Here's how good this book is - before I could write this review, I went online and ordered it. That's a first for me. Constance tell you everything about marketing your art in a clear, friendly and well-written manner. She advises you to read the book from start to finish and make notes to yourself in the wide margins. Even if you've been selling your art successfully for many years, you will learn a great deal in these pages. As soon as my copy arrives, it and a pencil are going on my night table and I'm starting again at page one. *Alice Korach, The Bead Bugle*

I just finished reading *Art Marketing 101* and loved it. Now I'm going back to start initiating what I've learned. I wish I'd known these things years ago. *Susan Burton, MI*

Art Marketing 101 is in the ALA's library and mine. It's a great book and I'm already learning lots I thought I already knew! *Ann Dentler, LA*

I used your book to create a marketing plan to procure government, and it worked! I've received a grant that will enable me to survive for one year while I start to sell my paintings. Thank you! *Artist, Nova Scotia, Canada*

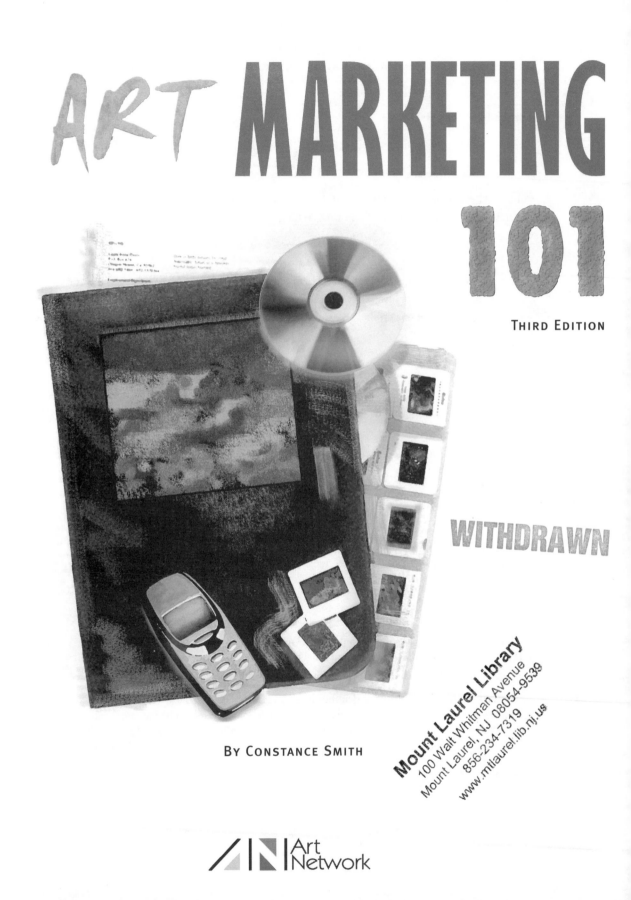

ART MARKETING

101

THIRD EDITION

WITHDRAWN

BY CONSTANCE SMITH

Art
Network

ART MARKETING 101, A HANDBOOK FOR THE FINE ARTIST, THIRD EDITION

Third Edition May 2007

Copyright 2007 by Constance Smith

Cover and interior design by Laura Ottina Davis

Published by ArtNetwork, PO Box 1360, Nevada City, CA 95959-1360
(800) 383 0677 (530) 470 0862 (530) 470 0256 Fax
www.artmarketing.com <info@artmarketing.com>

ArtNetwork was created in 1986 with the idea of teaching fine artists how to earn a living from their creations. In addition to publishing business books, ArtNetwork also has a myriad of mailing lists—which we use to market our products—available for rent to artists and art world professionals. See our web site for details.

Publisher's Cataloging in Publication (prepared by Quality Books Inc)

Smith, Constance, 1949-
 Art marketing 101 for the fine artist / by Constance Smith.--
 3rd ed.
 p. cm.
 Includes index.
 ISBN 0-940899-49-3
 13-digit ISBN 978 0-940899-49-0

 1. Art--Marketing.

 N8353.A78 1997 700.68'8
 QB196-40361

Disclaimer: While the publisher and author have made every reasonable attempt to obtain accurate information and verify same, occasional address and telephone number changes are inevitable, as well as other discrepancies. We assume no liability for errors or omissions in editorial listings. Should you discover any changes, please write the publisher so that corrections may be made in future printings.

Printed and bound in the United States of America

Distributed to the trade in the United States by Consortium Book Sales and Distribution

FOREWORD

Art Marketing 101 is the most effective reference book ever published about the business of fine art. Ms. Smith, with her penchant for perfection and details balanced by her easy conversational style of writing, has produced a comprehensive, yet easy-to-read book. This most pragmatic handbook is only possible because of her varied experiences as a curator, writer, lecturer and artist's representative.

The text is divided into units that permit the reader to obtain specific information or to read the whole story of marketing art in the order planned to maximize understanding. Legal, licensing and psychological aspects are given equal time to prints, greeting cards, sales and one-person shows. The chapter applying computer technology to the business of art is invaluable.

After reading *Art Marketing 101*, I returned again and again to certain chapters to sharpen my approach to the issues of most concern to me. In teaching painting and commercial art, I have integrated segments of the handbook into the syllabus. Very useful are the sections on phone and computer use. "Recommended Readings" at the end of each chapter are as useful to the instructor as they are to the student.

This handbook should be in the library of every art school and academic institution. The pages are laid out in a thoughtful manner that promotes ease of reading and comprehension. Fine and commercial artists will find a myriad of uses for this encyclopedic work. This handbook has been long in coming, but well worth the wait.

Alvin C Hollingsworth

ACKNOWLEDGMENTS

When I started this company in 1986, that there weren't enough artists interested in marketing their artwork to support a publisher of fine art marketing tools. I disagreed and have since proven them wrong. More and more people seem to be going into vocations they enjoy, instead of jobs they must endure. Artists are no exception.

Turning around the myth of the struggling artist is no easy task! By transforming this myth, we will do our share to change the world.

Getting an artist to purchase a marketing book is not as hard today as it was 20 years ago. Some colleges have finally incorporated the study of business for artists in their curriculum, and they use this book.

Reading and "doing" the book from cover to cover is quite a feat! When artists then implement some of the ideas and begin their business, it is practically a miracle. I receive calls daily that indicate people have had their lives changed by this book—indeed, a marketing book!

I want to thank all the artists who have participated in ArtNetwork's growth—who purchased books, attended our seminars, had a consultation, gave us an interview, and sent us unsolicited thanks for our many projects. It is those artists who have inspired me in my daily tasks. It is those artists who are making a difference in our world today.

Constance Smith

Table of Contents

Chapter 16 Pitching the Press

Chapter 17 Reps and Galleries

Chapter 18 Shows and Fairs

Chapter 19 Locating New Markets

Chapter 20 Alternatives to Sales

Chapter 21 Marketing Plans

INTRODUCTION

This book was written to empower the artist. Over the past six years that the first edition was in print, I have verified that it has done its job. I wanted to create a user-friendly handbook, one that would take artists through the skills of business and marketing, step-by-step. It is hard for many to acquire business knowledge or to think of themselves as businesspeople. I wanted to make it as fun and easy as I could. I can see from the multitude of positive responses that this book has done just that.

WHAT IS THIS BOOK ABOUT?

This handbook is about self-promotion, strategies for emergence as an artist and the furtherance of your career. The business of marketing art has become more and more complex and sophisticated. An artist must be educated in the art of business.

By and large, the only question university art classes deal with is how to look good enough for a gallery—rather than how to get into a gallery. Developing business savvy is often viewed amongst artists as detracting from the main act of art. It's all supposed to "happen." Let's be practical! Waiting to be discovered is like waiting for Noah's Ark!

WHAT IS THE PHILOSOPHY OF THIS BOOK?

I believe that it does not harm an artist's creative skills to think about business issues. Artists have the right to survive in this society while practicing their creative endeavors. To survive, however, requires knowledge. By helping artists become informed about the business of art, I seek to increase their business survival rate.

It is impossible, even with great effort and talent, to guarantee a major career. Major artists emerge as the result of a confluence of factors. It is possible, however, to have a career that allows you to use your artwork as a major source of income.

WHOM IS THIS BOOK FOR?

This book has been written to give fresh ideas to emerging and professional-level artists. It is intended to help artists function in modern society, to guide them through the basic business techniques they need to know, and to gain a positive attitude toward business.

WHAT WILL YOU LEARN?

You will learn the basics needed to create a successful business.

You will learn that marketing is a process—a continuous, ever-changing activity. Marketing is determining how and to whom to present a product. Having this knowledge will eliminate confusion and costly errors you might otherwise experience.

You will learn practical information to further your art career. There are helpful tips, addresses, telephone numbers, forms you can copy and use, and research data that would take an individual years to accummulate.

Starting and progressing in any business is a life-building experience. You can't really fail; you can only learn.

HOW TO USE THIS BOOK

How you use this book depends on how much you are committed to a career as an artist. This is not a "rah-rah" book. It's a book describing proven techniques that must be put into practice.

Treat it like a workbook. Fill in the blanks. Do one thing at a time. Start with the little things, and soon the bigger areas will become easier. I've tried to make the format simple to read, with plenty of space to jot down notes as you proceed through the chapters. Write all over the margins, as it will help you remember ideas. The detailed Table of Contents and Index should make it easy to find the exact topic you are looking for. At the end of six months, if your book is well-thumbed-through and full of scribbled notes, you're on your way to success as a marketing artist!

As any author would, I suggest not skipping chapters. They are in a particular order for a reason. If you skip to the end, you will be missing some of the most important information on how to succeed in business. You're asking for the kiss of death! Even if you think you know all about a particular topic, take the time to read and reinforce what you know. You might be surprised at all the new ideas you find.

Don't expect to find the one-minute magic answer in this book. Planning your marketing action takes time, open-mindedness, effort, aim, commitment and knowledge. You will need to discover as much about the art environment as you possibly can. All kinds of information about galleries, publishers, shows, competitions, portfolios, press releases and more will be useful in the progress of your career. Even successful artists must continue to learn in these areas in order to continue promoting their work successfully.

If it is in your heart and you want to earn your livelihood from that which you like to do most—your artwork—you will learn from this handbook that it is possible to do that. With knowledge and strength, you will be able to make it through all the difficult times and make your dreams come true.

Everything we do reflects who we are. In most areas of our lives, the clarity of our aim has a direct relationship to the success that we achieve. This book is intended to help you form a clear aim in the area of marketing your fine art.

Good luck and stay with it!

Chapter 1

The Psychology of Success

Psychological roadblocks

Changing your inner vision

Tough times

Whatever you can do or dream you can do, begin it.
Boldness has genius, power and magic in it. Begin it now!

Goethe

PSYCHOLOGICAL ROADBLOCKS

The business of art is a marathon, not a sprint.

You probably didn't expect the beginning chapter of a book on art marketing to be about psychological preparation. Just as tennis is a psychological game, marketing is, too.

Every entrepreneur must wear more than one hat. Many entrepreneurs are not skilled in all facets of business. After all, there's a lot one needs to know: accounting, marketing, tax preparation, sales, product development, design, planning, legal rights and more.

When you enter the marketplace with your artwork, you'll need to have all your psychological artillery ready for action. This artillery will be crucial to taking you through the pitfalls of your business and your life.

All of us have been raised with many attitudes that undermine our higher possibilities. Throughout our life, we all must attempt to overcome those old barriers and attitudes and begin to think for ourselves—our better selves. As an entrepreneur—and that is what you are when you decide to start your art business—you will be, as defined by Webster's, "a person who organizes and manages a business undertaking, assuming the risk for the sake of profit."

ASSUMING RISK

Yikes! You will need to become aware of your psychological blocks in order to take a risk and succeed in business. You will need to study your negative attitudes toward success within your own psyche to find out what might be holding you back. You must get rid of attitudes that impede you and only keep those that assist you in succeeding with your business aims. That sounds simple, but we all know it's quite difficult to change an ingrained attitude. Assuming risk is an attitude you must develop toward your art business.

DON'T USE ANY EXCUSES

If you have any excuses, keep them to yourself. Don't voice them. Excuses become more of a reality if they are voiced. Understand that they are only excuses. In case you're having difficulty seeing those excuses, here are some favorites:

- ▸ I work full-time. I don't have the time to market.
- ▸ I've never marketed anything before.
- ▸ I'm shy.
- ▸ I live in an uncultured town.
- ▸ There's too much competition.
- ▸ I don't know how to price my work.
- ▸ I don't want to part with my work.

- Financial success will poison my artwork.

- The art market is saturated.

- I don't have any business abilities.

- A true artist should be discovered.

- I would feel guilty about making money at what I love to do.

If you continue to listen to these voices that defeat your will, you will get nowhere. To make a living as an artist, you will need to have the courage—and take the risk—to break through your personal roadblocks. If you *truly desire* to accomplish the task of marketing and selling your art, you will create the courage to conquer these barriers. You can. You must. There's no alternative! You've broken through barriers in other areas of your life. Break through these, too.

By the way, you've already begun the process. You purchased this book because you *want* your career as a fine artist to flourish.

MYTHS

Artists and non-artists alike are familiar with this ubiquitous myth: Artists never make much money and don't care about money. This is just one of the many myths that have been heaved upon the creative people of the world. Don't believe it! Rubens, for example, didn't believe it. He was a politician and a very good businessman.

I know many artists across the U.S. who don't believe this myth, and for that reason they have prospered in the art business. They are not necessarily famous among the masses, but that isn't their aim. Their aim is to make a living as a fine artist.

You do not have to feel guilty about making money from your talents. You are fortunate enough to have a talent that can become an occupation. People want and need art. Get on with what you *like* to do! Have an attitude-change toward the business of art. Put an end to those lies society programmed into you.

Conquer the myth of the struggling artist. Get on with becoming a surviving artist.

FEAR OF REJECTION

You will need to learn to distance yourself from—but take heed of—criticism. You are educating yourself for intelligent marketing. Listen to what people say when they comment on your work. They can give you important clues for future planning.

- Are they rejecting your presentation and possibly not the work?

- Did you catch them in the middle of a hectic day?

"Art is big business and I can be part of it!" This is the new attitude you are developing.

You must have the attitude that your work is worthy. Without that attitude, you cannot succeed.

- ▸ Were you late to your appointment?

- ▸ Did you choose an inappropriate gallery to approach?

As an artist, you don't have to take criticism personally. If you feel your work is truly inspiring, surely there will be other people who feel the same. If you consider your artwork of a top standard—and you should if you intend to market it—why is the opinion of someone you don't even know so distressing to you? Perhaps you don't really think that your work is *so* good?

Without the fortitude you gain from these inevitable critiques that hurt, you may not receive the psychological strength you need to be a success. Once you start marketing your artwork on a regular basis, this gut-level fear of criticism and rejection must begin to diminish.

On the road to success you will discover many tools that are helpful to your growth. Sports trainers use visualization to help their athletes succeed. As an artist, you can also use this technique.

VISUALIZING

Visualize your artwork hanging in different venues: homes, galleries, corporations. Visualize yourself shaking hands with corporate buyers, with an art publisher at ArtExpo, whomever you imagine can help you along the way.

GOING PUBLIC

You will also find it helpful to go public. Start calling yourself an artist. You've probably considered yourself an artist for some time. Now you must announce it to the world. When someone asks you what you do for a living, your reply should be, "I'm an artist."

Once *you* start calling *yourself* an artist, you'll be surprised at how many other people will start referring to you as an artist too. Hearing others call you "artist" creates an inner image that reinforces your aim.

DEFINING SUCCESS

Do you realize that you can set your own standards of success? Wow! This is a revelation! *You* decide what success is for you. Is it selling three originals? Is it finding a publisher? Is it finishing 10 pieces of work? Is it making $25,000? $5,000?

If you want to believe what someone else tells you success is, then you are going against the possibility of creating your own vision. Without the passion of your own heartfelt aims, you lose your inner power. You won't be able to create the passion to succeed if you use someone else's idea of a goal—and passion creates great powers within each of us and is needed to succeed in any business.

Take each year as one more step in building what *you* want—not what your mother, father, friend or business associate thinks you need, but what *you* determine you want.

PERSEVERANCE

In most parts of our lives, we've found that we must persevere through troubled and difficult times. It is no different for an entrepreneur, be he artist or baker. Just to survive in life, we must persevere. To do what we want, we must really be committed.

You must plan to remain at this venture, not one or two years, but ten to forty years, i.e., all your life. You are an artist, after all: What else can you do? What else would you *want* to do for a living? With this attitude, you will be able to conquer problems when they arise.

CHANGING YOUR INNER VISION

You must define what you want. Only then can you make the efforts to get it.

Along the way, remember the adage, "It takes money to make money." If you are not willing to spend money on promoting yourself, why would anyone spend money on buying your work? You need to value your work more than anyone else! If you are not willing to invest time, money and energy in your career, who is? With that kind of attitude, you certainly won't be able to convince an art rep or gallery to work for you for a commission. You will need to invest in portfolios, books and other promotional tools that will help build your business. How much will you sacrifice to achieve your goals? How important are they to you? How easily do you give them up or let life take them away? You are the one to decide your fate.

TAKE A RISK

To progress in any area, you must get out of your comfort zone. Try to remember a risk you once took in relation to something other than business. Most likely, the courage you had then helped you survive whatever imaginary block you thought you wouldn't be able to overcome. You can do it again, here, now.

Have a hard time setting goals?

Try creating them when you are in an energetic frame of mind. Write them down on your master plan. When the time comes to do the project and you don't feel like it, don't back out. Go to that good frame of mind you had when you set the goal. Plunge in. Take some deep breaths and make the best of it. Just begin. You'll be breaking through habits of laziness and will gain from this "pain." Opening your eyes and putting your best foot forward will guarantee surprising results.

Setting goals in your everyday life

Are you consistently rushing? Start by taking a one-day vacation from rushing. Don't make your schedule so tight. Have you ever tried not to plan a day, to just take it as it comes? Is it too scary for you to change your plans on a dime? Then going into business for yourself may also be too scary.

Try to react differently.

Have you received another rejection? Try to change your automatic response. How about feeling sorry for the gallery that doesn't get to show your work? Proceed to enchant another gallery. You can't let rejections get you down. Rejections are part of any business (and life). If you understand your larger goal, then it's not so hard to continue. There will be pain with gain, you can count on that. Take what you've learned, get up and run another mile. Know that there is an even better situation awaiting you.

POINTERS

→ If you are already established in another occupation, make your change slowly and intelligently to your new art business.

→ As an artist, you will have two roles—creating art and marketing art (which includes organizing, selling, bookkeeping, taxes, etc.).

→ You will run up against some brick walls—both in yourself and in others. It's inevitable, even for the experienced.

→ Take each step as it comes.

→ Try to think of competition as a good thing, i.e., it keeps you on your toes. There is space for everyone.

→ Get your personal life in order. You will then have the proper energy that it takes to make your business survive. Starting a new venture while your life is in chaos will just defeat your aims.

→ Know what you are willing to invest, money- and time-wise, in order to reach your goals.

→ Let your family and friends know your intentions of starting a business. Also let them know that it won't detract from your responsibilities to them, though it might change these responsibilities a bit. Get their support, emotionally and psychologically. You will need it.

→ Make a total commitment or no commitment at all!

DEFEATING WILL

Probably about now a little voice is saying, "But this business stuff, I have no interest in it."

You will need to start working on this voice and become passionate about your success. If you don't take an interest in your business, no one will.

Oh, but you want a rep? All the reps and gallery owners I know take an artist on after she has developed her marketing a bit—after she has proven that she can sell her work, that she has buyers.

Realize now that you want to start this process and stop this voice that is defeating your aim. This business of marketing art is actually a creative venture, and you are one of the best people to take it on.

Present yourself as the artist you want to be, whether you've reached your goal or not.

TOUGH TIMES

Tough times in the economy don't need to mean you retire! You must remember your five-year plan. That's one thing that can help keep you going. Here are some more.

PERSISTENCE

Keep putting your work in front of potential customers who fit your niche market. Most businesses fail before three years. If you don't give up in that time, you'll have made it a long way. If you are as good an artist as you claim to be, you must continue to believe in your work. Who else will if you don't? Consider your business a marathon, not a sprint.

START SMALL

Don't expect overnight success. Do expect results. Aim for the slow, consistent road and stay on it. There's no sense in giving away all your work at a super-low price, but if you can keep below the general market by a few bucks, you'll make more sales. Downsize the parts of your business (and personal life) that create deviations, both monetary and time-wise. Think of it as a spiritual cleansing.

PRESENTATION

Present your work and yourself professionally. This could mean the addition of a simple frame, a printed sign instead of a handwritten one, or a thank-you note. Be sure to put your name, address, telephone number and web site address on everything you hand out (flyers, brochures, etc.) or anything you sell (a business card on the back of your painting). Professionalism counts during tough economic times more than any other time. Answer phone calls promptly, and be extra courteous and friendly. Do what's required, then go one more step beyond—dazzle your buyers. Do something special for them.

DIVERSIFY

Is it time to start selling giclées or look for a publisher or licensor? Should you teach an art course?

TAKE A FEW SMALL RISKS

Every business owner must take risks to advance. Invest $250 for a booth at a fair; volunteer in an organization so you can expose your artwork to them. Learn from failures, switch gears and keep growing.

WEB PRESENCE

In this day and age, a web site is a valuable tool. Create an e-mail list from visitors who leave their e-mail address at your site. Once a quarter, send your potential

clients an informative e-mail: tips on collecting art, how to view art, your newest exhibition, etc. Make the e-mail personal. Have links to appropriate sites from your web site—your Chamber of Commerce, local B&B sites (leave your brochure at B&Bs so prospects can visit your studio), local art and tourism sites, as well as art groups. Get listed with Google.com.

GRANTS

At some point you might extend your reach to the area of grants and fellowships. Hire an experienced grant writer and researcher to do the work for you. Some will even work on a percentage basis—whatever grant they get for you, they'll take a certain percentage.

NETWORK

Keep in touch with former and potential clients. Get to know your neighbors. Join your local Chamber of Commerce. Find a business sponsor. Remember: Selling your art is long-term; one person can multiply into many just in one year! Become part of your community. Be proud you're an artist.

AN EXERCISE

Write down your passions regarding your art career. Not your goals, but your desires, your wildest dreams—what you passionately want to happen. Don't hold anything back. You're writing this in the privacy of your own journal, so no one will see and critique you. If you could have anything you wanted in this area (your career), what would you choose? Don't be afraid that you won't get it: You will. Be free. Go for the moon. You can really have it! We've been told so often that we can't have whatever we want, that it's even selfish to think like that, so we hold back and don't allow our wishes to be fulfilled. List at least 10 passions relating to art. Do this exercise for four consecutive weeks, listing at least 10 desires relating to your art career each week. Be sure to spend some quiet time before you write these desires down. A muddled mind could lead you astray. Go back in a year and see how far you've progressed. Use a separate piece of paper and start now.
If you don't take a risk and complete this month-long exercise, will you be able to complete the other suggestions in this book?

INTERVIEW WITH A SUCCESSFUL ARTIST

I originally met Synthia Saint James through her exposure in *Living Artists*—an artist directory compiled by ArtNetwork. Soon after, I began to notice press about her in many art publications. I have seen her success grow and grow. Many of her comments below confirm what I tell artists about the business world. Her final words of wisdom were: "Success creates more work, less leisure. I'm working harder now than I ever did before."

How long have you been marketing?

Since my first originals sold as commissioned pieces, some 32 years ago. The early commissions came by word-of-mouth. Someone would see a painting that I had done for an individual's home or office space and ask if I would accept a commission. I didn't think of it as marketing at the time, but now I do—exposure is marketing. Conscious marketing took place after I started sending out mailings and having exhibitions. I did research on various galleries and competitions and got into my first group show. My first exhibition was a one-woman show in 1977 at Inner City Cultural Center in Los Angeles.

Some important things you learned and are still learning?

The importance of research, realizing that success is a personal responsibility, and the importance of working at my art as often as possible .

Do you have a rep or do you hire someone to assist you with office duties?

I have had agents, representatives and assistants. What works best for me is having a dependable assistant who can take some of the pressures off me, therefore giving me more time to paint.

Do you use the press to assist you? Do you advertise?

I make it a point to be listed for my prints in *Decor Source Directory* and *Art Business News Source Directory*, both of which come out annually for the art trade. Recently, with all the book covers I've done, I have an ad in *RSVP,* which comes out once a year, featuring ads from illustrators and designers.

How important is it to be in a gallery?

I feel it is important to exhibit in at least one gallery regularly. That way people will always have a place to go to see your work or to show friends. I also feel that there will always be special collectors of your artwork who should be allowed to buy directly from you. Galleries can be important outlets to sell reproductions. It is great to establish a list of galleries from which collectors can buy nationally.

Are you in any unusual markets?

Many types of companies have been licensed to use my images on various products: playing cards, mugs, magnets, boxes, T-shirts, greeting cards, neckties, gift bags, puzzles, etc.

Have you ever actually tried to paint for eight hours a day for months on end? Perhaps on your next vacation you could take an art retreat and paint for eight hours a day. Most artists find it quite hard, physically as well as emotionally. One artist I know who had the opportunity to do this for awhile actually injured her arm.

Dividing your 40-hour week (usually 60 for most of us these days!) into half—20 hours for painting and 20 hours for marketing—works out well. Seeing paintings put into buyers' homes is very inspiring.

TIPS FROM WORKING ARTISTS

→ Keep a journal about your art making. It proves that you are "sane" and can help get you back to the creative place that is hard to find.

→ Develop mechanisms to sell. What is stopping customers from buying? Do you need to put a time payment plan to work for your clients? What is it that can help them take home a piece?

→ Keep making appointments. You must contact people in order to sell.

→ No desperation: Have money in your pocket so you don't have to "give in" to some ridiculously low sales price.

→ Have integrity.

→ Have desire, always wanting to get better, both at art and selling.

→ When you meet new people and they ask what you do, proudly answer, "I am an artist." This will defy the myth of the struggling artist.

Five years after the interview on the previous page, Synthia was still going strong. In fact, she was going so strong that she withdrew her consignments from galleries. If they wanted to sell her work, they had to buy it outright for resale. Now that's power!

ACTION PLAN

- ❑ Define your personal roadblocks.
- ❑ List expectations you have for your art career.
- ❑ Identify some possible walls you might personally come up against.
- ❑ Announce to the world, "I'm an artist."
- ❑ Define your own terms of success.
- ❑ Define your goal, believe in it, and achieve it.
- ❑ Practice persistency.
- ❑ Take risks to advance your career.
- ❑ Present yourself as the artist you want to be.
- ❑ Create a timeline for launching your business.
- ❑ Practice visualizing success.
- ❑ Define your artistic passions and pursue them wholeheartedly.
- ❑ Stop! Don't just read this. Practice these ideas for a week or month, and when you feel you've overcome some of your personal roadblocks, then go on to the next chapter.

RECOMMENDED READING

Art and Fear by David Bayles and Ted Orland

The Artist Observed by John Gruen

The Artist's Way by Julia Cameron

Change Your Mind, Change Your Life by Gerald G Jampolsky and Diane V Cirincione

Creative Visualization by Shakti Gawain

Get the Best from Yourself by Nido Quebein

Happiness Is a Choice by Barry Neil Kaufman

Real Magic: Creating Miracles in Everyday Life by Wayne W Dyer

Unlimited Power by Anthony Robbins

Visual Journalizing by Barbara Ganim and Susan Fox

What No One Ever Told You About Starting Your Own Business by Jan Normal

Wishcraft: How to Get What You Really Want by Barbara Sher and Annie Gottlieb

Chapter 2
Business Basics

Becoming a legal business

Getting organized

A marketing schedule

Creating an office environment

The Internet

Locating business assistance

To know how to live is all my calling and all my art.
Montaigne

BECOMING A LEGAL BUSINESS

Once you've made your commitment to start an art business, there is *no* way around the need to learn basic business practices in order to succeed. Learning these practices is not a guarantee for success, but it is certainly the most intelligent way to approach success.

Even if you have a rep to show your work, you will need to understand some business basics, to help the rep and to protect yourself.

If you plan to earn a living as an artist, you must start by establishing your business as an entity. You want to become legal. This will reiterate that you are serious. People you deal with will then take you seriously also.

Take the following tasks one step at a time. They will take several hours/days to complete, some patience and a little money. When you finish, you will be a professionally-registered artist:

- ▶ Business name
- ▶ License
- ▶ Bank account
- ▶ Sales tax permit
- ▶ Insurance
- ▶ Federal tax ID

It's a good idea to photocopy the contents of your wallet, including both sides of your driver's license, credit card, etc. Keep the copies in a safe place at home in case your wallet is stolen.

BUSINESS NAME

You don't have a business name? Well, it's a good time to start thinking of one! You don't have to come up with it right away; in fact, spend time brainstorming with friends and family. See Chapter 8 for more help on selecting a business name. Don't finalize any name until you are certain that it's a good one. Test it out. Make sure it creates the image you want for you and your artwork.

Why have a business name—why not just use your own name? Your business name can summarize your style, subject matter or philosophy in art—and that's what it should do! Make it show clearly who you are and what you do.

When you've decided on the perfect name, you will need to go to your local County Clerk's Office to register your fictitious business name. They will verify that no one in your area is doing business with that name. You will have to place an announcement in the local newspaper. The total cost will be around $25-50. Do this. You will be giving birth to a new entity.

Read

LICENSE

Contact your local Chamber of Commerce to find out about any license you will need for doing business in your particular area.

Getting a basic business license will give this new entity power. You are laying the groundwork for the future. Neglecting this detail will make your foundation weak.

BANK ACCOUNT

Open a business checking account. Have business checks printed with your company name. It will make you feel and look professional. You are not required by law to have a separate account, but if you ever get audited, it will make it easier to convince the IRS that you are in business. Use this account for all your business deposits and expenses. This will make it easier to keep track of your business income.

CHECK COMPANIES

Tired of the bank's boring checks? Try these companies for more artistic checks.

Artistic Checks
(800) 224 7621
Unique checks with labels to match.

Check Gallery
(800) 354 3540

www.checkworks.com
Share the art of Frida Kahlo and Diego Rivera each time you write a check. One-part checks (200 per box) are only $7.95.

Rosencrantz & Guildenstern
(800) 354 4708 www.coolchecks.com
These checks, called "Exceptional Banknotes," are ones that every artist should have. I wouldn't be caught without them! From Monet to Münch.

Try to find a bank that will give you a free checking account. For instance, by keeping a $100 balance in my checking account, my monthly bank charge is zero. That saves close to $100 per year.

BALANCE YOUR CHECKING ACCOUNT

Many people I speak to do not take the time to balance their checking account monthly (or their credit card accounts). Banks do make errors. Make it part of your regular business practice to balance your accounts monthly.

Recently, I opened my checking statement and noticed three unfamiliar checks. I thought the bank had made an error and debited the wrong account. Since the total was over $500, I called the bank immediately. Turns out, someone had committed fraud with my account number. They had created checks with my account number and cashed them at stores. Needless to say, I was shocked.

My main puzzlement was, "How did they get my account number?" In the recent past I had tossed some six-year-old cancelled checks in the trash without mutilating them. Perhaps someone had gone through the trash—my trash can was stolen twice last year!

SALES TAX PERMIT

All states require a retail business—and that's what you are—to collect sales tax, and as a retailer you must add sales tax to your retail sales, just as a car dealer, a drugstore or a department store would. When you write up the sales receipt, you add on your state sales tax. The sales tax that you collect from customers is paid by you to the state Board of Equalization (usually annually in your case).

When you sell to a wholesale client (i.e., someone who resells your work), you do not charge tax. This wholesale client must have a sales tax permit—just as you do. (They ultimately retail your product.) You must keep a record of that resale number on your invoice in case you get audited. The auditor will want to know why you didn't charge sales tax.

Apply for a permit at your state Board of Equalization. A sales tax permit does not cost anything; you simply need to apply by filling out a form. When you fill out the form, indicate honestly what you think you will be making in your first year of business from the sale of your artwork. Be modest. They are not holding you to any figures. They could require you to make a security deposit if they see that the amount of monthly sales will be substantial. So don't exaggerate.

The state Board of Equalization will give you all the information you need to know on the amount of sales tax to charge as well as how to fill out your sales tax return. The sales tax office does audit regularly, and they love to audit both commercial and fine artists, so keep accurate and honest records.

A resale number also allows you to buy certain products without paying taxes. Anything that becomes part of an artwork intended to be resold (paint, canvas, frame, marble, etc.) can be purchased without paying tax. You will be asked to present your sales tax permit number when purchasing such products. Items such as

Do not think that sales tax is cutting into your profits. You add it on to your retail price and eventually pay that sales tax to the state.

easels, paint brushes, books, etc., do not become part of your end-product and are therefore taxable.

INSURANCE

Examine your situation to see which types of insurance you might need: private possessions, artworks, health/medical, life, liability, fire, earthquake, absence from work due to illness, auto, etc. You can also get coverage for your studio, business records, and artwork in progress. But do you need all this insurance? Probably not. Find a good insurance agent, see how much it all costs, and then make your educated choice.

Some artist organizations offer package deals on various types of insurance. See if the artist organization you belong to offers the insurance you need.

If you have an active studio with many people coming and going, you should consider casualty/liability insurance. The same is true if you exhibit at fairs and shows. People could sue you if they tripped over a rug in your booth. If you work with arts councils on big commissions, they generally require you to have liability coverage.

If a work of art is lost or damaged while being delivered to a client, your homeowner's or renter's policy probably *won't* cover the loss. The insurance you need is called inland marine insurance and is usually added on to a regular policy. If you ship a lot of work, this could be a useful policy. It rules out any need for additional insurance coverage when shipping by mail or freight.

FEDERAL TAX ID

If you hire employees, you will need to apply for a federal tax identification number. If you are considering hiring help, remember: It ends up to be more expensive than just a per-hour salary. As an employer you have SDI taxes, FICA taxes, benefits, workers compensation insurance, etc., to consider.

Unless you have a very good reason for hiring someone, try to work with freelancers. The general requirements for being considered a freelancer are:

▸ Freelancers are in business for themselves (i.e., they have their own business card, business license, checking account, etc.). Freelancers usually have a variety of clients they work for.

▸ Freelancers conduct their activity off your premises. They can have meetings with you there, but they cannot do the actual physical labor on your premises.

▸ Generally, you must pay them by the job, they cannot be on the payroll.

GETTING ORGANIZED

So much of being successful is about being organized.

Some people have a tremendous problem getting organized, whether it be in their private or their business lives.

ARE YOUR FILES A MESS?

Is your desk a collection of piles? Organizing stores have sprouted up in most shopping malls to assist you. There are even college and adult education classes offered on organization techniques. This must be a problem common to many. So don't fret!

Invest a little time and money getting organized and you will feel more clear about your entire business situation. You'll finally get to experience how nice it is when you can quickly find the file that you are looking for.

You need to set up your files so they work for you. Even if it takes an entire day to do this chore, it will save lots of time in the future. Refine your filing system as you go.

RESOURCES

Deluxe Office Products (800) 328 0304

Drawing Board (800) 527 9530

Quill (800) 789 1331

ArtNetwork www.artmarketing.com/books
Art Office, a book that has 80+ forms, sample letters, charts, legal documents and business plans to help get your office organized

TITLES FOR FILE FOLDERS

Accounts receivable	Bank account	Sales receipts	Legal documents
Sales tax returns	Fictitious name permit	Press releases	Slides
Résumé	Letters to clients	Hot file	Prospective clients
Idea file	Sample flyers, business cards, etc. for reference		

OFFICE ITEMS YOU'LL NEED

Calculator	Daily planner	File cabinet	File folders
Hanging files	Highlighters	Letter opener	Message pads
Note pads	Paper clips	Paper cutter	Paper shredder
Pens	Rolodex	Rubber bands	Ruler
Scissors	Stapler	Staple remover	Tape
Three-hole punch	Wastebasket	Check endorsement stamp	

Not only must you be organized in your office setup, but you also must be organized in your activities schedule.

DAILY PLANNER

In the highly complex society that we have become, bombarded constantly with figures, ideas, facts, commitments, tasks and deadlines, we have a lot on our minds. If you don't already have an organizer or daily planner, get one (or photocopy the forms from *Art Office*). You will be amazed at how your life becomes simplified—providing you use your planner!

When you decide on the best marketing hours for you, remember that during these hours you can only do marketing activities—no artwork. You can write down a great artistic idea, but that's it. If you start deviating toward artwork, you are doomed. Don't do it! If you have a block during those hours, then sit and do nothing. *Do not start creating artwork!*

CREATIVE IDEAS

Be sure to write down creative ideas—things you notice that you might want to use in the future. Don't vainly think you'll remember! You'll almost always forget. Did you attend an exhibit and note something about the display? The prices? Writing things down will free space for other things in your memory bank.

TO-DO LISTS

To-do lists should not be posted all over the walls. A to-do list should be one list that you repeatedly review so it pesters you. Studies show that the moment you start a to-do list, you become 25% more efficient!

MAIL ORGANIZATION

It is helpful to divide your incoming mail into groups so that you can prioritize and handle what is necessary first:

▸ Handwritten letters from prospects, family

▸ Promotional letters from businesses

▸ Bills

▸ Catalogs and brochures that you want to peruse when you have the time

▸ Catalogs and brochures to dump directly into the recycle bin

You only have two hours a week to spare for marketing? Wednesday or Friday is probably best, from 10–12. Remember: Even with only two hours a week, you're going to get further in marketing than the person not marketing at all!

The to-do list helps you set priorities and focus on important tasks.

LISTS TO KEEP

▸ Cash expenses

▸ Books to read

▸ Clients

▸ Current projects

▸ Future projects

▸ Ideas

▸ Potential clients

▸ Travel expenses

How much time are you devoting to your artwork right now? How much time to marketing?

THE 50/50 THEORY

I know you don't want to hear the following, but please take heed. As a start-up business, you will need to dedicate at least half of your art time to marketing! Even as you progress, the 50/50 theory applies. When I tell this to artists, most of them gasp. The only ones who don't choke are those who have already prospered with their career and understand this theory.

Many artists learn that they have to spend *more* than 50% of their working time on marketing. The time never gets shorter—it's already at a minimum at 50%. The only exception would be if you hired someone to help you.

SET SPECIFIC MARKETING HOURS

The best schedule for a part-timer is to market on the same day(s) and hours each week. Marketing will then become habitual, thus easier. For example, if you have 10 hours a week to work at marketing, work seven hours one day and three hours the next day. Take advantage of the momentum that can be created by marketing on consecutive days.

DISCIPLINE

In the case of a 9-5 Monday-Friday job, here is some practical advice:

- Spend a half-hour of your lunch time researching, reading and planning what you need to do.

- Plan time on the weekend to go to the library for research, to attend an exhibition, to go to a gallery.

- Contact people by phone during your lunch time.

- Take a risk and ask your employer for a slightly different schedule, say 7-3; or ask for a two-hour lunch one day a week, making it up on another day. Attempt what it takes so you can use this time for marketing.

- Let your family know exactly what your marketing hours are. They are not to interrupt you during this time. Make your own rules and enforce them. Get respect!

Determined people are able to accomplish remarkable things. Going into business for yourself, whether it be as an artist or carpenter, takes great determination as well as discipline.

A MARKETING SCHEDULE

Whatever the total time presently devoted to your creation of artwork, divide this time in half. That is the amount of time you should be devoting to marketing.

CREATING AN OFFICE ENVIRONMENT

To accommodate your art business, you will need to create an office environment. If it can't be an entire room—if it's only a small desk—make sure it's private, quiet and comfortable. You'll be spending lots of time there. You can't work with people interrupting you constantly. Is there ample lighting? Is there a phone connection? Electrical outlets? Heat?

Set up your desk, file cabinets, etc. so they are convenient. Put energy into your office environment. If you don't, you are not taking your business seriously, and you are neglecting an important factor for success.

TELEPHONES

The telephone is one of the best marketing tools you have. Learn how to use it. Read more about telephone sales techniques in Chapter 15.

POINTERS

→ If you do business outside your local area, get an 800 line so you can leave an 800 number for calling you back. That is impressive! Don't advertise this number (unless you've decided it's worth it), but do make it available to those special clients. Call your local telephone company to find out about the new low rates—sometimes as low as $9.95 per month.

→ Don't be a penny-pincher. Follow up on all leads, even if they require long-distance calls.

→ Don't give your business number to friends. Have them call your home phone.

→ Instead of using Call Waiting and interrupting your conversations, install a second line and answering machine to take your calls while you are chatting with a client.

→ If you will be away from your phone for periods of time, Call Forwarding can come in handy so you don't miss calls.

→ Caller ID is a low-cost service that identifies callers—a great way to screen calls.

ANSWERING MACHINES

The message on your answering machine should be brief and professional, with an upbeat tone. It should include your company name and a request for callers to leave their name, phone number (with area code) and a message.

COMPUTERS

Computerizing your art business is a must. A small business without a computer these days is like a dinosaur. You'll be able to create a business presentation,

Don't interrupt a business call with an incoming call—it will make your first caller feel unwanted. If you get Call Forwarding attached to your main business line, that second incoming call can be forwarded to your home line or second business line.

resume, and letters and do your bookkeeping, time management, research, e-mail communication and more.

It will take some hours to learn how to use the various software programs on your computer—word processing, bookkeeping, page design and layout, database management, calendar planner, Internet software (often combined with e-mail retrieval), and viewers for PDFs/Portable Document Format readable by Adobe Acrobat and other types of documents.

CHOOSING THE RIGHT COMPUTER

Talk to friends. Get advice from business associates. Take a class. We love Macs here. These days they come with many software programs ready to go.

DESKTOP COPIERS/SCANNERS/PRINTERS

More often than not these days, a desktop printer will act as a scanner and copier too.

The more expensive the software, the longer and more elaborate the learning curve. It's also unlikley that you'll need all the bells and whistles of an expensive program.

If you can't afford a computer, you can go to a service bureau and rent a computer by the hour. Service bureau computers have access to a variety of clip art and fonts and to good printers. You can save your work on a diskette.

THE INTERNET

If you're a total Internet novice, locate an Internet cafe—a cafe that has computers connected to the Internet. You can rent time on their computers ($6-10 per hour). Perhaps your local library even has a connection for free!

PREREQUISITES FOR CONNECTING

▸ Computer

▸ Modem

▸ Color monitor (no fun to look at art in B&W!)

▸ Lots of paper

▸ Lots of time to spare

▸ Software

▸ Server access; about $15 per month for dial-up, more for high-speed

▸ Instruction book or class

INTERNET OPTIONS

▸ **E-mail.** A must these days. If you have foreign correspondents, you'll save bucks.

▸ **Communication forums.** You can subscribe to forums where people who want to exchange information on a particular topic discuss their ideas. To find artist groups, search for "news list newsgroup" and it will bring up various topics. Be sure to save the web addresses you are interested in, or they might get lost to you forever.

▸ **Transferring files.** There are possibilities for downloading files onto your own computer: clip art, software, etc.

▸ **Travel.** Information about hotel chains, airline reservations, etc.

▸ **Banking.** At some banks' web sites, you can verify cleared checks, bank balance, etc.

▸ **Looking at art.** You can view art galleries and museums in distant communities. Though you might have an avoidance factor towards computers and going online, you will need to overcome these attitudes if you intend to have an active business.

▸ **Exhibiting your artwork.** Exhibiting your artwork online is very important for artists, not necessarily for direct sales, but moreso for exposure. You can create your own web site (costly at $2000[+] unless you know how to use web software) or be part of an online gallery (much less costly at $100[+] a year.) Many online

gallery venues will tell you that artists sell many pieces directly from their web site, but this is often inaccurate. If you intend to sell original pieces between $50-200, online sales might occur. Higher priced pieces, however, will require a direct viewing from the potential patron.

When you have a close, intimate mailing list, you will be able to send out invitations via e-mail, ultimately only costing you design time. Once you have one invite designed, you can duplicate it for your other shows and fill in the new words and photos. There are Internet companies, such as www.mailermailer. com, that will keep your e-mail database updated.

You will be able to do all kinds of research, both for business and pleasure. We have found many appropriate art consultants, interior designers who work with artists, projects and people in the same genre that particular artists work in, and much more. You'll be able to study what other artists are creating, as well as what they are charging. The Internet is an amazing tool and as a progressive business you have to take advantage of it.

You can attempt to sell your art on eBay. Several artists are making good money doing this, but it takes time and experience. The artist who wrote our special guide to selling art on eBay, which is part of our book entitled *Internet 101* made over $30,000 in one year.

You can join (or start) a blog about art marketing. You will also be able to do a lot of your talking via e-mail. This process can often save lots of time and frustration.

WWW.MARKETINGARTIST.COM

MarketingArtist can help get your business records in order and keep you on top of communications with clients:

▸ Maintains a calendar of appointments

▸ Reminds one of telephone calls to make

▸ Reminds one of daily and weekly to-do's, upcoming appointments and events

▸ Organizes client contacts, both e-mail and snail mail addresses, and prints out mailing labels from your contact list

▸ Keeps track of each of your artworks, its historical data, what shows it's been in, what gallery has it on consignment at the moment, etc.

▸ Sends e-mail to people about your upcoming art shows

▸ Is continually updated

Online exposure of your artwork is mainly for use as a portfolio.

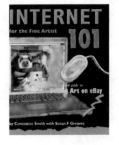

There is enough to learn about the Internet to fill an extire book—and here it is: Learn about Internet lingo, broadcasting, acquiring a URL, search engines, meta tags, online galleries, designing a home page as well as how to sell art on eBay (available from www.artmarketing.com).

You can enroll for on-line usage for **free**. If you're small and you stay small, you don't need to pay anything—ever! Once you realize how convenient and useful this software is to help run your business, send your e-mail and create labels for postcards, you will be using it daily. A small monthly fee is charged when used regularly.

LOCATING BUSINESS ASSISTANCE

Sometimes you will need an experienced person to help you learn about some aspects of business. Contact one of the following groups and set up a consultation (usually free for new businesses) to get direct guidance. By making a few calls, you should be able to find an expert willing to help with almost any business problem that you come across.

RESOURCES

Small Business Administration/SBA
(800) 827 5722
Offers more than 100 business booklets for a nominal fee (most under $2) that address a number of business topics. Ask for a directory of publications.

The Service Corps of Retired Executives/SCORE
(800) 634 0245
Comprised of 13,000 people with varying business backgrounds. Counseling is free and confidential. Special programs for women.

Artist in the Marketplace/AIM
The Bronx Museum of the Arts, 1040 Grand Concourse, Bronx, NY 10456-6181
If you live in New York, The Bronx Museum of the Arts has a 12-week program on career management for artists—a great opportunity to learn more, become motivated, and network within the art community. Eighteen lucky artists are accepted into the program each year. Deadline for applying is mid-January each year. For application, send SASE. Application fee is only $10.

BREAKFAST CIRCLE

If you're not networking with other fine artists who are marketing their artwork, you are missing out on an important element leading to success. An artist recently told me about her local (Soho, NY) "Artist Breakfast Circle." Once a week from 7:30-8:30AM, about 15-25 artists meet at a coffee shop. The "meeting" is conducted in a very specific fashion—no one is allowed to ramble on and on. One artist is in charge of the meeting, keeping things under control. Marketing issues are brought up and briefly discussed. Those who want to get together afterwards do so on their own. It is thought-provoking and energizing—a real boost to everyone's marketing week.

ACTION PLAN

- ❑ Register with the County Clerk's Office.
- ❑ Open a business checking account.
- ❑ Apply for a sales tax permit.
- ❑ Investigate what insurance you might need.
- ❑ Organize a filing system.
- ❑ Create a marketing schedule with specific days and hours.
- ❑ Create an environment in which to do your business activities.
- ❑ Invest in a separate business telephone line.
- ❑ Learn how to use your computer.
- ❑ List several ways your computer could help you with your business.
- ❑ List several ways your business could present itself better than and differently from a competitor.

RECOMMENDED READING

Breaking Through the Clutter by Judith Luther Wilder

Business Etiquette by Jacqueline Dunckel

Conquering the Paper Pile-Up by Stephanie Culp

How to Organize and Operate a Small Business by Clifford M Baumback, Kenneth Lawyer and Pearce C Kelley

How to Start Your Own Business . . . and Succeed by Arthur H Kuriloff and John M Hemphill

Running a One-Person Business by Claude Whitmyer, Salli Rasberry and Michael Phillips

Small Business for Dummies by Eric Tyson and Jim Schell

Working Smart: How to Accomplish More in Half the Time by Michael LeBoeuf

Chapter 3
Number Crunching

Keeping records

Studying your business

Tax preparation

Budgets and projections

In art, economy always is beauty.
Henry James

KEEPING RECORDS

This chapter will only touch upon the topic of money and bookkeeping. You will be informed of the most important aspects of recordkeeping for your small business. As your business progresses, you will need to find a more detailed book on this topic. For now, however, we want to keep things simple. What you will learn in this chapter will suffice for your new business.

THE PURPOSE OF ACCOUNTING

Though the IRS requires all businesses to file tax returns calculated from appropriate backup documents, you need to understand that you are keeping records for your own good. Yes, for yourself! Once you learn to read your accounting records, you will understand the full benefits of keeping good records. Good planning and budgeting are crucial in any business; they could mean the difference between success and failure.

ORGANIZING YOUR RECEIPTS

Saving receipts is key to recordkeeping; without them, you won't be able to record any numbers. If you do get audited (about a 1% chance), you also will be sharing these records with the IRS.

Save all your art-related receipts, both income and expenditures, for at least five years. Also save calendars, appointment books, businesscards of galleries you visited, copies of business letters you sent, lists of galleries to which you sent slides, press releases, awards, marketing plans, client lists, resumes, professional organizations to which you belong, and anything else that seems appropriate. If you are ever audited, you will need these records to prove that you were in business, i.e., attempting to earn a living through the sale of your art.

TIPS

→ Keep receipts in file folders, divided by the different tax-deductible categories.

→ Use one color of hanging files for expenses and another color for income.

→ You will also need file folders for such things as charge card receipts and bank statements.

→ If you are in your car a lot, keep an envelope in your glove compartment for receipts.

→ When you save meal receipts, write the name of the person you took out and his business relationship on your receipt.

→ Keep one credit card for business and one for personal use. This will save you a lot of time and headaches.

→ If you paid cash, indicate that on the receipt. If nothing is written on the receipt, you can assume you used your business checking account or your business charge card.

CHECKING ACCOUNT BALANCING

Look on the back of your bank statement for directions on how to balance your checking account. If you still can't figure it out, a customer service rep at your bank will give you free lessons. Once you get started, be sure you do it each month. It will then become simple to find errors.

QUICKEN

Quicken is bookkeeping software that costs less than $50. It keeps track of your income, expenses, and profit/loss statement and prints professional-looking checks. Easy to learn. With a simple business account such as you'll have at the beginning, it will take only five minutes monthly to balance your checking account.

INCOME CATEGORIES

Here are some starters for setting up your income accounts. Add what you need as you go along.

▸ Awards

▸ Commissions

▸ Consignment sales

▸ Direct sales

▸ Fairs/shows

▸ Gallery 'A' sales

▸ Gallery 'B' sales

▸ Grants

▸ Leases

▸ Miscellaneous income

▸ Royalties

You will have a paper file to hold receipts for each of your income and expense accounts.

DEDUCTION CATEGORIES

Accounting/bookkeeping/tax preparer fees

Admissions to art museums, trade shows, conventions

Advertising, business cards, stationery, brochures, etc.

Automobile expenses

Bank fees/bounced checks

Books (this one!), videos

Commissions to reps, galleries, etc.

Consulting fees

Donations to charities, museums, nonprofits, etc. (consult your accountant)

Donations of artwork (consult your accountant)

Dues to art associations/clubs

Educational expenses related to art seminars, classes

Equipment/furniture/machines for your studio or office

Entertainment, business-related (consult your accountant)

Fees to enter competitions and trade shows

Gifts to potential clients (limited per year)

Insurance

Interest on business-related loans

Legal fees

Licenses, permits, copyright application fees

Mailing list purchases

Materials (paint, canvas, brushes, frames)

Moving expenses

Office supplies

Photography fees for publicity photos, slides of artwork, etc.

Postage, UPS, Federal Express, packing supplies

Printing

Calculate what you pay each year from bounced checks, other bank fees, interest, and past-due charges. You may be shocked.

Promotion costs (business-related dinners, wine for studio showing, etc.)

Protective clothing

Rent and utilities on studio or office (gas, electric, garbage, water)

Research and development expenses

Subscriptions to art- and business-related magazines

Telephone

Travel expenses (airfares, hotel, food, car rental, taxi, etc.) to art events such as trade shows, gallery openings, seminars, conventions, fairs, etc.

STUDYING YOUR BUSINESS

PROFIT/LOSS STATEMENTS

When you have finished one month's recordkeeping and have calculated the totals for each category of income and expense, you create a profit/loss statement, otherwise known as a P&L Statement or Income Statement. This statement gives you the bottom line on how much you made in any given month. When you put three months of totals together, you have a quarterly P&L Statement—probably a more viable tool for analyzing your business than a monthly statement.

This P&L Statement is the primary instrument used to diagnose your business's health, to note trends and growth in your business. You will be able to study where your income is derived from as well as where your expenditures go.

It is a great help to know how to read your P&L Statement for planning future goals. If you are doing a particular project or promotion (i.e., having an open studio, doing a promo to publishers), classify all those expenses into specific categories. When you read your financial statement at the end of the quarter, you will be able to see at a glance if the special promo was profitable (see following page).

BALANCE SHEET

A balance sheet is a picture of what you own and owe business-wise, a statement of your financial condition. It also shows what you have personally invested in your business. Assets = liabilities + proprietorship (what the owner has put into the business). Have your accountant help you prepare your first balance sheet.

FIXED ASSETS

A fixed asset is a major piece of office equipment, a computer, furniture, automobile, etc. When you start your business, you should make a list of all major

A balance sheet shows your net worth. If you apply for a loan, your banker will want to see a balance sheet.

BALANCE SHEET

ASSETS		LIABILITIES	
Computer equipment	$2000	Auto loan (50%)	$2000
Office furniture	500	Computer	1500
Auto (50%)	4,000	Business credit card	450
		Total liabilities	$3,950
Total assets	$6,500	Owner's proprietorship	$2,550
		Total Liab & Prop	$6,500

pieces of office property you already own and use in your business. You will then begin depreciating them starting from their present value. When you purchase new assets over $300 (under $300 they are considered a direct expense), maintain a log noting date of purchase and price paid. You will need to depreciate the purchase price over a period of time, determined by the type of equipment. You will use the IRS Depreciation Form 4562.

If this is the first year you will be filing a business tax return (Schedule C), I recommend that you hire a professional tax preparer. You can actually lose money by doing it yourself if you complete the forms inaccurately!

P/L STATEMENT – JANUARY 2008

Income from sales

Gallery	$ 1,200
Open studio sales	$ 400
Rentals	$ 125
Prizes from contests	$ 150
Total income	**$ 1,875**
Cost of goods (supplies to produce artwork) $	375

Expenses

Advertising	0
Auto	$ 53
Bank charges	$ 8
Dues/publications/books	$ 19
Entertainment/refreshments	0
Entry fees	$ 25
Insurance	0
Interest	0
Legal/accounting fees	0
Miscellaneous	$ 40
Office supplies	$ 45
Personnel/assistant	0
Printing	$20
Rent	$ 100
Rental equipment	0
Seminars	$ 50
Shipping/postage	$ 15
Telephone	$ 20
Total expense	**$ 395**
Net profit	**$ 1105**

TAX PREPARATION

When you go to an accountant, have all your papers in order for him—most importantly, the year-to-date profit/loss statement. You don't want to pay him to do your bookkeeping, only your taxes.

If you decide to do your tax return, the IRS does provide instruction brochures to help you. You will need to file Form 1040, Schedule C (Profit/Loss from Business/Sole Proprietorship), SE (self-employment tax) and possibly Depreciation Form 4562.

AUTOMOBILE DEDUCTION

You should keep an auto-log in your car to record your business mileage. If you ever get audited by the IRS and have deducted usage of your car, you will need this log to validate your mileage. You can calculate your business mileage deduction in either of two ways: by the 'actual mileage method' or by 'per-mile method.' It's best to do both methods and see which one is the larger deduction for you in any given year.

ACTUAL MILEAGE METHOD

If you use the actual mileage method, you will depreciate the car (business % prorated) on IRS Depreciation Form 4562. You will deduct on Schedule C the business percentage of your usage. Be sure to keep all your auto receipts: gas, repair, lube, etc.

CALCULATING PERCENTAGE OF AUTO FOR BUSINESS USE

A. 51,366 Odometer 1/1/07	B. 63,366 Odometer 12/31/07
C. 12,000 Total miles driven	D. 6,000 Business miles from auto-log

Subtract A from B to get C. Divide C by D to get a 50% business use for the business year 2007. Use this 50% figure to calculate what portion of your 2007 auto expenses you can deduct. This calculation needs to be done each year, as the percentage could change.

PER-MILE METHOD

This is a simpler method for deducting your business car use. Each year the government sets a per-mile deduction rate. After you figure out the total business miles from your mileage log (in this case 6,000), you multiply the miles times the government-set per-mile rate to get your mileage deduction.

HOME-OFFICE DEDUCTION

To establish a home-office deduction that meets the IRS requirements, you must be able to prove that your home office is used both *exclusively* and *regularly* for business

purposes. That requirement is absolute and must be met by every taxpayer who takes the home-office deduction.

You paint at home, right? You market from your studio/office. This studio/office deduction will most likely apply to you. Art teachers, for instance, who teach at a school and then come home to use their office for an hour a day will not qualify. To verify the percentage of time that you use your in-home office space, you should keep a log.

Additionally, you must meet at least one of these three conditions:

1. Your home office is your principal place of business, or

2. Your home office is a place where you regularly meet with customers or clients, or

3. Your home office is a separate structure not attached to your home.

If you can prove one of the above, you can take a home-office deduction. Home-office deductions cannot exceed the net income from your art business. (Talk to your accountant about this.)

If you qualify for home-office deduction, you can deduct a:

▸ Percentage of the home that is used for business

▸ Percentage of heating, lights, air conditioning, cleaning, etc.

Alternatively, if you decide to rent a studio away from your home, 100% of those expenses can be deducted.

If you rent, it is simpler to calculate the deduction for a home office. You simply write a check each month to the landlord for that portion of the home that you use as office and storage. That becomes your rent expense. For instance, if 400 square feet of your 2000-square-foot rented house is your home office (1/5), and you pay $500 rent, you would write one check from your business account for $100 (1/5 of the total rent) and one from your personal account for $400.

EDUCATION EXPENSES

You can deduct education expenses that further the possibilities of your income, such as a watercolor workshop, framing workshop, marketing seminar, etc.

AUDITS

If audited, you must be able to convince the IRS that you are running a professional business, so have your files in order. The records you've been keeping will prove that you were actively engaged in creating and marketing your artwork. Keep these records for five years.

Even if you hire an accountant at year-end to file your tax return, you still have to keep records.

Your business (Schedule C) and personal (Form 1040) tax returns are due by the same date—April 15.

THE TAX MAN COMETH AGAIN

by Barbara A Sloan

The mere mention of the word "tax" has most of us running for shelter. Fortunately for artists, many shelters can be found nestled within that complex and cryptic diatribe known as the Tax Code. And all these tax breaks for artists are perfectly legal!

The importance of keeping good records

In the world of taxation, there is nothing more important than accurate bookkeeping. Not only does it make your tax preparation incredibly simple, but your books can show you where your money is coming from (which venture) and how you are spending, and, ultimately, what to change to become more profitable. Your records do not need to be kept in any particular format, but they must reflect your taxable activities. Should you have receipts for activities that are "ordinary and necessary" to your business, do not hesitate to use them as deductions. Keep in mind, however, this tax adage: Pigs get fat; hogs get slaughtered.

Income tax filing requirements

Not all income is taxable, but gross profits from sales, barters, and trades certainly are. If you are a hobbyist, your hobby income is subject to tax, and you will necessarily pay more in income tax than if you claimed your income and expenses as a business. If you are a sole proprietor earning more than $400 net profit within the year, you must file a Schedule C (Net Profit from Business) and Schedule SE (Self-Employment Tax) with your Form 1040 and perhaps include a Form 4562 (Depreciation) and Form 8829 (Business Use of Home).

Extensions and amended income tax returns

If you can't finish your return before April 15, file Form 4868 (before 4/15) to get an automatic four-month extension. A second extension (Form 2688) for an additional two months requires approval from the IRS. Note that extensions only delay the filing deadlines, not the due dates for your tax payments. If you have underpaid your taxes, you could be subject to interest and penalties. Once you file your return, you can amend it by filing Form 1040X.

Beyond income taxes

Despite the focus on Federal income tax, there are other types of taxes for which you may be liable. There are Federal taxes on employment (for Social Security and Medicare), certain gifts, and some estates. Many state and local governments assess taxes not only on income but on sales and special types of property. There are even taxes on unemployment! Taxation has a tremendous function in American society, but it should never become the basis for your personal or business decisions. Use it wisely!

Barbara A Sloan is an award-winning artist who has been selling her work since 1968. She has worked with artists' taxes since 1979 and holds a Juris Doctorate in taxation. Her QUICK-FIX TAXKITS—easy-to-use tax kits for Schedule C, general taxes, and recordkeeping—are in their tenth year of publication. Barbara can be contacted by e-mail at info@akasii.com or by writing AKAS II, PO Box 123, Hot Springs, AR 71902-0123. Phone consultations available. www.akasii.com

ESTIMATED TAXES

Once you decide to go into business, you will be self-employed. The IRS will then require that you pay your estimated annual tax liability one quarter at a time. They will send you the proper forms to fill out each quarter. Use your quarterly profit/loss statement to determine estimates of income for the year and thus your quarterly tax payment.

Keep in mind: You can be employed and self-employed at the same time. If this is your case, you might not have to make quarterly estimated tax payments. Your employer is already taking taxes out of your paycheck. Consult with your accountant or the IRS to discuss your situation.

INSTALLMENT PAYMENTS

Form 9465, an Installment Agreement Request for those that owe less than $10,000, can be filed. If approved (and it usually is), you will be allowed to pay off your taxes due over as long as three years with interest.

FORM 1099

If you receive more than $600 in any calendar year from a company or individual, you should expect to receive a Form 1099-Misc from them.

Likewise, if *you* pay someone over $600 in any calendar year for services rendered (i.e., work-for-hire, a printer, landlord, free-lancer, etc.) you need to:

▸ Report this on Form 1099-Misc by January 30 of the following year to the person to whom you paid the funds.

▸ Send a summary report (Form 1096) to the IRS by February 28.

Forms 1096 and 1099 can be downloaded from www.irs.org.

TAX BOOKS

▸ JK Lasser's: Your Income Tax

▸ Ernst & Young Tax Guide

▸ Consumer Reports Guide to Income Tax

TAX WEB SITES

www.irs.ustreas.gov

www.1040.com

www.hrblock.com/tax/refnd

You will use form 8829 for home-office deduction. Be aware: Home-office deduction might evoke an audit.

If you anticipate making no more net profit (after expenses) than $2000–3000 annually on your art business, you probably do not have to pay quarterly estimated taxes.

IRS TAX ASSISTANCE

Recorded info (800) 829 4477

Assistance (800) 829 1040

PUBLICATIONS

(800) 829 3676 www.irs.org
Most of the following publications are free. Ask for an order form.

#334 Tax Guide for Small Business
#463 Travel, Entertainment and Gift Expenses
#505 Tax Withholding and Estimated Tax
#508 Education Expenses
#530 Tax Information for Home Owners
#533 Self-Employment Tax
#534 Depreciation
#535 Business Expenses
#536 Net Operating Losses
#538 Accounting Periods and Methods
#539 Employment Taxes
#541 Taxes on Partnerships
#542 Tax Information on Corporations
#545 Deduction on Bad Debts
#547 Casualty Losses
#551 Basis of Assets
#560 Retirement Plans for the Self-Employed
#583 Taxpayers Starting a Business
#587 Business Use of Your Home
#589 Tax Information on S Corporations
#936 Home Mortgage Interest Deduction
#910 Guide to Tax-Free Services
#911 Tax Information for Direct Sellers
#916 Information Returns (non-employee payments)
#917 Business Use of a Car
#921 Explanation of Tax Reform Act for Business
#946 How to Begin Depreciating Your Property
#1391 Donation Guidelines

TAX ISSUES

If you've been doing proper bookkeeping all year, you will have paid your quarterly estimated taxes and will not be strapped to pay the entire amount all at once.

Many artists worry about taking a loss for more than three years on their Schedule C. Such cases have come before the courts. When an artist keeps in-depth and accurate records and is actually doing business, his continuous losses are considered valid. For instance, if you studied art, sold some of your work, approached galleries for shows, kept a mailing list, had articles written about you, got a grant, taught art—all these validate that you are attempting to make a living at selling your art. Don't feel guilty about reporting a loss. You should see Bank of America's tax return loss! If you have a continuous loss for many years, especially a large one, you can eventually expect to be audited. But don't sweat it: If you have kept good records and are not cheating, you will pass the audit with flying colors.

Don't mislead your clients when you are part of an auction. Some people tell their clients that a purchase at a charity benefit is deductible. Buyers, however, cannot claim a deduction for an art donation when they receive something in return for their payment (in this case the artwork), unless they pay more than the fair market value. IRS Publication #1391 (Donation Guidelines) explains this ruling in full.

BUDGETS AND PROJECTIONS

Projections help you to see mentally what you need to accomplish physically. All profitable businesses use projections.

A projection statement is very similar to a financial budget. On a projection statement you will try to predict what income you will have in the near and distant future, as well as the expenses for that same period.

Let's say you have been accepted by Bank of the Mediterranean for a one-person show for January. Project the amount you expect to make from this exhibit, both on-site and with follow-up. Of course, you don't know exactly, but create some goals. It could help you close a sale! This projection will help you to see if you have the funds to hire a salesperson, send postcards, buy refreshments, etc.

PROJECTIONS

January 1, 2008 - March 30, 2008

Sales		
Bank Exhibit	$ 1500	
Personal/past clients	$ 500	
Cards/prints	$ 200	
Patrons @ $100 per month	$ 600	
New patrons @$100	$ 300	
Projected income	$3100	
Expenses		
Bank Exhibit		
Mailers/invites	$200	
Reception	$100	
Salesman	$350	
Overhead	$900	
Printing of greeting cards	$250	
Printing of letterhead	$150	
Projected expenses	$1950	
Total projected income	$1150	

If you are not content with the outcome of $1150 in projected income, then it's time to think of what you can do to make it higher—either lower your expenses or try for more sales.

Whether in your private or business affairs, it is very important to learn how you spend, as well as why and when. The following suggested task is not pleasant for most people. Perhaps that's why, if you try it, you will learn so much.

TASK

In order to see exactly how, why and when you spend, keep track of *every expenditure* for at least *three months*. When you keep track for three months, you will be able to see your weaknesses regarding spending. You must write down *every cent* you spend: $1.25 for morning coffee, $1 bridge toll, $1 to beggar, $5 for shoe repair, etc. I guarantee that you will be surprised by the results when you calculate your totals for weekly, monthly and quarterly expenditures! Use a 20-column worksheet, or make your own chart. Be a fanatic about writing everything down, or the result will not be truthful and will not assist you in your study.

Make a summary, similar to your P&L statement, at the end of each month, as well as at the end of the three months. Once you make this analysis, you will need to curb certain spending tendencies that are out of hand.

RESOURCES

Spending Plan: A Spiritual Tool
www.solvency.org
12-Step Program Debtors Anonymous

Artists' Bookkeeping Book
Chicago Artists' Coalition, 70 E Lake St #230, Chicago, IL 60601
(312) 781 0040 www.caconline.org
Workbook explains how to keep records and what deductions to take. You can record your income and expenses, summarize your cash flow on a monthly basis and balance your books. Updated annually.

If you know already that you have trouble balancing your personal budget, use only cash or check—no credit cards.

ACTION PLAN

- ❏ Start keeping all business receipts.
- ❏ Balance business checking account monthly.
- ❏ Use a separate charge card for business purchases.
- ❏ Produce a profit/loss statement monthly and quarterly.
- ❏ Start an auto-log. Keep it in the car.
- ❏ Prepare a balance sheet.
- ❏ Create a quarterly business projection.
- ❏ Analyze personal expenditures for three months.

RECOMMENDED READING

How to Turn Your Money Life Around by Ruth Hayolen

Keeping the Books: Basic Recordkeeping and Accounting for the Small Business by Linda Pinson and Jerry Jinnett

Living More with Less by Doris Longacre

Small Time Operator by Bernard Kamoroff

Straight Talk on Money by Ken & Daria Dolan

The Tax Workbook for Artists and Others by Susan Harvey Dawson

Your Money or Your Life by Joe Dominguez and Vicki Robin

Your Money, Your Self by Arlene Modina Matthew

Chapter 4
Legal Protection

Copyright

Model releases

Legal rights

Estate planning

Contracts

User-friendly agreements

Finding the right lawyer

"No! No! Sentence first, verdict afterwards."
Through the Looking Glass, Lewis Carroll

COPYRIGHT

The sale of your artwork does not give buyers the ownership of copyright. If they want this additional benefit, they must have your written agreement. You should never, however, give up your copyright unless you are being paid very well. It is the most valuable asset for your business and for you as an artist.

You can sell rights—they are not usually "lifetime" or "complete"—to a copyrightable piece without selling the original. Each type of right of usage will require a separate legal agreement.

Any new business must investigate legal rights related to their particular needs. An artist is no exception. If you know your legal rights, you will be a wiser negotiator and a better businessperson. If you know these rights from the start, chances are you will not be taken advantage of.

This chapter cannot possibly cover all the details you will need to know to understand any given legal matter, but will inform you about some of the basics of which you need to become aware. Even when you know your legal rights, it is likely you will encounter some legal problems. Even the most cautious person cannot prevent these occurrences.

BASIC COPYRIGHT

Copyright is your form of protection, provided by law, for the creation of original works. As owner/creator of your copyright, you have exclusive right to do (and to authorize others to do) the following:

▸ Reproduce the work in copies

▸ Prepare derivatives of the work

▸ Distribute copies to the public by rental, lease, or sale

▸ Display the copyrighted work publicly (for example, include in a motion picture)

COPYRIGHT REGISTRATION

Since 1978, you are not required to put the copyright © symbol on your work to protect it. You still have to prove it is your original creation, however. So how do you do that? You could take snapshots or slides and get them printed with a date on the photo. This is some proof. But this *will not* hold up in a court case. If you don't file copyright formally with the Copyright Office in Washington, DC, you cannot sue someone for infringing your copyright. When you register with the copyright office in Washington, DC, you become eligible to receive statutory damages and attorney's fees in case of an infringement suit.

To be copyrightable, a work must be both original and creative; it must be a physical expression of an idea. It may be a logo, illustration, fine artwork, oil painting, transparency, photo, chart, diagram, video, filmstrip, motion picture, slide show, computer software program, typeface, etc.

Formal copyright registration costs $30. For this fee you register:

▸ One published work (print, poster, cards, etc)

▸ A group of 20 unpublished works. These 20-plus pieces must be of the same style and medium.

Completion of a standard Form VA is necessary. (Find one that you can photocopy in *Art Office* available at www.artmarketing.com.)

COPYRIGHT LAW OF 1976

Under the copyright law of 1976, any work created on or after January 1, 1978 is protected by common law copyright as soon as it is completed in some tangible form. As the creator, you have certain inherent rights over your artwork, including the ability to control how it is used.

▸ You have the exclusive right to reproduce, sell, distribute and display your artwork publicly. This protection lasts until 50 years after an artist's death. It can be renewed by an artist's heir(s).

▸ You also have the right to transfer the copyright to heirs in your will.

▸ You can transfer part or all of your copyright through a sale, gift, donation or trade. You must do this in writing. This is not the same as selling or transferring ownership of an artwork. You can sell a first-reproduction right to one company, say for greeting cards, and a second-reproduction right to another, say for a calendar, as long as each contract allows you to do that.

INFRINGEMENT

Infringement occurs when someone derives a work of art directly from a work by someone else. If you derive a painting from a photograph clipped from a magazine, for example, you might be infringing. With computer-generated art, this has become an increasing concern. If you copy from an existing image, you need to alter your work to the extent that a casual observer would not notice a resemblance.

RESOURCES

Copyright Hotline
Library of Congress, Copyright Office, Washington, DC 20559
(202) 707 3000 (202) 707 9100
Ask for Copyright Basics (Circular 2), The Nuts and Bolts of Copyright, Highlights of the New Copyright Law, New Registration Procedures, Deposit Requirements for Registration of Claims to Copyright in Visual Arts Materials, as well as Form VA.

Self-Help Law Center
www.nolo.com
Many books on a variety of legal topics

An international copyright that will automatically protect an artist's works throughout the world does not presently exist. Protection against unauthorized use in a particular country depends on the country's laws.

When you hire a photographer to take pictures of your artwork, the photos are his copyrightable images! You will need to get in writing that he agrees to relinquish this right.

MODEL RELEASES

INVASION OF PRIVACY ACT

If you execute a portrait of someone, be sure you obtain a model release for future use of this painting in your brochure, newspaper article, publicity, for sale at an exhibition, etc. Without this release, you cannot reproduce it or exhibit it in public without the possible threat of a lawsuit.

Any failure to obtain such a release can be construed as a violation of the rights of privacy of the individual who served as the model. When the model is a minor, the written consent of a parent or guardian is necessary.

Models can also object to altered images. If your model release form does not cover altered images, the model may bring an action under an invasion of privacy or publicity rights statute that enables the model to control the use of her name, likeness, voice, signature, or photograph in connection with the advertising of goods or services. The model need not show injury to reputation.

Invasion of privacy doesn't apply after someone dies; however, an estate may have the right to all images of any given celebrity.

The Marilyn Monroe Estate controls the image of Marilyn Monroe. When an artist executed a painting and had 5,000 prints made, the estate caught wind and took the artist to court. The artist tried to give the estate a royalty, but they would not accept the offer. The artist was told by the court to destroy all remaining prints. The estate personnel made certain this was done by going to the artist's studio and assisting him!

Another artist had a wonderful offer from an art publisher. The publisher wanted to reproduce the painting she had created by copying a photograph originally taken by a professional photographer. She called the photographer to find out if he would sign a release to allow her painted portrait to be published. Even when he was offered a royalty, he refused to give her permission. She had infringed on the photographer's rights by copying his photograph.

MODEL RELEASE

On _____ 20__, I posed as a model for artwork (to be) created by _____ _____. In consideration of the payment of the sum of $ _____ at the conclusion of this modeling assignment, I hereby grant the irrevocable right to the use of my likeness in any and all media and in any and all manners including composite or segmented representation for the preparation of works of art or any other lawful purpose. I hereby waive my rights to approval/rejection of the completed works which may incorporate my image, and hold harmless the Artist and the Artist's Representatives against any and all liability arising herein.

I am an adult living in the State of _____. I have read this model release and understand its contents.

Date _____ Model _____

Address _____

If the model is a minor

As Parent/Guardian of the above-named Model, who is underage, I hereby consent to all the terms stated above and accept in behalf of the Model the consideration set forth above.

Date _____ Parent/Guardian _____

If your painting of a publicly-known person or a public building is used to inform and educate the public, then you won't need a model release. The only exception is if the painting depicts something that could be embarrassing to someone. If the painting is used for promotion, endorsement, advertising, or other commercial or trade use, you will need a model or building release.

LEGAL RIGHTS

In almost all cases, the creator of a commissioned work owns the copyright, not the person who commissioned it. Only certain types of commissioned work are treated as works-for-hire.

Under California law, any gallery, representative or owner who sells a work of art must inform the artist, upon request, of the name and address of the new owner.

California has also enacted a law to help protect artists when their work is resold, entitled Resale Royalties Act. It enables artists to continue receiving a share of royalties when their artwork is passed from one collector to another. For an emerging artist, this might not mean much money. When you become known and your works are being auctioned, you will appreciate this law!

Under federal law, the artist must be given proper credit when his work is exhibited or displayed. The piece exhibited cannot be a distorted or altered version of the work unless preapproved by the artist.

Only artists who can prove tribal membership can be advertised as Indian or Native American. Fines may be as high as $250,000 for the dealer or artist who does not comply with this regulation.

Most states have statutes requiring dealers to provide a certificate of authenticity or a similar document disclosing pertinent facts about multiple editions. This certificate must be given before or at the time of the sale. This disclosure must also appear in promotional materials regarding limited editions. Failure to provide a certificate or to disclose information properly entitles the buyer to rescind the transaction and receive his money back with interest. An artist who sells his works directly is considered a dealer.

Many publishers are purchasing large numbers of paper prints and reprinting them onto canvas and reselling them without the artists' permission. This is a violation of the artists' rights. Dealers in such works will subject the printer, publisher, gallery or framer who creates or sells such works to liability. In one lawsuit, a widow of a famous artist sued a publisher who mounted prints of her husband's work taken from books onto ceramic tiles and sold them. This was found illegal without her (the heir's) permission.

WORK-FOR-HIRE

Work-for-hire occupies a special category under copyright law. If you are employed or apprenticed and you create a work of art through the scope of your employment or apprenticeship, your employer or master owns the copyright to your work; that is, the copyright owner of works-for-hire is the person who does the hiring. The creator has no rights to the work whatsoever, unless she and the employer have agreed in advance to the contrary. Any such agreement must be written and signed by both parties.

WORK-FOR-HIRE AGREEMENT

Agreement made this _____ day of _____ 200 __, between _____ (hereinafter "Company") and _____ (hereinafter "Artist") for the preparation of _____ artworks for the _____ (hereinafter "Project").

Witnesseth: NOW, WHEREFORE, in consideration of the mutual covenants and promises set forth herein, the parties agree as follows:

1. Artist will create _____ artworks for the forthcoming Project.

2. Artist shall submit the artworks in finished form no later than _____ 200___.

3. Company will pay the artist the sum of $ ____ for each artwork, to be paid one-half upon delivery of preliminary studies and one-half upon delivery of the finished artwork.

4. Any and all artwork created pursuant to this agreement shall be considered a work made for hire and Company shall be the sole owner of the original artwork and all rights, including copyright in and to the work for any and all purposes throughout the world.

5. Artist warrants that he/she is the creator of the artwork specified here, that the work has not been published previously, that it does not infringe on any rights of copyright or personal rights and rights of privacy of any person or entity and that any necessary permissions have been obtained.

6. Artist agrees he/she is working as an independent free-lance contractor and will be responsible for payment of all expenses incurred in preparation of the artwork.

IN WITNESS WHEREOF, the parties hereto have duly executed this agreement the day and year first above written.

Company _____ Artist _____

A commissionable work is not considered a work-for-hire since you are not employed. Artists confronted with "work-for-hire" imprinted on the back of checks received from patrons should cross out the wordage to fight the attempted rights takeover.

ESTATE PLANNING

If you plan correctly, your artwork can survive after your death. Should you become ill, or be at the age where you feel comfortable with estate planning, here are some pointers. If you have not done your homework throughout the years, it will be much more difficult to get the necessary records in order.

- ▶ Your work needs to be organized, documented, and inventoried.

- ▶ You will need to decide, if the works are in your possession when you die, who will be responsible for finding a good home for them.

- ▶ Don't name any persons, public facility or company as a recipient of your work unless you have talked to them first.

- ▶ Hospitals and libraries are two public institutions that would benefit from donated artwork. You don't want your art stored away. It does nobody good in storage.

- ▶ You need to prepare a will that indicates your desires. Be sure to note in the will who will own the copyrights. It is best to pass the copyright ownership along with the artwork; otherwise your heirs might owe more taxes than they planned.

RESOURCES

The Marie Walsh Sharpe Art Foundation
www.sharpeartfdn.org
A Visual Artist's Guide to Estate Planning, published in 1997, can be downloaded at this site for free.

Allsworth Press
10 E 23rd St #510, New York, NY 10010 (800) 491 2808 (212) 777 8395
www.allsworth.com
Protecting Your Heirs and Creative Works: An Estate Planning Guide for Artists, Authors, Composers and Other Creators of Artistic Works is one of the many legal books this publisher compiles. Call for brochure.

CONTRACTS

If a gallery says they don't sign contracts with artists, run out of there like a rabbit. Don't have anything to do with them.

There are two types of contracts you can use in your business. When dealing with another art professional, i.e., a gallery, consultant, museum curator, publisher, etc., you need to have a formal contract. When dealing with a small-time private collector, you can have a user-friendly agreement.

Artwork professionals often will have a standard contract that they want you to sign. Take time to look it over. See if you have questions. Make sure you ask them about anything that you do not understand or anything that you disagree with. Do this in writing so you have a record of what you asked and what they answered. If you don't like their answer, then propose an alternative approach. If that doesn't get approved, then another compromise will have to be made. Both parties must be content upon signing. Do not give up rights that you shouldn't, but don't get stuck on small details.

CHECKLIST FOR CONTRACTS

Listed below are frequently-used points in a contract between a gallery and artist. Only in the cases of very successful artists, where large amounts of money and complexities of arrangements are involved, are all these points included. Use common sense. Protect your rights, but don't be fanatical.

❑ Parties involved
 Gallery: Continuity of personnel, location. Assignability.
 Artist: Extension to wife, children. Estate.
❑ Duration
 Fixed term, contingent on sales/productivity. Options to extend term. Different treatment of sales at beginning and end of term.
❑ Scope
 Media covered. Past and future work. Gallery's right to visit the studio. Commissions. Exclusivity. Territory, studio sales, barter or exchanges, charitable gifts.
❑ Shipping
 Who pays to/from gallery. Carriers. Crating.
❑ Storage
 Location, access by artist.
❑ Insurance
 What's protected, in-transit/on-location.
❑ Framing
 Who pays for framing; treatment of expense on works sold.

(continued on next page)

❑ Photographs
Who pays, numbers required (B&W and color), ownership of negatives/transparencies, control of film.

❑ Artistic control
Permission for book/magazine reproduction. Inclusion in gallery group exhibits. Inclusion in other group exhibits. Artist's veto over purchasers.

❑ Gallery exhibitions
Dates. Choice of works to be shown. Control over installation. Advertising. Catalog. Openings. Announcements/mailings.

❑ Reproduction rights
Control prior to sale of work. Retention on transfer or sale of work. Copyrights.

❑ Damage/deterioration
Choice of restorer. Expense/compensation to artist. Treatment for partial/total loss.

❑ Protection of the market
Right of gallery to sell at auction. Protection of works at auction.

❑ Selling prices
Initial scale. Periodic review. Permission for discounts. Negotiation of commissioned works. Right to rent vs. sell.

❑ Billing and terms of sale
Extended payment; credit risk, allocation of monies as received, division of interest charges, qualified installment sale for tax purposes. Exchanges/trading up. Returns.

❑ Compensation of the gallery
Right to purchase for its own account.

❑ Income from other sales
Rentals. Lectures. Prizes/awards. Reproduction rights.

❑ Accounting/payment
Periodicity. Right to inspect financial records. Currency to be used.

❑ Advances/guarantees
Time of payment. Amounts and intervals. Application to sales.

❑ Miscellaneous
Confidentiality of artist's personal mailing list. Resale agreements with purchasers. Right of gallery to use artist's name and image for promotional purposes.

❑ General provisions
Representations and warranties. Applicable law. Arbitration.

A user-friendly agreement is a letter or form, often on business letterhead, that states in simple terms the rights of the artist.

The first time I wrote an agreement as an art agent (for a portrait commission), I made two major mistakes.

Firstly, I gave the contract to the client about two-thirds of the way into the commission. A contract should be signed previous to the start of any work by the artist. Partial payment accompanies the signing.

Secondly, being new to the realm of contracts, I copied verbatim a contract from a legal guidebook for artists. Within a day, I received a call from the frantic client with several hesitations. I was unable to answer her questions as I didn't know what the contract meant! Needless to say, I was embarrassed. After doing some research and resolving the matter successfully, I learned to draw up a user-friendly agreement. I also learned to study and understand what my contracts mean.

In a user-friendly contract, you would want to include all or some of these:

- ▸ Rights of reproduction

- ▸ Right to photograph

- ▸ Right to reacquire the work for a retrospective

- ▸ Royalty on sale of artwork

- ▸ Share of rental income

- ▸ A limitation regarding exhibition of artwork

USER-FRIENDLY AGREEMENTS

Whenever you send an agreement through the mail, register it with a return-receipt attached. You will then have a record that it was received.

69

The following user-friendly agreement suffices for a bill of sale.

June 17, 2007

Dear Mr. Tyler,

I appreciate your interest in my artwork. I am shipping *BLUE HERONRY* to you today via Federal Express COD, per your request.

The price of this piece, as we agreed, is $804.38, which includes the California sales tax. I have added on $45 for shipping to total $849.38.

I like to inform my clients of the terms of sale as follows:

▸ All works are originals, unless otherwise indicated.

▸ All works are certified to be free from all defects due to faulty craftsmanship or faulty materials for a period of twelve months from date of sale. If flaws shall appear during this time, repairs shall be made by me.

▸ Copyright of work is held by artist.

▸ Resale or transfer of work requires that I be informed of the new owner and the price of the sale. Should the price be more than the original price stated herein, according to California state law, 10% of amount over original price shall be given to artist by seller.

▸ Artist shall have right to photograph piece, if necessary, for publicity or reproduction purposes.

▸ Artist shall have right to include artwork in retrospective show for a maximum of three months.

▸ If artwork is rented out by purchaser, artist will receive 25% of rental income.

▸ Artwork cannot be exhibited in public without written approval of artist.

Sincerely,

Artist

As an artist with a legal question, you don't want to hire a lawyer who specializes in real estate or accident law. If you are working out a licensing or royalty agreement, you want an "intellectual property attorney" who specializes in copyright and publishing law.

Understand the lawyer's pricing structure, i.e., how much you will be charged for speaking to him for five minutes on the phone, etc. If you have a big project, it's a good idea to evaluate your lawyer's credentials. See what cases she has worked on that might be similar to yours.

RESOURCES

Martindale-Hubbell Law Directory
Lists lawyers by areas of practice. Reference at your library.

Volunteer Lawyers for the Arts
www.vlany.org
This organization, with divisions throughout the country, provides artists and art-related businesses with legal assistance—sometimes free, sometimes for a nominal fee. Informative newsletters and excellent books about legal issues are published by some branches. Some hold seminars and classes related to legal rights for artists.

FINDING THE RIGHT LAWYER

You want to feel confident and comfortable with the lawyer you choose.

ACTION PLAN

❏ Know your legal rights.

❏ Copyright your work at the copyright office in DC.

❏ Prepare a standard model release.

❏ Prepare a standard user-friendly agreement.

❏ Contact the Volunteer Lawyers for the Arts in your area and attend a seminar.

RECOMMENDED READING

Art Law in a Nutshell by Leonard D DuBoff

The Art Law Primer by Linda F Pinkerton and John T Guardalabene

The Artist's Friendly Legal Guide by Floyd Conner, Peter Karlen, Jean Perwin and David Spatt

The Copyright Guide, A Friendly Guide to Protecting and Profiting from Copyright by Lee Wilson

Business and Legal Forms for Fine Artists by Tad Crawford

Legal Guide for the Visual Artist by Tad Crawford

Make it Legal by Lee Wilson

Chapter 5
Pricing

Pricing methods

Maximizing your art's value

A fool and his money are soon parted.
Anonymous

PRICING METHODS

Your goal is to set a price that strikes the consumer as fair, at the same time enticing him to buy.

When you think about pricing your work, think of it as having a "price range," not just one price. Determine an average price range, and then price according to size, subject, media, framing costs and importance of work. Having a price range, you will touch upon many segments of the marketplace when you have an exhibit. You'll have to do some research in order to find out what this price range should be for your work.

TIME AND OVERHEAD PRICING

In order to survive, most working artists will need to be able to complete at least five originals a month. This doesn't mean you will sell all five pieces each month, but you need to build a stock so your clients have a variety to choose from. If it takes you a month of working eight hours a day to finish one painting, this probably means you will have to get involved in the print market and forget about selling your originals. (See *Licensing Art 101* available at www.artmarketing.com.)

To calculate time and overhead pricing:

1. Calculate total business expenses for the year (dues, education, utilities, publications, postage, etc.) to figure the per-month overhead. $6000 per year = $500 per-month business expenses.

2. How many pieces do you complete in a month on the average? 5

3. Divide the monthly overhead by the number of pieces.
 $500 ÷ 5 pieces = $100 per piece overhead

4. Decide on an hourly rate of pay for yourself. $25

5. How many hours to complete an average painting? 30

As a potential buyer, I might think something is wrong with a piece, or won't value it much, if the cost is less than what I feel is its fair market value.

6. Add a 10% profit margin.

7. Add a 100% commission (that's for the seller, you, a rep or a gallery).

 $100 overhead cost

 750 labor cost ($25 x 30 hours)

 $850 subtotal

 $85 10% profit margin

 $935 subtotal

 $935 commission at 100%

 $1870 retail price on unframed work

To this you would add tax, shipping, and, if the artwork is framed, the price of the frame.

FRAMING

If you do the framing, the frame price would include your labor but no mark-up, i.e., the same cost as a frame shop charges.

If you sell the piece, you keep the commission. If your gallery sells it, they get the $935 commission.

MARKET-VALUE PRICING

Another method used to calculate price range is to go into the actual marketplace and see what other artists with the same type of background and similar art are selling their artwork for. Do verify that these artists are selling—not just exhibiting. Maybe they are charging too much and not selling a thing.

PERCEIVED-VALUE PRICING

When you have a show, you'll discover that pricing an artwork at either $175 or $225 will often get the same sales results. You might see that if someone can pay $100, they most likely will be able to pay $150-175 but not $200. Products or services are bought on the basis of perceived value in the minds of buyers and not on the basis of what it costs you to produce a product.

TO COMPARE

Where do you go to compare? You don't go to the most expensive gallery in Beverly Hills. You go to juried shows, outdoor shows, smaller galleries, and open studios in your area. Most prices in the art world are related to the price paid for similar work sold in the recent past.

When comparing pricing, keep in mind the aesthetic and technical merits of works, the style, medium and reputation of the artist and intrinsic cost of production.

After you have done some research and calculations, consider the following:

▸ From your research, does the time-and-overhead price of $1870 seem to be in the appropriate range?

▸ If you are selling through a dealer and make $935 (this includes the overhead and labor plus 10% profit margin), will you be able to make it financially?

It's generally a mistake to base your prices solely on the amount of hours spent creating a work. It's good to know, however, if the time you spend creating and the prices you are charging make it possible for you to earn a decent living. Perhaps you cannot earn $25 per hour when you start out. If that rate were lowered to $20 per hour, the price of the piece would drop to $1540. Is this closer to your perceived market value? This is the type of thinking and research you need to do before you set your price range.

Before long, an artist who keeps labor records on each piece can learn to estimate quite accurately the approximate number of hours needed to produce any given work. This information can be useful when scheduling projects, budgeting and pricing commissions.

To study perceived value, you need to be on-site at your exhibit. Study how people are reacting, what they're saying about your work, prices, etc. What are they buying?

Gradual increases in price is the way to go. Collectors like to see a little movement in an artist's prices over the years. If the market softens, you won't find your prices out of line.

It's amazing how often artists forget to include the cost of their labor in a project. If you don't fully recoup your labor and outside costs, you are basically subsidizing collectors. Why would you want to do that? In dire times a sacrifice might be necessary, but to make it a practice is downright stupid.

PRICING TIPS

→ When you have an exhibit, always have at least one piece priced at twice the price of one of the highest pieces. Perhaps you don't want to sell this piece, as it's your favorite (this is the piece that often sells first!).

→ People expect a small work to be priced lower than a large one. Though this does not make sense to an artist, as miniatures are more time-consuming to produce than large pieces, this is the psychology of the general public. If you don't think you can price smaller pieces for less, create large pieces.

→ The price that you charge from your studio and the price for which your dealer sells must be the same. You get to keep the commission when you sell a piece from your studio. Some collectors mistakenly expect your studio price to be 50% less, but it should never be.

→ Develop a long-term strategy connected with the pricing of your artwork. As you sell more, your prices will, of course, rise. Soon your pricing will establish itself, rising slowly—no more than about 10% per year. As your prices increase, have smaller works or prints available in the lower price range.

→ Keep your work affordable to all your previous clients.

→ Studio inventory should always be at least 10 pieces. If you only have four pieces in stock, it might be because you're selling at too low a price.

→ Always note the retail price on your price list.

→ Your prices should not vary from state to state.

→ Don't undersell your work. You must feel comfortable with the prices you decide on; otherwise, you will feel resentful.

→ Never prepare a proposal or model of a piece for anyone unless you are being paid for it. This is customary for architects and interior designers, and, as an artist, you need to make it customary, too. Clients will respect you more if you do this.

→ Your clients should know that the price on the tag does not include sales tax, packing and shipping. If the frame is not included, you need to note that.

→ Know your prices. When you have studied the market and know the various factors involved in pricing a product, you will have more confidence when someone questions a price.

A gallery owner wanted a lower price on a work by an artist I was representing. Since it was a rather simple-looking piece, he thought he could get me to come down on the price by asking me how long it took the artist to paint it. It was my favorite piece and the artist's first in a series, as well as the best of the series. I answered the gallery owner that it took the artist 60 years to paint. That was true. The artist was 60 years old, and until he painted that particular piece, he could paint none like it.

DISCOUNT POLICY

Did you know that it is illegal to charge one customer a lower price than another customer on the same product? The Robinson-Patman Federal Act is designed to prevent unfair price discrimination. There are ways around this policy, however.

▸ Discount when purchasing a second piece.

▸ Discount with cash in hand, usually 2-5%. In all other cases—check, credit card, money order—the full retail price is paid.

THE GOLDEN RULE

Don't sell anything that you wouldn't want to be known as your work. It might reach the wrong hands and bring you bad publicity someday. Be proud of every piece you sell.

You need to have a reason for sale prices to be lower, but don't give the idea of selling something inferior, old, not wanted. Instead of a "Sale," have a "Special Buy."

MAXIMIZING YOUR ART'S VALUE

As you enter into the business world, you must look at your art career with a broad perspective—at least 20 years into the future. Potential clients want to know that you will be around for a while.

DOCUMENTING WORK

Many artists overlook the area of documenting their work. They don't realize how important documentation is. It does take time and a bit of money to document your work. What happens when you are 65 and a big publisher wants to do a book about you? If you haven't kept track of your paintings, to whom they have been sold, etc., you will have only current work for the book.

For this reason and others, you need to keep an accurate record of all completed works throughout your career.

▶ When you sell a piece, keep track of the name and address of your new client. In the future, when you are ready for a retrospective, you will know where to find your important pieces.

▶ If a client, in turn, sells/donates/gives away your piece, you want to be informed.

▶ Save your sketches and minor works, especially those that have developed into major works. These can be especially useful in a retrospective show.

Once you have your artwork reproduced in the form of slides/photos/jpgs/transparencies, you will catalog them, similar to how a museum would do its collection. Your records should tell you:

▶ Date and title of artwork

▶ Inventory Number. Develop a code—year completed, month, and number—071132

▶ When the work was completed and how long it took to complete

▶ Who owns the piece. If a buyer sells, put the new owner's address in your files.

▶ Price you sold it for, as well as subsequent prices it sold for

▶ Who sold it (you, gallery, rep)

▶ What inspired the work, costs of materials, specifics of materials used (perhaps even where you purchased them), frame type, etc. All this information could help in any future restoration project. When you become known and museums start buying your work, this will help them with their archives.

To help you get your inventory documents in order, use *Art Office*, a book with 80+ forms, available at www.artmarketing.com.

One artist I know has an attitude that I hope you will develop. He did not skip documentation. He knew since he was 18 years old that he would be an artist. He did graphic design at times, comics, and a myriad of other tasks related to art, which also helped his fine art career. He took 8x10″ transparencies of all his important works from the very beginning of his career. This artist had the attitude that he would be well-known. He knew that someday a book would be published on his life and that these transparencies would be needed to produce the book. When I met him at age 62, the stack of transparencies was six feet high! He will soon have a monograph of his work published.

SIGNING WORK

Your signature can become your "trademark" and validates the authenticity of your piece. When you become collectible, your signature will make it easier to decipher forgeries. You can sign a piece on the front or back—it's up to you, but be consistent with whichever way you choose.

TITLING WORK

There are several reasons to give your work a title:

▸ For cataloging purposes

▸ To give the viewer a particular intellectual or emotional connotation

▸ To give a clue to some subtlety

▸ Because people remember titles and associate back to them when referring to a work of art

If you don't like one of your paintings but can't bear to destroy it, don't sign it.

ACTION PLAN

- ☐ Research and calculate your price range by time and overhead.
- ☐ Research and calculate your price range via market value.
- ☐ Sign your work.
- ☐ Title your work interestingly.
- ☐ Document your work to maximize its value.

RECOMMENDED READING

Pricing & Ethical Guidelines Handbook by Graphic Artists Guild www.gag.org

Chapter 6
Shipping and Displaying

Packaging

Crating

Shipping

Framing

Hanging

Labeling

Care

I have a predilection for painting that lends joyousness to a wall.

Renoir

CHAPTER 6

PACKAGING

As your career expands geographically, you will need to learn more about proper packaging and shipping of artwork.

PACKAGING TIPS

▸ When unframed graphic work is shipped, be sure to mark it clearly. Works on paper could be mistaken for packing materials and discarded.

▸ Mark the exterior of the box, "Fine Art," "Fragile," "Handle with Care," or "Glass."

▸ Mark clearly on the inside of the box the name of the gallery and the particular show at which your piece is being exhibited. Sometimes more than one show is occurring (or an agent is handling more than one show), and things get mixed up. The date of the show can also help.

▸ Put a small label on the back of your artwork with the title of your piece and your name, address and phone number in case it gets separated.

▸ Put instructions for return mailing (i.e., packing provided; return carrier,) on back.

▸ If you package more than one piece in a carton, put them back-to-back or face-to-face with a piece of corrugated cardboard placed in-between. When taking them in a car a short distance or carrying them in a box, remember that screw eyes and other protruding objects on one piece may damage the other. Either remove these screws or bulging areas, or pad securely between the two items.

▸ Flat prints should be placed on a foam board and shrink-wrapped. Package the foam board in heavy cardboard so nothing can puncture the piece. This is also an excellent way to display your pieces at a show—you'll avoid fingerprints and torn corners.

MATERIALS FOR PACKAGING AND CRATING

These companies carry a variety of packaging supplies that you can order through the mail. Call them for a free brochure.

Airfloat Systems
PO Box 229, Tupelo, MS 38802 (800) 445 2580 (800) 562 4323
www.airfloatsys.com
Double- or single-wall, corrugated, lightweight cardboard boxes in various sizes, lined with three layers of polyurethane on the inside. Foam suspends the art in the box, providing protection. Reusable boxes. Less expensive than a wooden crate.

MasterPak
145 E 57th St, New York, NY 10022 (800) 922 5522 www.masterpak-usa.com
Offers archival materials for packing, shipping, storing and displaying fine art.

Pro-Pak Professional Shippers

527 Dundee Rd, Northbrook, IL 60062 (800) 397 7069 (847) 272 0408
www.propakinc.com
Art Carton Series is a product made of double-wall corrugated cardboard that
protects fragile framed and glass-covered artwork. Comes in a variety of sizes.
Custom designs can be ordered. Can be reused many times.

RT Innovations

4938 Hampden Ln #345, Bethesda, MD 20814 (301) 654 7055
www.portfolios-and-art-cases.com
Port—a convenient way to carry your artwork—is a line of expandable portfolios
and oversized carrying cases.

SHRINK-WRAP

Printers, art associations or framers in your area will know where you can have
a piece shrink-wrapped locally for a nominal fee. If you will be doing a lot of
wrapping, a shrink-wrap system can be purchased from $200+. It is small enough
to set up on a desk. It comes with a heat blower to shrink the plastic wrap tightly
around any product.

SHRINK-WRAP MACHINE VENDORS

Clearmount Corp

PO Box 540, Foxboro, MA 02035 (800) 541 5472 www.clearmountcorp.com
The Wand shrink-wrap system gives you the most flexibility and efficiency to
shrink-wrap any size and shape of artwork. Uses an ultra-clear film.

Pictureframe Products

(800) 221 0530 www.pictureframeproducts.net
Mini shrink-wrapper

MAILING TUBES

You can roll prints, watercolors, and even some oil and acrylic paintings for
shipment into tubes purchased at art supply stores. They are made of heavy
cardboard, plastic, or metal. Ten watercolors wrapped together in this manner can
arrive undamaged.

CRATING

It might be best to take the first piece that you need shipped to a "pack and ship" company that does professional packaging. Watch how they pack your work—or unpack it after they finish—and learn what they did to make it secure.

Proper crating is crucial to protect the artwork from damage. Most shippers recommend the use of wooden crates rather than cardboard. Most carriers discourage shipping glass-framed artwork. In fact, you can remove the glass and have a new piece installed for much less than it would cost to insure it.

All work should be wrapped in plastic sheeting to prevent water damage. Framed works should be further protected. Rolled-up newspapers are a good way to protect the corners. The ends of the rolled paper should be stapled to the back of the frame.

A larger painting might need a wooden crate, side bars for protecting borders, and a liner to protect the canvas. If you have to go this way, allow two inches of space on each side for packing bubbles or other cushioning materials. Buy some "corner mounts" from your local shipping or frame shop. They protect the corners of artwork, even when it is moved in a van, etc.

When shipping framed, glassed works, it is important to tape the glass so that, in the event of breakage, it does not damage the work. Masking tape is strong enough to prevent pieces of glass from coming loose. Never use tape requiring water, as it could damage the work.

First tape a large ✗ on the glass. Then tape horizontal and vertical rows a couple of inches apart. Do not overlap the frame. Works covered with Plexiglas need no tape because it is break-resistant.

A wooden box is the best crate. The crate should be about two inches larger on all sides than the picture. The same size is not good because a diagonal shock can break a corner of the frame. The top and bottom of the crate must be able to resist puncture. You can build a crate. Museums usually recommend $^6/_8$-$^7/_8$ inch-thick pine, but less expensive boards are as good as the more expensive. Masonite is not desirable because it can be punctured. Construction board is adequate for the sides of a crate.

Cut a piece allowing a 2″ leeway all the way around the work. Butt longer boards against shorter sides and nail together with $2^1/_2$″ resin-coated box nails about $1^1/_2$″ apart. Measure the outside dimensions of the frame sides and cut the top and bottom panels for the crate accordingly. Nail the bottom of the crate to the sides ($1^1/_2$″ plasterboard nails work well for this). The top of the crate should be screwed on with either six or eight 1″ flat-head screws.

If you wish to reinforce the corners of the crate, use 1x4″ board cut to the width of the two sides, top and bottom. These eight pieces should be nailed to board ends before crate assembly. Longer nails are required here—$3^1/_2$″ is good. On the longer sides, these boards should overlap enough to butt against the braces of the shorter sides, which are flush to the end of the side. Be careful not to leave nail heads protruding into the crate. Bend them into a U shape rather than just turning them, and hammer them into the sides.

Once the sides and bottom of the crate are assembled, a sheet of corrugated cardboard should be placed in the bottom. Put in the artwork. Wedge strips of corrugated cardboard around the corners of the picture on all sides until the artwork cannot move. If the sides of the crate are significantly higher than the artwork, add an additional piece of cardboard and two or three boards across the inside of the crate. This will prevent the artwork from shifting—the most common cause of damage.

Whenever you ship a piece, consider:

- Timing. Start early so you don't have to pay an overnight rate.

- Rates. Compare carriers.

- Insurance. Be aware of what coverage you are receiving.

- Weight. Learn restrictions.

- Size. Learn restrictions.

- Extras. Does the shipper also package or pick up?

AIR FREIGHT

Commercial airlines are fast, dependable, and price-competitive. Airline and cargo services can be less expensive than air freight companies, but airlines do not pick up and deliver, as do freight companies. Some airlines won't handle ceramic pieces because of their extreme fragility.

BUS LINES

Rates are quite economical. Greyhound and Trailways offer door-to-door pickup and delivery. Bus lines will accept crated artwork up to 100 pounds and five feet in length. They will insure up to $500 for in-state delivery and $250 for out-of-state. They generally accept glass.

POST OFFICE

The post office will handle artworks but has a 70-pound weight limit and a size limit of 84″ combined length and girth. You can purchase a return receipt, which will tell you exactly when a piece arrived at its destination.

UPS

Though UPS is slower than some other methods, it costs much less. UPS requires that an artwork have a certified appraisal within a year or proof of insurance value if a claim is filed. Normal insurance coverage is $100. For higher coverage you will need to pay slightly more. Articles can be no larger than 132″ (combined length and twice both width and height), weighing no more than 150 pounds. UPS will pick up and deliver. A wooden box can be used, but the box itself will not be insured. You can purchase a return postcard to verify delivery date. Glass pieces can be no larger than 8x10″. If you plan right, this could be your best bet. Call (800) 742 5877.

SHIPPING

Shipping artwork is something that many artists don't think about until it's too late: They have sold a piece and neglected to charge for shipping. Be sure you make it clear to your clients that it is their responsibility to pay for shipping and handling. Know the approximate cost to package and ship a piece, and offer that information to your client at the time of purchase.

Don't wait until the last minute to ship. You will have to pay twice the amount!

MOVING COMPANIES

Moving companies usually have a 500-pound minimum charge. Cross-country time is several days to several weeks. Vans will pick up and deliver directly to galleries, museums, and private homes and will uncrate articles for an additional fee. Items without glass can be packaged in special van containers.

TRUCK RENTAL

If you intend to transport an entire one-person show, consider renting a truck and driving it yourself!

SHIPPERS

Shippers consolidate shipments to different parts of the country. If you are shipping several paintings/sculptures and can't drive yourself, it probably is more cost-effective to go with a packer/shipper than a courier such as UPS or Federal Express. This is the way to go for international shipments also.

INSURANCE

No carrier treats packages gently. Insure all goods to the maximum value of your retail price. Various carriers set different maximums for the insured value. The process of reimbursement can be difficult. If a carrier finds that the artwork was extremely fragile or was not packed carefully, the insurance company may reject the claim. The artist must prove the value of his piece by providing sales receipts for objects of similar size or materials.

TIPS

→ If you can, place paintings upright instead of stacking them on top of each other. If you must stack the paintings, you need to separate them with something that will not damage them. This material must be as large as the largest painting it is touching and stiff enough to support it. Stack the largest piece on the bottom and work towards the smallest. If one or two small paintings are shipped along with large works, it is important to put the larger works in first and cushion them along the sides with strips of cardboard. Smaller works should be laid next to one another and stacked evenly. It may be necessary to provide compartments for small pictures.

→ When transporting glass by car, you will need blankets for protection. Take the time to do this. Wouldn't you hate to ruin a painting because some glass has broken and torn the paper or canvas?

→ Plan the arrival of your artwork about two weeks before any deadline or show. In case problems arise, there will be time to take care of a repair or search for a lost package.

→ Don't expect to get compensation for damage to your work from a gallery because of their poor packaging. They will never take the blame! You have to hope for the best.

→ Start saving packing materials from direct mail orders that you receive. Recycle!

RESOURCES

The Exhibition Alliance
(315) 824 2510 www.exhibitionalliance.org
This organization has several publications available. *Way to Go* is a publication explaining in detail how to pack your pieces. Order online.

Some artists offer free installation and delivery within a 25-mile radius of their studios. This can work out well as you get to know clients a little more intimately and see what they have hanging on their walls. You might be able to give input not only for the piece you're helping to install, but perhaps by suggesting another piece for another bare wall.

FRAMING

A frame is a tool for protecting an artwork. It also should complement the color and texture. It should never overpower the art.

Study framing by going to frame shops, galleries, museums—see what you like and don't like. Since framing is costly, you'll want to train your eye before you spend money. Find a good framer who is knowledgeable and helpful. Before you decide to work with a framer, examine some samples of his work.

Many artists these days avoid framing altogether. They wrap their canvas around their stretcher bar, paint over it and call it a frame. For some styles this works quite well. Some hang their work on special hangers or with pins, without frames. I personally love all these nicely done "frames." It creates a modern touch and is very individual (and usually a lot less expensive and burdensome). If you can figure out your innovative hanging method, it can become part of your signature look. However, smaller pieces, or artwork completed on paper or other material, are incomplete without an appropriate frame.

FRAMING TIPS

→ Go to the frame shop or art store and pick out some ready-made frames that go well with your style of artwork. What sizes do they come in? What standard sizes do mats come in? Buy canvases the appropriate size to fit these standard frames. Complete most of your pieces in these standard sizes. When you do a piece other than standard size, charge more.

→ The wire in the back should be neither too taut nor too loose. You don't want it to hang beyond the top of the frame. If it's too taut, it's hard to hang on the hook. Ideally, the wire should be between one-third and one-fourth down from the top of the frame.

→ Simply done or elaborately contrived, the mat must complement the artwork and not detract from it. Matting can be an art form in itself. Don't try to enhance a carpet or sofa when framing; the mat color or frame should enhance the artwork. You might need to teach your clients this concept too.

→ To prevent degradation or damage to paper, use only acid-free mat board. The best mat board is made of 100% rag.

DO-IT-YOURSELF FRAMING

If you are on a tight budget, this could be a way for you to save money. You can buy the tools and set up a small studio in your garage. This can be an investment, so make sure you are capable of such work.

If you do the framing yourself—not only choosing the frame but physically cutting it, etc.—you need to charge for your time. In essence, you should charge the same price a professional framer would charge you to get the same piece framed, providing you do as good a job. Do not add a commission to this part of the price.

If you are having a one-person exhibit, it is important to frame your pieces in a cohesive way, giving a more professional look.

FRAMING RESOURCES

Cardcrafts
475 Northern Blvd, Great Neck, NY 11021
(800) 777 MATS (516) 487 7373 www.cardcrafts.com
Quality mat boards, competitive pricing

NAMEPLATES

A final and impressive touch for your frames could be a nameplate containing the title of your piece and your name—for example, a bronze tag usually located on the bottom of the frame. You've probably seen them on museum pieces. Prices range from $1 up. Nameplates come in brass, satin brass, black-coated brass and more.

NAMEPLATES BY MAIL

Brassco Engraving
(800) 447 7712

Quality House Engraving
(608) 328-8381 www.monroespecialty.com

Signs by Paul
11082 Milliken Ave, Conifer, CO 80433 (303) 697 8003

HANGING

Hanging artwork in a home or at an exhibition space is not easy. It takes time, effort and a bit of knowledge to do a professional-looking job. Study outdoor art exhibits, large art expos, museums and galleries. Note the variety in approaches to exhibiting and hanging. Which ones do you like best? Why?

Study the space you will be using before you begin to hang. What color are the walls? What size? Where will you hang what? Artworks should be both a part of the environment and separate from it. Don't make an art piece an afterthought. Choose the correct size of piece for the space. The art should be the most important item in a room.

→ Hang artwork at eye-level—about 6'6" from the floor to the top of the piece. The average-height person will then look up at the work.

→ Consider whether people will be sitting or standing while viewing the piece.

→ A painting should be no more than a foot above furnishings so that you see them as a unit.

→ White background surfaces are best for hanging. Some galleries and museums hang on blue or other colors. Brickwork can tone down the piece quite a bit.

→ Do not touch the surfaces of paintings; oil marks from fingers are difficult to remove.

→ You should wear clean, old, white, cotton gloves when working with certain frames and delicate pieces so as not to get marks on glass or frames.

→ Do not carry a painting by the top of the frame. Carry with one hand underneath, the other at the side to support the structure.

→ If you are hanging a large painting, share the task of lifting with a second person.

→ When resting a painting on a floor, avoid abrasive surfaces.

→ Don't hang in excessively cold or damp locations.

→ No crowding or wall-to-wall art, which generally demeans pieces. Quality over quantity.

→ If you can't put holes in the wall, try using gallery rods hanging from extruded aluminum ceiling moldings.

→ Transparent fishing line can be used instead of unsightly wire.

→ If you plan to group works together in an exhibit, the bottom edges of frames should remain on the same line. Place the strongest pieces at either end. There should be a flow and variety about the grouping.

→ Lighting is an essential ingredient. Watch for glare on artworks framed under glass.

MAKE IT INTERESTING

Intrigue viewers—your potential clients—as they look at each piece. Try to keep them in front of each piece for a bit of time. Have a card with a small history of the piece or a quote from a famous person that relates to the piece, or a story about the piece. I recently saw this technique at a Lucien Freud exhibit at the MOMA/LA, and it certainly enhanced my viewing.

LABELING

Study how labels are placed, whether it be at an art fair or a solo exhibit in a gallery.

▸ Labels should all be the same format: same paper, same layout. Use paper that will complement the wall. Some fancy paper can be very inexpensive and adds a nice touch. You can lay out 10 labels per sheet. Use your computer printer to print the labels or use nice, legible calligraphy.

▸ When doing an art fair or show, post the price of your work. Yes, I know galleries most often don't, but you're not a gallery. Many people will think a piece is too expensive if the price is not noted, and they won't dare ask the price. If they see a price posted on it, they might actually become more interested.

▸ Don't put a date on your label. For some mysterious reason, buyers think that a five-year-old painting has something wrong with it. They might think you haven't been able to sell it to date, that you're trying to "dump" it. Actually, they might be getting one of the artist's favorite pieces, which, up until now, you've not been willing to part with!

▸ A label should include the title, price, name of artist, and medium.

Valencia, Spain

Oil on canvas by Mary Smith

$700

Valencia, Spain

by Mary Smith

Oil on canvas $700

LABEL PLACEMENT AT AN EXHIBIT

Place the labels on the same side of all individual pieces. It doesn't matter if labels are on the top right side, bottom left side, under the painting, but never put them above a painting. Have all labels in the same position, as in the layout below.

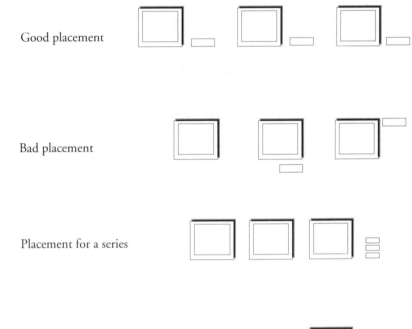

Good placement

Bad placement

Placement for a series

Don't place labels between two pieces

Stacking framed pieces in this manner can work well, especially if you have limited space for display.

CARE

Knowing how to care for your artwork will benefit you throughout your career. When you inform your clients of care techniques, they may appreciate your work even more.

LIGHTING

The amount and duration of light are key factors when thinking about where to put an art piece in an exhibition.

Ultraviolet rays, found in all light and heat, escalate the aging process of dyes, pigments, oils, canvas and paper. Sunlight can dry out or physically burn an artwork. Paintings should never be positioned directly in the full-flood illumination of a bulb. Artificial light, in the form of fluorescent tubes, incandescent bulbs and halogen lamps, can be as damaging as natural light.

Lighting experts have devised a plastic filtering sleeve, believed to screen out nearly all of the ultraviolet rays produced by a fluorescent tube. These sleeves are available at specialty lighting companies in most cities.

All lighting systems produce light that in some way alters the way you see your art. Incandescent lights tend toward yellow, while fluorescent light is greenish-yellow; both produce an unbalanced perception of color.

The closest approximation to noon sunlight is the halogen lamp. Move it far away from the viewer and don't over-light. Picture lights attached above pictures should be no greater than 25 watts and should be used sparingly.

TEMPERATURE

- ▸ Avoid extreme changes in temperature.

- ▸ Do not hang artwork over a working fireplace or a wall heater.

HUMIDITY

- ▸ Do not store prints in shrink-wrap for long periods as it might create moisture.

- ▸ Painted canvases should be rolled with the painted side on the outside, inter-laid with silicone-treated paper and kept at around 70 degrees/50% humidity.

- ▸ Do not hang artwork in a bathroom. Excessive dampness permits mold to flourish.

- ▸ The ideal climate for paintings on canvas is 50-55% relative humidity and a temperature of 65°.

- ▸ When cleaning a glass-covered picture, do not spray directly onto the glass—spray the dust cloth and then clean the glass.

- ▸ Do not store paper in tubes, as they may cause acid and staining damage. Pieces on paper should be stored flat, protected by layers of cardboard and acid-free paper.

- ▸ Works on paper can suffer irreversible damage in humidity over 70%.

CARE CHECKLIST FOR CLIENTS

With any sale you make, be sure to give your client a copy of "Care of Artwork Hanging and Storage Tips." Include some of the instructions below and any others you want!

CARE OF ARTWORK

HANGING AND STORAGE TIPS

→ To transport, put in plastic bag, then wrap with padding for protection (sheets, towel, blanket).

→ Plastic first because fibers and lint from fabric can stick to varnish.

→ Do not place anything on surface of painting.

→ Do not leave in a hot car, especially in the trunk, as varnish can blister.

→ In the case of a painting on canvas, be careful not to lean the painting against anything sharp (corner of table, chair, etc.) that could cause denting, stretching or tearing of canvas fibers.

→ Do not hang in direct sunlight.

→ Do not hang over a direct heat source—radiators, vents or too near a fireplace, smoke, ashes and heat damage artwork.

→ Try not to hang in an excessively damp or cold location.

→ Never put water on the surface of any painting.

→ Try not to touch surface of painting—oil marks from fingers are sometimes difficult to remove.

→ If necessary, dust with a clean, dry, soft brush.

ACTION PLAN

- ❑ Learn about packaging methods.
- ❑ Know shipping methods and costs.
- ❑ Frame artwork.
- ❑ Have nameplates made for major pieces.
- ❑ Learn the proper method for hanging and displaying artwork.
- ❑ Become knowledgeable in the care of artwork.
- ❑ Make a "Care of Artwork" checklist for your clients.

RECOMMENDED READING

The Art of Displaying Art by Lawrence B Smith

The Art of Showing Art by James K Reeves

The Care and Handling of Art Objects: Practices in the Metropolitan Museum of Art by Marjorie Shelley

Caring for Your Art: A Guide for Artists, Collectors, Galleries and Art Institutions by Jill Snyder

The Right Frame by Henry Heydenryk Jr

Chapter 7
Planning an Exhibit

The twelve-month plan

Painting isn't an aesthetic operation; it's a form of magic designed as a mediator between this strange hostile world and us, a way of seizing the power by giving form to our terrors as well as our desires.

Pablo Picasso

THE TWELVE-MONTH PLAN

It probably has become obvious to you by now that an important aspect of marketing your artwork is making sure it gets seen by the buying public.

Planning an exhibition is an essential experience for every artist. It's also a major undertaking. "Shouldn't the gallery be doing this?" you ask. Before you get accepted to exhibit in a commercial gallery, where the gallery owner will take on most of the responsibilities of an exhibit, you will probably have to exhibit in several venues.

Finding an exhibition space is a matter of being creative. Local community-event calendars and cultural newspapers can alert you to non-gallery exhibitions that are being held in your area. Possible locations are:

Coffeehouses	Dinner clubs	Nursing homes
Your studio	Libraries	Bookstores
Hospitals	Furniture stores	Theaters
Churches	Shopping malls	Hotel lobbies
Friend's home	Frame shops	

You most likely will need to promote and execute such an exhibit yourself. This undertaking will help you appreciate what a gallery does when it puts on an exhibit for you and why it is making a 50% commission. You'll be able to assist your gallery to make it a more profitable opening when you know how to put on an exhibit yourself.

GROUP EXHIBIT

A group exhibit might be the way you'll need to go the first time, either due to cost or lack of experience. Don't fret. This can be to your benefit. You'll not only have someone to assist you, but you'll have more guests.

You will need to make sure each group member's obligations and commitments are clear. It is best to write out a plan so each person can see clearly who is obligated to do what. This might take a couple meetings, a little typing and a few photocopies. You'll all decide who is best at, and therefore responsible for, publicity, installation, dismantling, handling sales, invitation design, number of pieces each artist will show, etc.

Make your exhibit an annual event—it will be remembered more easily. If you can coordinate it with something occurring in the community—a festival or a special event—this can help bring people to your exhibit. They are already out and about, and another stop can be fun.

12 MONTHS PRIOR

Just as galleries do, you are going to start planning your exhibit 12 months prior to your intended date! At this time you will concentrate your search efforts for a location in your immediate area.

Contact the spaces you've decided upon in your area. Keep trying until you find an appropriate one. When searching for the ideal space, consider:

Safety of area	Wall space	Lighting
Parking	Cleanliness	Date of show
Insurance coverage	Restroom facilities	Accessibility for visitors

TIMING

Consider the time of year and the day of the month or week you plan your exhibit. It can be a one-day, week-long or month-long event.

▸ October and December are good due to the Christmas buying spirit.

▸ Springtime is also good—people are coming out of hibernation.

▸ An after-work/before-dinner event, usually on a Thursday or Friday evening from 5-8, works well for many people.

Can the show be associated with a fund-raising event? It's likely to get more publicity if it can be.

One of the best exhibitions I've seen was at a private collector's home. This collector wanted to give a party for an artist he was fond of. He had the perfect Mediterranean house—indoors and out—for such an exhibit. He even hired a salesman to assist the artist. It was a cocktail party. No pressure was put on the attendees; everyone had a good time. I asked the salesman (whom I barely recognized as such) before I departed if he had sold any pieces. He said no, he would do that in the next few days. I took his number to check up on the results. By golly! Three days later he had sold one piece, and one week later, two more. He had sold one piece to an interior designer who was interested in more for her clients, and the other two to a businessperson—one for her home and one for her office.

10 MONTHS PRIOR

You will need to consider monetary costs. How much are you willing to spend?

Refreshments	$ _____	Framing	$ _____
Hired assistant	$ _____	Invitations	$ _____
Photographer	$ _____	Mailing	$ _____
Advertising	$ _____		

Images of your work on a postcard is one of the most effective ways to entice new clients to your exhibit.

Invite hotel bellmen, concierges, inn hosts, convention and visitor bureau volunteers and workers and others who deal daily with tourists in your area.

Select your best B&W photo of your artwork for your press release.

THEME

Think of a theme for your show: A catchy idea may win you some press coverage. You'll be planning invitations, refreshments, flowers and music around this theme—maybe even your artworks!

ADVERTISING

Free publicity receives much better responses than an ad. Only advertise if you've studied the publication and it's very specific to your locale. Determine your target audience. You might be able to barter the cost of an ad or try to get a discount on a three-time rate.

8 MONTHS PRIOR

Confirm the date of your exhibit in writing with a user-friendly letter directed to the building owner or representative. Discuss your hanging plan, refreshment plan, timing, publicity. Make sure the owner of the space understands all the details you have in mind. Can you place brochures/postcards/business cards in an appropriate area when the opening is over?

CREATE YOUR INVITATION LIST

Previous clients	Friends	Art consultants
Art critics/editors	Relatives	Art school personnel
Patrons of the arts	Museum curators	Newspaper writers
Artists	Arts councils	Local TV personnel

6 MONTHS PRIOR

Create a publicity plan. Include some wild promotion ideas as possibilities. Start creating your press release. Get help editing it.

INVITATIONS

Be creative! You don't need to spend a lot of money. Use your allotted budget wisely. You are starting to design this invitation three months before you need to print it, so you can think and rethink your approach. It is no small matter to create an attractive marketing piece.

A simple postcard—even in black and white—can be striking. Maybe you want to make a more formal invitation—one that's enclosed in an envelope. Many invitations are available these days that can be printed directly from a computer printer; likewise with postcards. It certainly would be less expensive than having something printed conventionally. Check out this possibility if you have a computer and good printer.

Don't forget to put the address of your exhibition, date and hours of the opening, dates and hours your exhibit will be open for viewing and directions to it. You want people to come to the opening, but if they can't, make it easy for them to visit on another day.

A brief, handwritten note on an invitation always adds interest.

TICKLER POSTCARD

A tickler postcard is a promo that is sent in three or more parts. They are connected to one main idea/event and arouse your interest as you receive them through the mail. The final card generally resolves the question or problem that was hinted at in the beginning cards. This could be a fun way to promote your exhibit to your select group of clients.

4 MONTHS PRIOR

Start framing your pieces. Have you allotted for these costs?

3 MONTHS PRIOR

Print the invitations.

Mail necessary press releases to monthly publications on your list.

Arrange for a salesperson to handle your opening.

2 MONTHS PRIOR

Address the invitations. Include potential and current clients, as well as new art world professionals you want to entice.

1 MONTH PRIOR

Mail press releases to semi-monthly publications.

Mail press releases to radio and TV stations. Don't forget your local cable channel.

Mail press releases to weekly publications.

Mail invitations.

Plan your opening reception: refreshments, flowers, music, napkins, plates, etc. Make it as simple and comfortable as you can. Stay within your planned budget. Know what printed materials you will have available for people to take home. Arrange for help if need be.

Did you notice that the hanging and prep work does not occur on the day of the opening, but three days before? This allows time for problems to be resolved.

2 WEEKS PRIOR

Call the press (TV and radio, journalists, editors) to see if they can cover your exhibit.

Make phone calls to current clients and let them know about your exhibit. Ask them if you can send an invitation to any of their business associates or friends who might also be interested in coming—or send your clients some extra stamped postcards to send to their friends.

3 DAYS PRIOR

Hang your artwork. Consider both natural daylight and artificial lighting when you hang your show. Allow yourself an entire 12 hours to look at the work in the various lighting conditions. If you can't see the artwork due to reflecting windows or bright lights, how can you expect someone to be willing to pay $1500 for it?

DAY OF EXHIBIT

Get there early! Allow plenty of time to set up and an extra half-hour so you can relax.

Greet every visitor. Encourage interested guests to sign your guestbook.

Keep circulating. Have fun.

Have someone else do the sales.

FOLLOW-UP

Handle the dismantling of the show as efficiently as your hanging. The property owner will be very pleased and will recommend you to other venues.

Send a thank-you note to all who have assisted in making your exhibit a success.

Evaluate what worked well and what didn't. Get your mailing list in order. Write a note to special patrons you want to cultivate.

Celebrate! Your community has begun to view your art and become familiar with your name.

ACTION PLAN

12 months prior	___	Locate a place.
10 months prior	___	Develop a theme.
	___	Develop a budget.
	___	Do I want to advertise?
	___	Confirm your exhibition date.
8 months prior	___	Develop your mailing list.
6 months prior	___	Design invitations within budget.
	___	Select a B&W photo for PR.
4 months prior	___	Frame pieces.
3 months prior	___	Print invitations.
	___	Mail PR to monthly pubs.
	___	Find a salesperson.
2 months prior	___	Address invitations.
1 month prior	___	Mail press releases to semi-monthly and weekly publications, TV and radio stations.
	___	Mail invitations.
	___	Plan refreshments, decorations, etc.
2 weeks prior	___	Call press.
	___	Call current clients.
3 days prior	___	Hang artwork.
Day of opening	___	Arrive early.
Follow-up	___	Dismantle.
	___	Write thank-you notes.

RECOMMENDED READING

Artist's Guide to Getting and Having a Successful Exhibition by Robert S Perskey

Good Show! A Practical Guide for Temporary Exhibitions by Lothar Witteborg

Chapter 8
Creating an Image

Presentation elements

Acessories

Branding

A fool is a man who never tried an experiment in his life.

Darwin

PRESENTATION ELEMENTS

If you expect first-class treatment from an artworld professional, you need to contact that person in a first-class manner.

In this chapter, you'll learn that it pays to be attentive to the details of your presentation—from business name to letterhead.

The combination of the right business name, logo and tagline can make all the difference in the world for a company's success or failure. These are the three elements of your business that people see first—on a letter, on your portfolio or in a press release:

▸ Business name

▸ Logo

▸ Tagline

Don't take shortcuts with your presentation. In this world of competition, it can mean the difference between someone reviewing your portfolio or tossing it in the trash. Many artists fail to understand this. They might create great works of art, but their publicity, ads, and promotional materials are haphazard—even cheap-looking.

When I receive a well-made promo piece—postcard, flyer, letter or portfolio—it suggests to me reliability, seriousness and commitment. I receive a good first impression, and I respect whoever sent it.

To attract certain groups of art world professionals your way, you must look like you're in business—and in business to stay. No fly-by-nights wanted! If your flier is haphazard, it might be assumed that your artwork is also haphazard and you are not serious about your career.

Marketing is an ongoing venture, occurring throughout the life of a company. As an artist, you need to plan a series of actions for a length of time. Self-promotion only makes an impression over time.

Let's start exploring the different elements that will make up the fantastic presentation you will soon create.

BUSINESS NAME

Your business name is the element from which all the rest of your presentation—from logo to letterhead—will spring.

Your presentation pieces should look like an extension of your arwork.

If you pick too trendy a name, chances are it might not mean anything in several years. You don't want to change your name, so try to use common sense when considering a cliché. Don't rush into some name you won't be happy with the future.

The right business name, logo and tagline show a visual that will help potential clients remember the artist. Examples of some good business names for artists are:

▸ European Expressions

- Essence Art

- Renegade Press

- Spirit House

- Art Focus

- Visions Realized

- Long Skinny Picture Company

Not such good names for an artist might include Gordon's Art or Tristan Marketing. They don't say anything creative, fun or descriptive.

Make your business name

- easy to say and spell.

- simple to remember.

- associative to the style of artwork you do.

- create a visual image of what you do.

Logos

A logo is something that people often remember more easily than a word or name. It is an integral part of your public identity. Over time this logo will become better known. It needs to make sense in association with your company name.

Your logo will be on all printed materials—letterhead, business cards, press releases, web site, possibly even on your paintings. It is your "trademark." Spend time studying logos in the Yellow Pages or ask your librarian for a trademark directory to review.

If you feel unable to design your logo, find a graphic artist who is adept at logo design. If you're fortunate, you can do a trade with the designer for one of your art pieces. Make sure you can communicate well with this designer. You should have a good idea, though not too rigid a one, of the direction you want the designer to go.

A good logo:

- photocopies well.

- is easy to read, not too complex.

- is distinctive and aesthetically pleasing and creates a positive reaction.

- wears well over time.

- has impact and is memorable.

When choosing your business name, think of creating impact.

A logo is the visual expression of you and your business. It must leave an impression on the viewer.

TAGLINES

A tagline is similar to a slogan—for example, "The Un-cola." The tagline, along with the logo and company name, helps define your product. (Yes, your artwork has become a product if you are selling it.) A tagline should note the physical features of your artwork, the emotional aspects and the special qualities. As an artist, you also want your tagline to help define the style and/or subject matter of your artwork, just as your business name and logo do.

The following taglines all give a specific image to the reader. The reader can relate to these descriptive words:

Paw Prints. This artist paints dogs.

Renaissance Artist. Doesn't say specifics, but does give a visual image.

Passionate Flowers to Smell. Sounds exotic.

The taglines below are too vague and unemotional. Be more creative! Remember that you are trying to help the reader create an image of who you are and what you do, possibly without seeing your artwork.

Fine Artist. Doesn't say anything, except that you create art.

Watercolor Artist. I want to know more than just the medium.

Landscape Artist. Let's be a little more specific. There are thousands of landscape artists.

Famous Artist. How come I don't know about you?

LETTERHEAD

A letterhead and envelope are often the first impression someone receives of your business. Quality in this case means being taken seriously enough for people to open your package. It is, after all, amongst 20 others to choose from.

- ▸ Make it fun for them to open.

- ▸ Make the receiver stop dead in his tracks and desire to know what's inside your envelope. Of course, you will incorporate your business name, logo, tagline, address, telephone number, e-mail and URL into your letterhead.

Make sure the typeface is legible and not too small. If you have a computer and laser printer, you will be able to scan your logo onto your computer and print your letterhead each time you write a letter. You can also print envelopes from your printer.

ENVELOPES

One of the favorite letters I received was typed on pink cloud paper and inserted into a see-through vellum envelope. I wanted to open this piece first, even though it did have a pre-typed laser label on it, which showed it was not a personal message. It was impressive and effective. Did you know that there are even aluminum foil envelopes available?

BUSINESS CARDS

Business cards are an essential part of any business. My favorite ones to receive from artists, and *save*, are those that have a four-color image of a work by the artist. What better way to advertise your work?

Keep your card a standard size, or it won't fit into the normal places people keep cards, i.e., wallet or Rolodex. Receiving an unusual business card generally opens people's eyes, creating a memory trigger. It doesn't have to be expensive for people to remember it. Be creative in your design and it will bring rewards.

If you decide to print in one- or two-color, go to your local printer. You could also use a laser printer with one of the business card selections from the paper companies mentioned on page 110.

INNOVATIVE CARDS

- ▸ Similar to a fortune cookie (and that could be a good idea too!) is a plastic vial or capsule (1.5″ round) containing a 3x2″ note, rolled up and stuck into the vile. Such vials were placed in a jar at one art show. Most people took one, not really knowing what they were!

ACCESSORIES

Start a file. Collect letterhead, brochures, any direct mail piece that inspires you. Use these for reference when it's your turn to design a piece.

Your envelopes will have the same logo and design as your letterhead, perhaps with a slight variation.

▸ If you design your business card horizontally, recipients can put it in their Rolodex. Be sure to leave space at the bottom so that when they punch it with the two holes for the Rolodex, your address and phone number won't be eliminated.

PAPER COMPANIES

There is an abundance of special paper these days. Fine papers are on the high side cost-wise, but you will not be using scads of letterhead. They also have matching labels, envelopes, business cards and folder covers. The paper you choose can greatly affect the cost of your printed materials. Ask for a brochure from these companies.

Paper Access
(800) 727 3701

Paper Direct
(800) 272 7377

Impact Images
(800) 233 2630 www.clearbags.com
Plastic see-through bags for greeting cards, postcards, flyers, etc. A sure-to-be-opened item.

Use no more than four to seven words in your tagline.

One artist has his business card printed on clear adhesive labels. When someone asks him for a card, he pulls one off the strip and asks the person where he can place it. People remember this artist because of this trick.

BRANDING

Branding has become a buzz word in the business world today. We know of big-name companies—Coca-Cola, Reebok, Nike—that have taken their name and, through their ads and press coverage, created a type of identity that gives their company a certain "flavor"—upbeat, cool, etc.

Individual artists can brand themselves by the way they present themselves. People or galleries who represent artists also give them a certain brand. Likewise brochures, a web site or portfolio brand an artist. By creating a particular style with your web site, you are saying something about your character. Generally you will attracti like-minded people who enjoy what you have to show.

ASPECTS TO CONSIDER

Responsibility - When you post a web site, make sure your e-mail is easily accessed by the public. Answer all your e-mails so you become known as the responsible artist.

Information - Most often when people jump online, it's to retrieve information. Put free information for collectors online and become known as the sharing artist.

Specialist - Show that you are a specialist in your art field, however you can do that.

ACTION PLAN

- ❑ Brainstorm a business name.
- ❑ Brainstorm a logo.
- ❑ Brainstorm a tagline.
- ❑ Design and print letterhead, envelopes and business cards.

RECOMMENDED READING

The 22 Immutable Laws of Branding by Al and Laura Ries

The Best of Business Card Design by Rockport Book Staff

Branding Yourself Online by Bob Baker

Business Card Graphics by P.I.E. Book Editors

Fresh Ideas in Letterhead and Business Card Design by Diana Martin & Mary Cooper

How to Register Your Own Trademark by Mark Warda

How to Design Trademarks and Logos by John Murphy & Michael Rowe

Letterhead and Logo Design by Rockport Publishers

Letterheads: One Hundred Years of Great Design by Leslie Carbarga

One Minute Designer by Rodger C Parker

Chapter 9

Resumes

Composing a resume

Resume categories

Artist statement

Works of art are indeed always products of having been in danger, of having gone to the very end in an experience, to where man can go no further.
 Rainer Maria Rilke

COMPOSING A RESUME

Read other artists' resumes. What do you like about theirs that could apply to yours?

Your resume—sometimes referred to as a bio or vitae—is a list of vital statistics of your art career. You can format a rough draft of your resume by simply making a list of art career activities, using the categories on the following pages as an outline. Once you have listed as many items as you can under each category, sift through them to see which ones are the most pertinent for your final resume. Resumes generally do not include all the categories listed. You need to select the ones you think are the most important to show off your career. The purpose of an artist's resume is to provide the gallery director, dealer, curator, grant-making panel or client with your achievements and credentials in the art field.

THE 20-SECOND GLANCE

Most readers of a resume give it less than a 20-second glance, maybe 30 seconds at most! The physical appearance and layout, therefore, are extremely important so that it *can* be read quickly. You want to make it simple to inhale in one fell swoop.

RESUME TIPS

→ Be selective and list only key exhibits, awards and purchasers.

→ At the very most, make it no more than two pages; one is best.

→ Neatness counts. No handwritten additions! Computer-generated only.

→ Update every six months. Hopefully you will be marketing enough to add something every six months. As time adds more achievements, you will eliminate the less important ones and still keep it to one or two pages.

→ Try to incorporate the layout on your letterhead.

→ Proofread diligently. Be scrupulous about the accuracy of your typing. If someone does it for you, be sure to proof it again before photocopying.

→ You might want to keep a "documentary" resume that has all your achievements on it. You can copy and reformat as needed.

I was once asked by a photographer to try to condense her 17-page resume (in tiny typeface) to one or two pages. What a task! She was in her 60s and had been working all her life as an artist, so she had many qualified listings on her resume. But who would read 17 pages? After much work, I condensed it to two pages and made the type larger, so you could see at a glance the history of her career. I kept only her most important national and international conquests, from all the periods of her life. It also stated on the bottom, "For a more complete compilation, please request my 17-page resume."

EXHIBITIONS

List the most recent exhibitions first, working backwards in chronological order. List date, title of exhibition, sponsor's name, city and state. If you've been in a lot of exhibitions, you can divide them into types of exhibitions—group shows, one-person shows, invitational shows, juried shows, upcoming exhibitions, touring exhibitions, museum shows, etc. If you have fewer than three exhibitions, it's best not to break them into smaller groups.

Selected exhibitions

2007	*Maximum Times*, Matrix Gallery, San Jose, CA	
2005	*Beyond Time*, Scarborough Museum, Norwalk, CT	
2004	*Now*, Soho Gallery, New York, NY	

COLLECTIONS

You could divide this into private collections, corporate collections, library collections, permanent public collections, etc. A collector is anyone who owns a piece of your work, not necessarily a purchaser of it. For instance, you could donate one of your pieces to a museum and list it here.

JP Rundige Museum, Anaheim, CA

COMMISSIONS

List the date, title of the commissioned work, sponsor and location.

2007 *Benoit Park Sculpture,* San Francisco Art Commission, San Francisco, CA

BIBLIOGRAPHY

List all the publications in which you have been mentioned or reviewed, including any articles that you have written. Quotes about your work can go here. Book entries should include author's name, title or pages of article, city of publication, publisher's name and date.

It is not surprising that our city has taken such a liking to Flence!
San Francisco Chronicle, 2006

2005 *Artwork at Bank of America,* San Francisco, CA; page 34,
E P Dutton Inc

RESUME CATEGORIES

Gallery owners are the people most interested in a resume. If you have nothing to put on your resume for a gallery, you probably aren't ready to show your work there!

AWARDS AND HONORS

List all awards and honors related to art: recognitions of merit, prizes won in competitions, project grants, artist-in-residence programs, fellowships.

2007 *Purchase Award for Painting,* San Francisco State College, San Francisco, CA

2007 *Emerging Artists,* First Prize. Juror: Fisch, National Arts Club, New York, NY

TEACHING AND LECTURING

Art-related only. Guest lectures, workshops conducted, professorships.

2006 *Artist-in-Residence,* San Francisco Art Institute, San Francisco, CA

2005 *Instructor in sculpture and painting,* San Francisco Community College, San Francisco, CA

AFFILIATIONS

List art organizations you belong to or community art activities in which you have participated.

2006 *Crocker Art Museum Liaison,* Sacramento, CA

EDUCATION

If you are a recent graduate, this category would be your first or second; otherwise, it is listed at the end, and in some cases not at all. List your educational credits in the following order: undergraduate degrees earned; graduate degrees earned; other institutions of higher education; notable artists you've studied with.

1967 BFA, San Jose State College, San Jose, CA

OTHER POSSIBLE CATEGORIES

Be creative—there are no rules carved in stone. Some possible categories:

Artist-in-Residence	Scholarships	Guest speaker engagements
Workshops conducted	Featured artist	Finalist in competition
Board of Directors	Professional membership	

You have never exhibited and have nothing to put on your resume? This book should get you going! You need to start exhibiting and exposing your work—entering competitions and juried shows, conducting private studio openings, etc. You could list student shows under Exhibitions; scholarships and teaching assistantships under Awards and Honors. Be creative but honest!

MARLENA PARTONSON

12245 Leibacher Road
Norwalk, CA 93422
(818) 693 1444

UPCOMING SHOWS

2008 *My Time is Now,* Galleria Pace, Milan, Italy, one-person show

ONE-PERSON SHOWS

2006 *Venice at Dawn,* Bianca Gallery, Milan, Italy

2005 *Please Say Yes,* Academy Museum, Saleno, California

GROUP EXHIBITIONS

2005 *Send Me More,* Studio Trisorio, Naples, Italy

2003 From Here to There, Galleria Pace, Milan, Italy

2002 *American Icons,* More Gallery, Milan, Italy

1999 *Academy Museum,* Saleno, California

1998 *Continental Galleries,* Los Angeles, California

COLLECTIONS

Academy Museum, Mylara, California

De Pasquale Collection, Milan, Italy

Various private collections in Chicago, London, Rome, Venice, Amsterdam

PUBLISHED

2006 *Arte,* October

1999 *Encyclopedia of Living Artists in America*

COMMISSIONS

2007 *Wall murals (in egg tempera),* private villas in Naples and Capri, Italy

2004 *Pair of folding screens for stage set,* Milan, Italy

ARTIST STATEMENT

Your statement should get to the heart of why you are an artist.

As your work develops and you are ready to exhibit, you need to develop a statement. A statement is a written dissertation of the idea behind your artwork. Your statement is your philosophy—the aim of your work or working process. It is not carved in stone and can change over time. It is not a place to tell your life story.

Essentially, you will be expressing in writing what you have expressed in your art. A statement helps give collectors and interested patrons a better understanding of your work.

Statements can also be helpful to reviewers and editors who write an article about your exhibition. They provide psychological material from which writers can draw.

If you don't have a long resume, a well-written statement can sometimes influence a buyer in your favor. You want to show that you know what you are doing, understand your personal creative process, and believe in your work.

Brief statements—even one sentence—are fine, if that is what you decide to convey. The ideal length is no longer than four sentences or one paragraph. The shorter it is—one or two sentences—the more likely it will be read! Your statement can be printed on a separate sheet or combined on the same page with your resume.

Regardless of the length, it must be well-composed. Have an experienced writer edit your statement.

CREATING A STATEMENT

Start by just writing—rambling on about your philosophy—the reason behind your artwork. Don't think about what a statement "should be." Just write. You can condense it later. You'll not be able to compose a final statement in one sitting, so don't even try. It will take about a month or two of various sittings. Look at it every few days. Ask others to look at it. Ask a writer friend to edit, condense, make it more concise.

- ▸ Why have you chosen to create your particular imagery?

- ▸ What is the role of the color, texture, motion in your work?

- ▸ What medium do you use? Is there anything unusual about the way you employ it?

- ▸ Does emotional, social or political content play a part in your work?

- ▸ What does your art say about your ideals?

- ▸ How do you feel when creating?

- ▸ How do you want others to respond?

- ▸ What are the key themes and issues of your work?

- ▸ Is there something that people don't understand about your work that you want to address?

Be intentional about the words you use. For example, "organized" is more powerful than "put together." Other good verbs to use are:

achieve	administer	advise	complete
coordinate	critique	develop	direct
establish	execute	formulate	gather
generate	improve	implement	initiate
instruct	introduce	invent	launch
lecture	manage	plan	research
review	select	solve	utilize

TIPS

→ Non-artists will be reading this, so don't use jargon and clichés.

→ Avoid "really," "very," "however," etc.

→ Be direct and concise.

→ Keep it simple—no poetic flights of fancy.

→ Take each sentence and try to explain it more clearly. Be as precise as you can.

If you have difficulty writing about your own work, perhaps you can find another artist to help you. You can write about him and he can write about you. Try whatever works. Remember, this can be changed at any time and is a work in progress—just as your artwork is changing and progressing

THREE EXAMPLES OF A STATEMENT

Art is the expression of a personal, sensual experience. An artist may communicate information, simple or profound, across time and space to the viewer, regardless of his background or epoch. My paintings have had success with an international audience from Rio to Tel Aviv. Do we speak the same language?

My artwork is dedicated to the vanishing species in Africa.

Five hundred years ago, a group of men working in Italy produced a genre of painting never since excelled. These painters from the Renaissance Period subsequently influenced in one form or another every painter. They firmly believed that Art's greatest role is to inspire and create higher ideals in people, to civilize humanity, nourish and protect the different ideas and myriad forms of culture. Anyone calling himself an artist today needs to have these thoughts at the back of his mind every time he begins a painting. Whatever happens during and after the efforts are made—if shaped by these ideals—can truly be called and acknowledged as Art.

ACTION PLAN

❑ Develop a resume.

❑ Develop a statement.

RECOMMENDED READING

Elements of Style by William Strunk and EB White

Writing the Artist Statement by Ariane Goodwin

Chapter 10

Photographing Artwork

Doing it yourself

Hiring a photographer

Web images

Other image formats

"That's the reason they're called lessons," the Gryphon remarked, "because they lessen day to day."
 Alice in Wonderland, Lewis Carroll

DOING IT YOURSELF

Remember, your reputation rests on your slides.

Creating a reproduction of your artwork to show someone else has changed radically in the last few years. With digital cameras and the Internet or cell phones, you can send someone a new picture practically instantly.

These reproductions may be the only way a juror, gallery owner or consultant will see your artwork. Poorly-presented slides will make a gallery owner wonder, "Why are they even bothering?"

Each time you complete a new group of work, you will need to photograph it, as well as copyright it.

If you failed photography class, you probably shouldn't try to take your own photos. If you must take your own photos due to monetary restraints, here are some guidelines.

GUIDELINES

- ▸ Try to photograph your artwork before it is framed.

- ▸ Use a tripod. Square up the picture before you snap the shutter. The camera should be exactly parallel to the artwork's surface and at the exact center. If not, you will get distortion and an angled reproduction.

- ▸ Try to photograph in daylight on an overcast day—indoor lighting takes a huge amount of equipment. Avoid tree shadows, cloud shadows, or patterns of light filtering through houses. Natural, but not direct, sunlight is best.

- ▸ Eliminate the background if possible. Viewers want to see the art piece. Use a simple, clean, neutral background or wall. A good piece of black, unfolded, unpleated velvet is a great neutral background.

- ▸ Take several shots of the same piece—at least five.

- ▸ Do not put varnish on your paintings until after you have photographed them. That way, you can avoid much glare.

Don't get glass-mounted slides. They often break when they are shipped through the mail.

HIRING A PHOTOGRAPHER

If you've decided you are not capable of photographing your own artwork, you will need to look for an appropriate photographer. You not only need to find a good photographer but one who specializes in fine art!

▸ If you live near a college, see if the art department has a photography division. You might find some very good photographers at a reasonable price.

▸ Look in the back of your local art newspaper. Usually you will find an ad for a specialist in the field.

▸ Ask an artist friend: They love to recommend good photographers.

▸ Call a local gallery or museum for a recommendation.

THE HIRING PROCESS

Hiring a photographer is expensive, so you don't want to make a bad choice. Here is a list of things to find out before you actually hire someone.

▸ Get references and call them.

▸ Look at samples of his work. Has he photographed two-dimensional work before?

▸ Know the fee specifics before photographing begins. Get a quote in writing.

▸ The photographer has the copyright to these pix that he takes of your work unless he signs this off in writing to you. Make sure that you own the copyright after the photo session. Get this in writing.

▸ Find out if the photographer has a customer-satisfaction guarantee.

WHAT IS A BAD PHOTOGRAPH?

It's blurry, has light reflections, is not full frame, the background is distracting, the color isn't anywhere near the original. What about that slide that shows a painting in an alley next to a trash can, the cat running in front of the artwork? Or the one with the foot coming out the bottom of the slide, hands on the side and head on top? It's all humorous but doesn't get the job done.

WEB IMAGES

The most important part of displaying your artwork online is to start with a good image. Digital cameras can be used for this purpose. Once you have a digital picture of your artwork, you will need to adapt it for the web by using a photo imaging program.

Photo imaging software programs are fun to use but take a while to learn. Most graphic designers know how to use photo imaging software. You can create jpgs for online use with these programs. With a software program you can translate them to a tiff format. This is the format you'll need if you're doing print reproductions.

▸ JPG - an acronym for a graphics format that is generally used for fine art displayed on the Internet: 72dpi, RGB. (pronoumced jay-peg)

▸ TIFF - an acronym for a graphics format that is used for fine art that will eventually be displayed in print: 300dpi, CYMK.

TIPS

→ Since small images are faster to download, give your viewers the option to choose which piece they want to see enlarged by listing a small thumbnail image first. Large pieces should be no larger than 500 pixels in any direction. That way, the entire piece will be viewable at once on most monitors.

→ A jpg's resolution should be at high-quality 72dpi (dots per inch). Make the image the exact size you will be using on your web page.

→ Jpgs must be created in RGB format, not CMYK (usually used for printing).

→ www.ulead.com can help you optimize your images—that is, make them the most compact they can be. If you have many large images, or 30-plus small ones, on one page, you will need to do this.

→ If you must make a choice, have your images be lighter rather than darker.

→ Break down web pages into sections so that they are not too long, with no more than 20 thumbnails on one page. Divide styles into two different pages—perhaps two genres, such as landscape and abstract.

RESOURCES FOR PHOTO IMAGING SOFTWARE

▸ Adobe Photoshop is the most widely known imaging software program. If you use this sophisticated program, you'll probably need to take a class to understand its full benefits. Adobe also has a "consumer-grade" program that runs about $99.

▸ PaintShop is a less expensive program and quite sufficient for creating images for the web.

▸ You might find some photo software for free at www.shareware.com.

When sending slides to a contest or juried show, do not tape or bundle slides. Simply put them in a slide sleeve, cutting the sleeve to the necessary size.

TRANSPARENCIES

A transparency is a transparent positive image. Transparencies are more expensive than 35mm slides. The most common sizes are 4x5 " and 8x10 ". These are rarely made these days since the advent of the digital camera.

COLOR PHOTOGRAPHS

Art world professionals often prefer to see photo prints of your work (rather than slides) for the first viewing. Photos can be glanced at in a second. You can easily make these from your digital jpgs.

OTHER IMAGE FORMATS

Keep in mind the proper way to note the size of your artwork: first the height, then width. The inch marks are only put after the two dimensions, with no spaces surrounding the 'x', i.e., 26x38 " not 26 "x38 ". If you are using a computer, put the inch marks in italic.

ACTION PLAN

- ❑ Take color photos, color slides, and B&W photos of all your important work.
- ❑ Duplicate slides.
- ❑ Label slides.
- ❑ Create a slide list of your marketable works.

RECOMMENDED READING

The Artists' Handbook for Photographing Their Own Artwork by John White

Chapter 11
Presentation Finesse

Portfolios

Cover letters

Criticism is easy, art is difficult.
 Destauches

PORTFOLIOS

You must come across as a pro, not an amateur. Art professionals can size you up fairly quickly, simply from a glance at your portfolio or web site.

A portfolio is a complete visual presentation of your work and includes a cover letter, resume, artist statement, price/slide sheet, and five to 10 photos/slides or high-quality color photocopies. The portfolio should give a brief, easy-to-digest, visual overview of your artwork. It should be assembled to create a specific perception in the mind of the viewer.

Collectors, consultants and gallery owners don't want to see a variety of styles— even if they are magnificent. They want to see consistency. This portfolio should be an artwork in itself. It doesn't have to be expensive, but you do need to spend time designing it.

OPTIONAL MATERIALS

▸ B&W photo of you and/or your artwork, or you creating your artwork

▸ Testimonials

▸ Brochure/flier

▸ Photocopies of newspaper or magazine clippings

▸ Announcements of openings

Do not include original artwork, articles or news clippings.

Be selective about those to whom you send a portfolio. First find out if a particular person deals in your style of artwork. After you send materials for reviewing, follow up in about four weeks to see if he has viewed them. If you want them back, be sure to include a self-addressed stamped envelope big enough to hold everything you sent! Note in the cover letter that you would like him to send back everything he cannot use for his files.

TIPS

→ Art directors and gallery owners don't have time to sift through a lot of extraneous material.

→ The artfulness of the exterior mailer hints at the quality of the work inside.

→ Delete any items that emphasize your limitations.

→ If you are showing three-dimensional sculpture, you should include photos taken from different angles.

→ All pages should be formatted the same and should look cohesive.

→ All photographs should be trimmed to the same size.

→ Enclose a SASE with appropriate postage.

A university was reviewing portfolios for a new position at the college—Assistant Photography Professor. So many people applied that there was a 6x12-foot stack of portfolios! It was kiddingly determined who would be the next professor by observing the outside covers of the portfolios from this large stack. It turned out that the person who was picked for the best exterior was also the one with the most outstanding work. He was hired. His presentation was so good that you could pick it out from the huge stack of portfolios!

You need to create several portfolios to be ready for anyone. Each is an offshoot of the other. Your web portfolio can be your most-often-viewed portfolio these days.

WEB PORTFOLIO

Remember, your web site is only one of the ways people will view your work. Many artists like to think it is the fast way to exposure, but it is only one of the ways. Ultimately, it is personal contact that will make your art career a success.

▸ All the items in your "carry" portfolio also belong on your web site.

▸ Be sure your site is easy to navigate and enticing to view.

▸ Make sure all the links work and your contact information is on each page.

▸ Each small visual should link to a full view image.

▸ Add a story about your life that is special.

DOCUMENTARY PORTFOLIO

This portfolio should be no larger than about 9x12", an easy size for carrying and showing. It should have a durable, permanent cover. You have only one copy of this portfolio, so you *never* leave it with anyone. Create a visually pleasing and unique presentation. Some galleries have this type of book lying out in their showroom for potential clients to browse through.

The first page will have a strong visual—perhaps with your name, but no other copy. The following pages will contain photoprints of your best pieces. As time passes, you will add new photos, at the same time removing outdated ones. Have them be consistent in size, large enough to see, and laid out pleasantly on the pages.

After an appropriate amount of your current artwork via photos (10-20), you will put in your resume and statement. Interspersed in this last part can be photocopies of press releases, color reprints from magazine articles, and, finally, a slide sleeve with 20 slides, and a slide list.

It takes an entire book to relate what an artist's web site should consist of, how to make the best use of the Internet, how to use e-mail to promote your work and how to make money on eBay: Internet 101 at www.artmarketing.com.

A portfolio is only an introduction to your work. You are enticing the art professional to a personal interview or studio visit.

FLIP-CHART PORTFOLIO

This portfolio has a much more casual style and is best no larger than 3x5″. It should be carried with you *at all times*, in your car, briefcase or purse. When people ask you what you do, you say, "I'm an artist," then, if appropriate, pull out this portfolio. Many artists use a photo carrier purchased at a photography store. Have no more than 20 photos to show. You don't want to overwhelm people. If they are interested in seeing more, invite them to your studio or web site.

PORTABLE PORTFOLIO

This is less necessary these days since most people can view your site online while you are sitting with them. However, some people still prefer to see paper! This is a portfolio that you will send to people you cannot visit personally. Due to its light weight and compact size, I call this type of portfolio a portable portfolio.

This portable portfolio can be from 5x7″ to 8^1/$_2$x11″. For convenience, don't make it any larger. It should fit into a 9x12″ envelope. It will be enclosed in a lightweight folder to keep all the materials together. It should contain at least five color representations of your work in a format other than slide—photo or color photocopy is best—a resume, statement, price and slide lists, press clips and a very brief cover letter.

Make up 10-15 of these portable portfolios and have them circulating through the mail. If you want the portfolio back, you will need to enclose an envelope with the correct return postage. Colorful envelopes for mailing, as well as for your SASE, can add to your overall presentation.

The best portfolios I've seen of this type are simple, yet original—designed by the artist.

One artist used 5x7″ color photocopies and bound them with spiral binding at her local print shop. Though this portfolio wore out after some months, it was economical and showed off her work quite well.

During your career as a fine artist, you will be writing a lot of letters or e-mails to various folks: thank-you letters to the press, follow-up letters, introductory letters to potential clients, etc.

A cover letter should be brief and to the point. Most people don't want to spend more than 15 seconds reading a cover letter. It is a short introduction to your presentation package. Note in your letter why you think your work is particularly suited to their venue. Do you have a particular theme in mind for a show? Briefly state that idea.

Your business letter is speaking for you. If it is awkwardly worded and poorly expressed (or rude), the harm it does can be permanent. Draft a letter, preferably on a computer, and wait a day or two to reread and edit it.

TIPS

→ Use a businesslike tone in your letter.

→ Use your letterhead for the final copy.

→ Make your request brief and direct. No history: all that's in your resume.

→ Don't use strange typefaces that are hard to read. Make it large enough to read easily.

→ Simplify every phrase and sentence so people will want to read it.

→ Read your copy aloud to find the gaps and faults.

→ Don't repeat the same adjective.

→ State that you will call on a certain date, mark that date on your calendar, and follow up with a call.

COVER LETTERS

The final touches of a cover letter can be subliminal, but they give you points.

ACTION PLAN

❑ Photocopy necessary items for portfolios: resumes, statements, clippings, price/slide lists, etc.

❑ Create a rough draft for your web site layout.

Chapter 12

Navigating the Art Market

Setting the stage

Marketing intelligence

The art of the telephone

Networking

Targeting your market

I owe all of my success in life to having always been a quarter of
an hour beforehand. Horatio Nelson

SETTING THE STAGE

Great marketers always make some mistakes because they are willing to experiment.

Planning your initial marketing efforts, now that you have your portfolio in order, takes time, focus, commitment and knowledge. You need to know as much about the art world as you can. To introduce yourself to potential collectors, you must learn to "swim the waters." All kinds of information about galleries, publishers, shows, competitions, portfolios and press releases will be useful in the progress of your career.

Setting the stage in this case means to attend art events and openings where you meet other artists, art patrons and the art press. Start to cultivate a support system with fellow artists and art organizations that will help you attain your goals, perhaps through joining museums or organizations.

It's important to keep a notebook and files on marketing ideas, strategies, and goals. Look at it periodically to see if you have been attempting to put any of them into action.

Few people are born with business knowledge. People good at business have studied, read books and magazines on their field, attended seminars, workshops and trade shows. They belong to associations and continue to discover new methods to approach their particular market. Learning marketing is an ongoing process. Make this quest for new marketing knowledge part of your monthly business activities. With practice, you'll become a confident marketer.

GETTING READY

Besides the business factors we've gone over in the previous chapters, your artwork must also be ready for the marketplace. Ask yourself some questions before you start your promotion:

▸ Are you able to produce artwork of a consistent quality and style?

▸ Is the quality of your work up to the standards of the market?

▸ Do you have a body of work ready to sell?

▸ Are you able to produce enough pieces per month (average of five for a full-time artist) to keep up with future demand?

▸ Are there any legal considerations in selling your product, such as model releases, etc.?

▸ Are you psychologically ready for the possible onslaught of criticism?

▸ Are you willing to part with your work?

▸ Do you consider the price you calculated in Chapter 5 an agreeable price at which to start selling your work?

BODY OF WORK

You must have a substantial body of work available for sale—at least 20 or more pieces that meet the standard of quality you have set for yourself. In order to be taken seriously by art world professionals, these pieces must have a consistent, cohesive style with a well-defined sense of direction.

Your style must be easily recognizable. For example, imagine that 10 artists each put 20 slides into a heap. An art consultant should be able to separate these 200 slides into 10 groups of 20 slides. If your work cannot be picked out of the heap in this manner, chances are that most art world professionals will not consider it for review.

A common mistake is to be too random in selection of style. Galleries demand consistency. To be marketable, an artist must have a definite personal style—a vision that sets him apart from everyone else—sometimes called a voice. This can take some artists years to develop.

Your paintings should not exist solely as individual entities, but as songs from a musical—each relating to and expanding on the others.

MARKETING INTELLIGENCE

If you can't find a book in your local library, use the Inter Library Loan service. Libraries will trace a particular book and then send it to your local library so you can borrow it.

Once you determine that your work is ready for marketing, you'll need to identify your target market.

LIBRARY RESEARCH

Research is an essential ingredient for all businesses. Keeping on top of the marketplace assists you in outsmarting the competition. Familiarize yourself with the staff of your local library. College libraries often offer extensive resources, too. When you go to the library, carry a notebook and some dimes for photocopying.

Read all the art-related magazines you can get your hands on. The library will have many. To receive a complimentary copy of art publications, write to their advertising department on your letterhead, asking for a sample issue and rate card.

INTERNET RESEARCH

With the Internet, almost any information you need can be gathered in the comfort of our own home.

FINDING LEADS

Throughout your research, you will be building your personalized mailing list. You will use this list throughout your career, so guard it closely. Try to contact everyone on your list at least once a year. The aim is not to have the biggest list, but the best—the most specific to your personal marketing needs.

You already have a list in your personal phone book to start with: family, friends, doctor, dentist, bookkeeper, insurance agent and all the other professionals you deal with.

ADD TO YOUR LIST:

Architects	Arts councils	Art critics	Art organizations
Businesses	Collectors	Galleries	Interior designers
Museums	Publishers	Publications/editors	

CODING NAMES

Keep track of your best clients by coding: #1 = collectors/buyers, #2 = interested parties, #3 = persons to "court," etc. The main idea is to know the importance of each client, the ones you want to contact the most.

Many artists have difficulty using the telephone to call a stranger. Believe me, even salesmen start out with this problem. The way they overcome this fear is by practicing. The telephone is one of the handiest tools in an office. Let's face it: You can't run a business without it. With it, you can do a great deal of research without leaving your chair.

You must attempt to develop a positive attitude toward using this great tool. Once you get used to talking on the phone, it will become second nature. As with most new tools, you just need to practice. Don't expect to be an expert in one month. You will improve every time you talk.

▸ Don't think you have to sell over the phone. With a phone call, you are generally informing a person of your whereabouts, the possibility of viewing your work, or perhaps asking for an appointment or studio call.

▸ Know what you want to accomplish before you call. Write it down in a brief outline—a script, if necessary. Envision your goals. Call from a quiet room without distractions. Rehearse your presentation and anticipate people's responses.

GETTING PAST THE RECEPTIONIST

One of the main responsibilities of a secretary is to screen calls. Some executives even give their secretaries the power to decide which calls to refer to them and which to fend off. Show the secretary respect—the same that you would show her boss. Your aim should be to become "friends" with her. She can be key in introducing you to her boss. If she likes you, you may come highly recommended!

CLIENT STATUS SHEET

As you begin to make more phone calls and contacts to art world professionals, it will become increasingly difficult to remember what you said to whom. Start keeping a notebook, with entries listed alphabetically, adding client status sheets as you learn about new clients. As you contact these people and get to know them, add their personal information to the sheet. When someone contacts you, pull out your notebook. *Art Office* (www.artmarketing.com) has client sheet layouts you can photocopy.

FIRST CALL

Your first call is an introduction, perhaps to verify an address or to make sure the person is interested in reviewing your work. Try to gauge by their tone of voice how interested they are. Add this information to your client status sheet for future reference. If the person is not interested but seems to be friendly, always ask, "Could you recommend a more appropriate gallery, consultant, publisher, etc.?" Often they do know of a more appropriate company but just didn't think to tell you.

THE ART OF THE TELEPHONE

Using the telephone is a learned art.

It's said by most companies that 80% of their business comes from 20% of their customers. This 20% is the group of people you will contact the most often.

One of the most common mistakes from new entrepreneurs is that they do not realize the importance of a follow-up call. To make a sale or to get an editor interested in coming to an opening usually takes more than one contact.

FIRST FOLLOW-UP CALL

After an interested person has reviewed your work, you will need to make a follow-up call to see what this person thought about your work. You want to be mentally focused when you make this call. Beforehand, brief yourself on different possibilities of what the conversation might lead to. Don't dwell or spend too much time on this prepping or you'll get too nervous. The first few times you do this type of follow-up call, you will make errors, get nervous, etc., but after several times you'll have it down.

Make a follow-up call about five days after you think they've reviewed your work. E-mails do not suffice for follow-up. You reach them on the phone and introduce yourself and ask if they've had a chance to review your work. Perhaps they've been busy, out of town, at meetings for two weeks, etc. If they haven't reviewed it, which is often the case, ask them if you can call them back in three days or so. They will give you a polite "Yes." This gives them a timeframe to review the work. You mark it on your calendar and call back in three days. No later. No sooner.

SECOND FOLLOW-UP CALL

Here is where most people err. They do not make the second follow-up call. In three days, when you call back and get their answering machine, leave a brief message with your phone number, but say you will call back in a couple of days. This could go on for some time. Keep trying every few days. At some point, if they don't return your call, you can act a little more aggressive—but not nasty—when you leave a message.

Sometimes their call will precede yours. This is an excellent sign, but don't show too much excitement or enthusiasm! Don't think this means, "Yes, I want to exhibit your work in my gallery." This is only one step in the process of building a business relationship. Take one step at a time.

CLIENT STATUS SHEET

Name_____

Address_____

City/State/Zip_____

Phone _____

Fax_____

Personal details _____

Art interests _____

Date	Time	Phone/Letter/Call	Notes	Follow-up

Try to see the world from your customer's point of view.

CALLING TIPS

→ Set up a schedule for making calls—at the same hour of the same day each week. This will help you get in a routine. Routine is often what you need in order to do something you don't like to do. Set a goal as to how many prospects you will call during this time—say, five to 10 calls each time. Reward yourself after the session by doing something you like!

→ Try warming up your telephone voice by calling a couple of friends or relatives first.

→ Call from a quiet place free of interruptions.

→ Prepare a checklist of points to follow.

→ Rehearse.

→ Anticipate responses and write down answers.

→ Know your topic and have all the facts at hand.

→ Be psychologically prepared and centered.

→ Know who you are calling and why. This is not a cold call: You have done research.

→ Did someone refer you? If so, mention that at the beginning of the call.

→ Don't justify your work, or anything else, for that matter.

→ Know the benefits for this person of doing business with you. Make a list of them before you dial.

→ Have your calendar handy for preparing a meeting date.

→ Speak clearly and concisely.

→ Be positive, but be prepared for objections.

→ Always thank the listener for his or her time.

→ Answer your business phone (yes, you do have a separate line for your business!) with an official business greeting, such as, "Good morning, ArtNetwork." You could follow this greeting with your name if you want to be more personal. Just saying, "Hello" is not a business greeting.

→ Don't allow your children, spouse or friends to answer your business line.

→ If you are in the middle of a project, let the answering machine take your call.

→ Always answer the phone with a smile and an upbeat tone.

→ If you spend a lot of time on the phone, have two lines—one for calling out and one to receive messages.

→ Don't answer so fast that the caller can't understand what you are saying. This happens quite frequently when I call a business. This is sloppy, as well as frustrating. If you have an employee, make sure she is answering the phone pleasantly, slowly and clearly.

→ When you call, don't waste people's time. Ask immediately if they are being interrupted. If so, is there a better time to call back?

→ Introduce yourself to the person you call, and make it clear who you are and where you met or who referred you.

→ Take notes on important facts and issues you discuss. Keep these on a client status sheet. This is called smart-calling. You will impress your client with what you've remembered!

→ Let the customer lead. Does he want to chat? Is he in a hurry?

→ If you leave a message, make it clear why you are calling.

Practice makes perfect.

9 WAYS TO KEEP CUSTOMERS COMING BACK

by Sue Viders and Constance Smith

Service

In today's tight economy, personal service is the only way to survive! Spend more time with your client discussing color, texture, ideas—whatever is necessary to give him special attention. Follow up with a call to see how he's enjoying his new art piece. Talk to him.

Reminders

Send clients a postcard of your newest painting and let them know who purchased it. Collectors like to know that other people are buying your work. It makes you more credible. Send them invitations to openings you are having, even if they are far away. They want to know you're a success. Call to invite past clients to your opening. Remind them to bring their spouse, friend or business associate.

Network

Go to other artists' openings at galleries and exhibition spaces. Get involved with your community art organizations. Get acquainted with the directors of your local arts council.

Toot your horn

Attempt to get press coverage in your area on a continuing basis. Collectors like to see your name in the paper and on TV. They want you to be a success because their investment will rise in value. They can say they helped discover a new artist.

Make it easy for the client to buy from you

Endorse a lease program. This is especially good for business clients. Start a patron program. Start a "look" program that allows previous customers to "sit" with an art piece in their home or office for a short time before they finalize their decision to buy.

Stay organized

Don't forget people's names, what they purchased, what they like. Return phone calls, confirm appointments and follow up on every contact, referral and press coverage with a thank-you note.

Stay educated

Search out classes and seminars to help improve your business techniques. Go to trade shows to see what's current. Read business magazines and books to keep abreast of trends.

Offer extras

Extra service builds goodwill toward future possibilities. Offer to hang the piece they purchased in their home or office. When you see their home, you will be able to make suggestions for other pieces that would complement their setting; many people need help in this area. Offer discounts for multiple purchases within a given period of time. Offer something special: customized framing suggestions, free delivery, home consultations, whatever it takes for them to value you and your artwork. They in turn will tell their friends, who will become great leads for future sales. Make it simple and easy for the customer. People who have money to buy art often don't have much time to spare.

Pay attention to your clients

This is the best way to know what to offer someone in the future. Most individuals are a reflection of many people's ideas and attitudes, so by listening to one person's views, you will be able to see what many people might want.

NETWORKING

There are networking groups in almost every civic community these days. They usually consist of business owners who meet once a month for cocktails, just to get to know each other. You can join these as an artist—no differently from an accountant, dentist, or newspaper writer who has joined.

▸ If you meet these local people through networking and they hear of someone who needs artwork for their office, new home, etc., they might recommend you.

▸ People generally prefer to patronize people they know. If you get to know them better and they like your work, they might offer you a show at their house.

TIPS

→ Networking is a two-way situation—giving and receiving.

→ Always carry your business card or a flip-chart portfolio with you. Everyone you meet could be a potential client—or at least know someone who is.

→ Don't be shy. When you pick up your drycleaning and pay your bill, hand them your business card. When anyone asks what you "do," have a business card to hand them—maybe even two so they can give one to a friend. Let everyone in your community know who you are; be proud of it. Pretty soon you will be famous!

→ Join different groups—Chamber of Commerce, artists' groups, PTA, etc. Start your own group. Serving on a committee, such as for the local arts council or museum, is a great way to network and meet new people.

WORD-OF-MOUTH PUBLICITY

Word-of-mouth is your largest advertiser, and this is what will start occurring once you have reached enough people in a community. If a customer is to refer you to another potential client, of course you must have happy customers. You want someone to say, "She even came to my house and helped me hang the piece! It looks great."

▸ Ask for a referral. If someone really likes your work, she will be more than happy to give you a lead to a friend or business associate.

▸ Give a little extra, and people will start talking about you. Install a piece of artwork at someone's home and there are bound to be stories about "the artist."

▸ Keep giving out those business cards and sending pictorial reminders.

The best salesperson for any item is a happy buyer. Pleased customers validate your work.

If you ever get a referral, be sure you thank, by card or phone, the person who gave it to you—even if you don't make a final sale. You want to have any excuse you can to call someone who was nice enough to give you a referral—that way they'll give you another!

TARGETING YOUR MARKET

You need to know what is special about your work. If you don't know, you won't be able to tell anyone.

There is a myriad of directions from which to enter the art marketplace. Think about your marketing ventures with creativity. Artists who are making it do just that—they're always developing new ideas on where and how to market their work.

Fill out the chart on the next page. It will help you to brainstorm various alternatives for selling your specific genre of work.

As you start the actual search for places to sell your work, remember that your main goal is to get your work out there for the public to see. If they don't see it, they can't react—nor can they buy. Your first aim should not be a New York gallery—or any gallery, for that matter. If that's your aim, you're hoeing a difficult path. Make a gallery your priority only after you have gained a reputation.

A target market is the group of people toward whom you will concentrate your sales efforts. Many artists overlook sales opportunities that could be quite profitable to them and think only of getting into a gallery. Artists I am acquainted with who are making a living from the sale of their art earn most of their income from sources other than galleries.

NICHE MARKETS

After filling in the data on the next page, you will have a better understanding of the specific people who might like your artwork, where to find them, how to attract them. This is your niche market. Don't be misled to think that the larger the niche market, the better off you will be. Word spreads fast in a small niche-market group.

WHO IS ATTRACTED TO MY ARTWORK?

How are they like me? _____

How are they different? _____

Values/tastes: _____

What do they read? _____

Impression I want to make? _____

Where do they hang out?_____

Where or how am I most likely to get their attention? _____

❏ Men ❏ Women ❏ Children ❏ All

Marital status: _____

Ethnic background: _____

Age group: _____

Religion: _____

Living environment: _____

Income level: _____

Education level: _____

Potential clients in order of priority: _____

What are their reasons for buying my art? _____

What organizations do they belong to? _____

Specific region of the country to sell to? _____

Describe exactly what I am selling: _____

Define more specifically my target market: _____

Features of my artwork: _____

Who is my competition? _____

What can I learn from my competitors? _____

Benefits to buyer. Can I offer something more, something different, something better than my competitors? _____

Experience, authority, expertise—why would someone trust me?_____

How will buying my artwork make the customer's life better? _____

How can people pay for their purchase (credit card, check, terms)? Will this satisfy my target market?_____

Am I able to produce enough original pieces for potential buyers in my target market?

Are there any legal considerations in selling my product to this (or any other) market?

ACTION PLAN

- ❏ Search out a target market.
- ❏ Start a mailing list.
- ❏ Conquer fear of the phone.
- ❏ Use a client status sheet during daily calls.
- ❏ Start networking locally.
- ❏ Treat customers as lifelong clients.
- ❏ Identify five possible patrons, business or individual.

RECOMMENDED READING

Homemade Money by Barbara Brabec

Positive Impressions: Effective Telephone Skills by A W Hitt and Kurt Wulff

Power Calling by Joan Guiducci

Taking the Leap by Cay Lang

Chapter 13

Promo Pieces

Postcards

E-mail newsletters

Brochures

Components of a brochure

Mailing lists

Invitations

Where my heart lies, let my brain lie also.
Robert Browning

POSTCARDS

Though e-mail is used these days to send out promotional material, the best way to entice new customers is still through the mail. Many people have set up their computers so that e-mails with attachments are automatically dumped. For your own in-house e-mail list, it's a great way to promote. But for that new customer, direct mail is still quite powerful—especially postcards. One doesn't have to open anything and yet sees the image that should entice him on further. A simple 4x6″ four-color postcard is all you need to start your promotions.

When it is time to go forward with your first printed promo project, make a budget. If you spend too much money, you might drive yourself out of business. Until you are well-established, stay with the postcard, which can be a fairly inexpensive way to get your visual image out to clients. Many artists use postcards as invitations to an exhibition. Others use them to keep in contact with clients.

INVENTIVE CARDS

As in most promotions, it pays to be unusual. You want people to keep your postcards? How about an oversized postcard that people can post on their bulletin board and use as a small poster? Make your promo piece hard to toss into the wastebasket. Make it valuable enough that the recipient will keep it.

You don't necessarily have to have four-color postcards printed for an exhibition or opening announcement. I've seen some beautifully designed one-, two- and three-color cards.

Card stock does not have to be the conventional 10pt. With paper prices rising, lighter-weight stock such as 8pt is common and fills the postal requirements.

- Standard 4x6″ postcards can get your artwork's image across, but being a bit more inventive may win you much longer viewing.

- Make an 11x7″ postcard (49¢ to mail) and get a lot more space on a bulletin board.

One artist I know goes travelling a lot. Her artwork is of foreign scenes, and so she sends postcards from distant places. I love to receive them, as do all her collectors and potential clients. Because she does this, I remember her and have taken a special interest in her work. In this manner she keeps me informed of how her career is advancing. This is called smart marketing!

POSTCARD PRINTERS

If you decide to print four-color postcards with images of your artwork, it's best to use a specialized printer. It's as easy to deal with out-of-state specialized printers as it is with local ones. Get quotes from at least three printers to compare costs. Many of these companies will print, address and send your cards for you—a great deal at a great price. You send them your database, or one that you've rented.

1-800-POSTCARDS
121 Varrick St, New York, NY 10013 (212) 741 1070
www.1800postcards.com

Clark Cards
PO Box 1155, Willmar, MN 56201 (800) 227 3658 www.clarkcards.com

Mitchell Graphics Inc
2363 Mitchell Park Dr, Petoskey, MI 49770 (800) 583 9401
www.mitchellgraphics.com

Modern Postcard
1675 Faraday Ave, Carlsbad, CA 92008 (800) 959 8365
www.modernpostcard.com

E-MAIL NEWSLETTERS

Companies are constantly on the lookout for innovative and economical ways to remind their customers of who they are. Many companies these days use e-mail newsletters as a way of updating their clients on their happenings.

TIPS

→ Put a tip or hint in the newsletter that will entice the recipient to keep it—how to clean a frame, where not to store unframed works, etc.

→ Note new purchases by customers. People love to see their name in print. (Get permission first!)

→ Note any experiences with customers you might want to share. Did one of your patrons have a show for you at her house? Let the other customers know how fun it was. Maybe you can get more patrons to offer shows for you.

→ Know your purpose—to inform, sell, inspire—and your goal—to create interest in your work—when you write the copy.

BROCHURES

Brochures are hardly needed these days for introduction purposes. Your web site does that in a jiffy. Traditionally, however, brochures are used to sell item(s), as an introduction piece, or in the place of a portfolio. Some day you might need one for a particular purpose.

Flier. Generally one sheet, printed on two sides. It can be folded. Sometimes called tear sheets or sales sheets.

Brochure. Can be any dimension, the most common sizes being 6×9″ and 8½×11″. Usually a minimum of four pages.

Catalog. Usually 5×8″ or 8½×11″ format with eight pages minimum, often more. We're all familiar with direct mail catalogs!

If you decide to print a brochure to replace your portfolio, it must be top-notch, thus expensive to produce. The paper stock, layout, copy, and typesetting must be of superb quality to make it effective.

REDUCING PRODUCTION COSTS

▸ Create a brochure that will fit a standard envelope.

▸ Make your brochure a self-mailer. This means it is folded in such a way that you don't need to put it in an envelope. By today's standards, this is quite acceptable. Contrary to popular belief, it is rare that a mailer gets damaged because of not being enclosed in an envelope.

▸ Print on standard stock paper. This doesn't mean it's ugly paper. Generally there is a variety of grades and choices of standard stock.

▸ Get quotes before you design your brochure. After your initial quote, ask more specific questions of the printers you are most interested in. Ask them, for instance, "What do you suggest I change in order to cut costs?"

▸ Many printers have "gang-runs" to accommodate those who are not under urgent deadlines. A gang-run means your piece is printed on the same paper with someone else's, thus saving start-up charges and other fees.

If you intend to design a brochure or flier yourself, you should have had some training as a graphic artist. You will need a computer and a page layout program such as Adobe's In Design. If you are not trained in graphic design and layout, try to do a trade with a designer. Simple errors make a bad impression on the visually observant.

COMPONENTS OF A BROCHURE

Keep all these ideas in mind for your web site, too.

OPENING STATEMENT

An opening statement may or may not be necessary, depending on the type of brochure you are designing. It can include your logo and/or name and a simple description of your artwork. Maybe you need to hire a writer for this special project. You'll be amazed at what professional writers can do to improve copy.

Use powerful and persuasive words when you compose your copy. Some words and phrases that are used regularly in brochures:

Bargain	Bonus	Check	Compare
Discover	Quick	Refundable	Safe
Save	Successful	Try	Get one free
Act now	Here's news	Trial offer	Never before
No obligation	You can trust	Special invitation	

BENEFITS

Keep in mind the audience you are addressing. You must appeal to them emotionally. Note the benefits of a purchase of your artwork. Why is your work special? Here are some examples:

- Honors and recognitions the artist has received
- High quality of the printing process (if a print)
- Shipped and packed to insure delivery in perfect condition
- An additional 10% discount if ordered within a certain time
- Prices include framing and delivery
- Scientifically and accurately rendered
- Guaranteed. If it doesn't fit the buyer's environment, return within 30 days.
- Lightweight and easy to transport.

TESTIMONIALS

Ask some of your previous purchasers to write testimonials for you. You can even tell them what you would like them to say—a statement that highlights one of your benefits, for example. This builds buyers' confidence immensely.

IMAGES

Reproductions of your most representative piece(s) are a must. A photo of yourself can add emotional impact. A high-quality line drawing or clip art can add character to your printed piece.

STATS

Your name, address and phone number should be included on every piece of material that you print. Don't forget web site address and e-mail address. It's very frustrating when an address or telephone number is lost because papers have become separated.

ASK YOURSELF

▸ What is the purpose of my promo piece (or web site)?

▸ What is my budget?

▸ To whom am I sending/showing this?

▸ Where do my customers hang out?

▸ What is a design style that could pleasantly surprise them?

▸ Which writing style would they understand?

▸ What kind of image do I want to create?

▸ What's a special benefit that could 'catch' my audience?

▸ What is the type of testimonial that would appeal?

THINK ABOUT

▸ Ways to make your audience respond: an order form, a postage-paid return postcard telling you they want to remain on your mailing list, get on your mailing list, etc.

▸ Ways to add authority: a testimonial, a list of corporate collections or museums that collect your work

▸ Way to make your piece easy to remember: a photograph of yourself, an unusual story, an unusual design, a reference to a recent public event in which you were involved

▸ Ways to make it useful and possibly saveable: hints on caring for artwork, discount coupon

▸ Ways to make it relevant: touch an emotional chord, i.e., "You're missing a lot by not having original art in your home," or "Support a living artist."

First and foremost, don't make your piece look like junk mail!

When you send something a bit different, professionals tend to keep it longer—maybe even post it on their bulletin boards. And that's the idea—to get them to keep it and call you!

BUDGET

Within your budget might be the following categories of expenses. At first, no doubt, you will do many of these tasks yourself. In that case, try to network with other artists and exchange critiques before the final piece goes to press.

Writing	Editing	Designing	Typesetting
Proofreading	Pretesting	Labels	Printing
Copying	Paste-up	Mailing prep	Postage

PROFESSIONALISM

▸ When listing the size of your two-dimensional artwork on your promo piece, list height, then width, i.e., 14×62″. Do not put the inch mark after the height, but only after the width. Do not leave any space on either side of the "×". A sculpture piece would have the depth added last: 14×32×12″.

▸ Do not leave two spaces after a period—leave only one.

▸ Have all your work proofread professionally for grammar and typos. Why spend a fortune on a brochure that doesn't present you well?

COMMON MISTAKES

▸ The mailing list is too generic—the more specific the better.

▸ The flier or postcard is sloppy or uninteresting and doesn't reflect your professionalism as a fine artist.

▸ You are trying to sell an original piece of work. Rarely will a direct mail piece sell a high-priced item. A better aim is to try to get people to come to an exhibit, then sell them your art in person at the exhibit.

Your average mailing—a one-page flier—generally costs $1 or more per piece, including postage, depending on total quantity you print.

SUCCESSFUL MAILINGS

Promotional mailings sent through the post office (usually in bulk) are referred to as "direct mail campaigns." Direct mail campaigns can be very successful if they have an appropriate product to sell as well as a good mailing list.

Factors to consider

Direct mail should be only one part of an overall promotional campaign. Promotion needs to occur in a variety of ways: through trade shows, fairs, exhibitions, web site, personal contact, etc.
Big-ticket items are difficult to sell via direct mail.
Have more than one product to sell.
Have a wide price range.
Repeat direct mail promotions to the same people. Once you've added someone to your in-house mailing list, you will want to keep mailing to her indefinitely or until she requests to be taken off.

Personal compilations

The best way for artists to create a good list of potential clients is to compile the list themselves from their own research. If you have 100 handpicked potentials on your list, you could have a great client base.
Browse the Internet for potential clients—fine art consultants, corporate art consultants, licensing agents, art publishers, greeting card publishers, etc. Review their web sites to find out what style of artwork each professional works with.
Include personal names from your acquaintances and attendees of previous exhibitions and open studios.
Browse through art periodicals to see what types of work galleries are selling. Add appropriate galleries.
Find names in home decor magazines or other resources.

Postcards make great mailers

Postcard companies are making it easier for you to do your mailings these days. You supply your mailing list via e-mail and they inkjet the names onto your cards and mail them. Since postcards require no opening, almost everyone takes a second to glance at them.
→ Mailing a postcard is less expensive than a brochure or flyer.
→ Printing a postcard is less expensive than a brochure or flyer.

Tips

→ List your URL on the front of the card, along with your artwork. On the back you might be announcing your open studio, a benefit with a nonprofit organization, or "Merry Christmas." Be sure to include all your data—e-mail, telephone, address and URL.
→ Part of your overall marketing plan could be to send 10 cards a week over one quarter, for a total of 120 cards.

INNOVATIVE IDEAS

▸ A group of textile artists created a "cooperative" mailing. They each printed their own 4x6" postcard, then all 50 were stuffed into one envelope—like a set of playing cards. This is less expensive for each artist to send, fun for the recipient to look at, and easy to keep.

▸ Carry postcards of your work at all times to give people.

▸ Keep printing costs down by printing on your personal color printer.

Create unusual mailings

Save mailings you receive in the mail that you particularly like. By studying these, you will start to get a feeling for the type of mailer you might want to create.

Have a plan

Know all your costs before you commit to a campaign:

▸ Printing
▸ Production
▸ Mailing list rental
▸ Postage
▸ Your time

How many prints or originals must you sell to pay back these costs? How many do you have to sell in order to make a profit?

E-mail campaigns

We have seen that direct mail, e-mail, networking and advertising are all needed to reach one's financial goals. Since e-mail campaigns cost a lot less to "mail" and only a bit of money to create, many companies are trying to go solely with e-mail campaigns. Using our in-house e-mail list that we have gathered from visitors to our site gets a great response and, indeed, saves lots on postage costs.

Innovation

To make his one-color brochure into a four-color piece, one clever artist pasted his four-color business card onto the front cover in the framed area he had printed with his computer. I could hardly tell that it was a business card. It looked and felt like it was printed right on the paper.

MAILING LISTS

DIRECT MAIL

If you decide to do direct mail, i.e., send a brochure to a large number of unknown people, having the right mailing list is very important.

Mailing lists are generally rented for onetime use. List renters normally include a number of "seed" names in their lists (phony names to inform them of multiple uses). Be ethical. If a renter discovers that you have used a list more than once, he will not rent to you in the future and will charge you for reusage.

E-MAIL

E-mail lists can be found to rent or buy; however, they are generally quite expensive ($1 for each name) or are not very specific. As an artist, you need a specific list. Since no smart person will sell his personal list of collectors, you are best to start collecting your own.

You can also take your in-house list and have it appended with e-mails (and telephone numbers). This could be a good idea if you have a large enough list and don't have e-mails attached to your list, as the minimum cost for doing this is $400. Not all persons or companies on your list can be found in the appendor's database, so this minimum charge could make each e-mail address rather costly.

An artist sent 1000 direct mail pieces to a specific area near where he lived—a very high-income residential area. He got great news. He had made two big sales—his originals sell for $9000—as well as evoked some interest from other parties. Needless to say, I was very surprised! The factors that made his mailing different from most are:
→ An exquisite brochure—11x17" folded in half and inserted in an envelope. The brochure probably would normally cost $1-2 each. He received this well-designed brochure free from his publisher.
→ This artist was known in the area. He had been the poster artist for a recent, well-known art festival. He was also part of a well-respected gallery in town, a gallery which hadn't sold any of his work for ages.
→ The gallery advertisements included his name—and his name was first because his last name began with the letter 'A', so his name had some recognition.
→ The people loved his style of art.
This steady exposure to a particular locale paid off. If he continues to mail to the same people, they will start networking and do his sales and advertising by word-of-mouth!

Patron lists from your local museum could be a very effective tool to begin with, especially if you're somewhat known about town and these people already will be familiar with your name.

ACQUIRING LISTS

Many organizations, museums and arts councils rent lists of their patrons. If you refer to your target market chart and decide on some specific genres of people you would like to approach, there is a mailing list of those specific people! Search the Internet.

Art World Mailing Lists

www.artmarketing.com/ML

ArtNetwork has for rent over 20 varieties of lists of art world professionals nationwide.

America Business Info

(402) 392 9000 (800) 555 5335 www.listbazaar.com

Mailing lists acquired from the Yellow Pages

Trade Shows

Most trade shows sell lists of attendees. ArtExpo or Art Miami might be a good way to solicit collectors.

Standard Rate and Data

www.srds.com

You will find this book at main branches of libraries. It has been a standard in the industry for years.

Magazines

If there is a magazine that you think your type of collector would read, you most likely can rent the subscriber list.

International Interior Design Association/IIDA

(888) 799 4432 www.iida.org

American Society of Interior Designers/ASID

608 Massachusetts Ave NE, Washington, DC 20002-6006

(202) 546 3480 www.asid.org

Minimum order is $300. Names are rented for $120 per thousand. You can order by geographic location or by type of design practice: health care facilities, residential, hotel/motel design, etc.

World Innovators

(860) 210 8088

A list broker that does not charge you a cent—the list renter pays them a fee for hooking them up with clients. Tell them exactly what you are looking for and they will try to find it. We work with them all the time.

INVITATIONS

It's more important than ever these days to send an invitation to your opening that stands out from the crowd. When your invite is more than a postcard, it gives a hint of what your opening will be like. A special invite suggests a special night.

▸ Don't forget to include all the facts: who, what, when, where, why (and directions)!

▸ If your design becomes quite elaborate, check with your local post office to verify cost to mail, and if it is indeed mailable. They are constantly changing their regulations. Recently we had 150 envelopes returned that had been sent to foreign addresses: We had put the label too close to the bottom of the envelope. We had to redo them all!

▸ Adhere appropriate art-related stamps to go with your design.

MUST-OPEN INVITE EXAMPLE

Inside a 4x5" opaque envelope was "floating" a 1x1" orange and yellow striped square card. On the back of this very small card (which was visible through the envelope) was some writing, difficult to read through the opaque envelope. Anyone receiving it would certainly wonder what it was. Impossible not to open.

AN INNOVATIVE STORY

A publishing company that prints posters of pool hall scenes sold the magazine "Billiard Digest" the rights to use an image on 1000 bags at the annual Billiard Congress of America trade show in Nashville, TN. They also did a direct mailing to 4000 pool halls and supply companies. The same publisher has a limited edition of a print called "Travesty of Justice." They will focus their direct mail campaign on criminal lawyers and advertise in legal magazines. They have found their target market, and their advertising and promotion works!

Your in-house mailing list is, of course, your prime list. You have worked long and hard to gather this list, doing much research.

ACTION PLAN

- ❑ Create a simple postcard for an opening.
- ❑ Create an e-mail newsletter for clients. Continue producing it on a quarterly basis.

RECOMMENDED READING

The Fine Artist's Guide to Marketing and Self-Promotion by Julius Vitali

In Search of Excellence by Tom J Peters and Robert H Waterman

Newsletters from the Desktop by Roger C Parker, Joe Grossmann and David Doty

Unleash the Artist Within by Bob Baker

Chapter 14

Sales Techniques

Learning to sell

Handling objections

Follow-up

Special sales programs

Never complain and never explain.
Disraeli

LEARNING TO SELL

Art mostly sells itself.

Most people will say that it's hard to sell art, that no one wants to buy art.

There are people who want to buy art, want to improve their lifestyle, want to feel good about themselves and enjoy art in their life. You need to find these people—where they hang out, what they do for their livelihood and hobbies. That's what marketing is all about—finding and contacting the right people.

People ask me all the time, "Where is the most active art market in the U.S.?" When I tell them their own city, they get really mad. They want to hear some magical answer, like Santa Fe, New York, Seattle.

The term "marketing" is sometimes used incorrectly as a synonym for selling. Marketing is the sum of several different kinds of activities: promotion, intelligent research, planning, pricing, studying competition, etc. Selling is the act of getting money (or perhaps a product you need, as in bartering) for the exchange of your artwork.

Art has been made out to be a thing for the rich. How absurd! I've bought many original works of art for under $250. At outdoor shows and co-op galleries, there are beautiful pieces ranging from $500-750, even less.

INSTILL CONFIDENCE

You need to instill confidence in buyers who approach as first-time purchasers of original art. They've been under the myth of "investing in art" and just don't know if they're making the right choice. At this level, a customer is not investing in art. He is simply purchasing a piece of art to improve his lifestyle and to enjoy. Indeed, the works might increase in value, but if he wants to invest in art, he will need to make monetary purchases in the thousands.

Knowing information about an artist or the creative process can help a potential buyer become more interested, but he initially has to respond to your work—there is no convincing involved.

EXCUSES YOU MAKE

Everyone who comes in front of you is a potential client. If you have excuses, it is because you don't want to make the effort to sell to them. When you are in a confident mood, you will not make up these excuses. Practice not having these excuses if this is your problem.

▸ He doesn't look like he has any money.

▸ He doesn't look like someone who buys art.

▸ She is not avant-garde enough for my art.

▸ Her fingernails are not polished. She doesn't have any money.

▸ No one off a tour bus ever buys.

Think of sales as introductions. "Sales" usually implies luring someone into a trap and selling them something they don't want. This is not the approach you want to take as an artist. It will surely backfire.

I was a juror on a court case. The prosecutor was a mild-tempered lawyer—you could barely hear his voice. The defense attorney was a power-infested madman. No one on the jury liked the defense attorney, although he appeared more like a winning lawyer. None of us wanted to listen to this disgusting defense attorney. I believe he lost his case mostly because people didn't like his personality. Likewise, if you sound like a stereotypical car salesman, people will walk away from you in an instant. Be natural, honest and kind, and you will sell more art. Pretend you are talking to someone in your own home about your artwork when you speak with a potential buyer..

STUDYING OTHER ARTISTS' SALES TEHCNIQUES

Keep in mind as you study the market which salesmen you would like to emulate. Make a special effort to study this topic. When you go to galleries, study how they do it. When you visit outdoor shows or an exhibit, see how they do it. Write your comments down. You will want to observe all types of salespeople and see how you react to them.

You will find some common denominators in the people you can deal with comfortably:

▸ You trust them; somehow they have gained your confidence.

▸ You like them—you might even consider them as a future friend.

When you hold a studio show or exhibit at an outdoor show, the people attending are all potential customers. Perhaps, however, they've only purchased prints or limited editions previously. Most of the people you will encounter do not go into galleries. Galleries intimidate them.

Art is a unique commodity. People want to fall in love with an artwork. They want to show it off to their friends. If you know why it's good to own original art, it will be easier to convey this idea to new buyers.

Unless someone is ready to make a purchase, she generally will have objections to handing over the cash. As you proceed with your sales, you will become more familiar with what is a normal objection and what is the difficult objection. One way to get around objections is by changing the subject and simply not answering them, or by asking another question.

▸ Some people might not be sure if they actually like the piece. They need reaffirmation—from a bystander, their mate, friend, etc. In this case you could offer them a money-back guarantee. They can display it for two weeks in their home. Then they'll have a chance to hear comments from friends and neighbors.

Learning your own buying style will teach you your best selling style intuitively.

You are giving people an opportunity when they buy your artwork—an opportunity to add a new dimension to their life.

HANDLING OBJECTIONS

Your potential customers must have confidence and trust in you before you can sell them anything, let alone a $2000 painting.

▶ A common objection is, "The price is out of my budget." Your answer would be, "How about a lease?" or "Why don't you join my patron program and pay by the month?" or "I do have a layaway plan." If you accept VISA/MC, you might even feel secure with giving them the piece with three installments on a credit card.

▶ Price is too high. They are not familiar with the serigraph process and think it is a poster. Educate them. Suggest they compare your prices to the artist down the path, that you just sold a piece to so-and-so or that your prices have risen slowly over the years because you are more in demand.

▶ The colors clash with my room. Show them a different but similar piece. Teach them that an art piece is what sets off a room, not the couch.

▶ They don't feel they deserve such a fine piece. This might not be said in words, but it is how some people have been trained to feel, especially new collectors who haven't had time to begin to appreciate art in their homes. Explain that everyone deserves to have a living image to view daily.

▶ I can't make up my mind. Make them feel confident in their choice. Introduce them to the patron program.

▶ Silent objection. They won't look you in the eye, they have nervous energy, their arms are folded, they won't shake your hand. Make them feel confident in you. Show them your portfolio, listing what museums collect your work.

SOLVE YOUR CUSTOMER'S PROBLEMS

Think of selling as solving a potential client's problem: Some of them have an easier time letting themselves being rewarded with artwork than others. For some, it is a new problem and they don't feel too confident. For others, someone else has imposed the problem; they have reached a certain financial status and others expect them to be owners of original artwork. They really don't know what they like, what they want. They want to be told, and want to trust the person telling them.

ESTABLISH CONFIDENCE

Your initial presence and stature must instill confidence.

▶ If you sell at the same outdoor show for several years running, this insures confidence. You are not an art peddler: you are an art dealer, which requires a relationship on an ongoing basis.

▶ You've been referred by a friend or associate.

▶ Someone else has bought from you.

Whether you are selling a poster for $10 or an original for $2000, it takes the same presentation. You have to make the same lines sound fresh each time.

▸ The local arts council or museum has a piece of your work.

▸ They saw your name in an article in the local paper.

SELL BENEFITS

People want to be sold benefits. Buyers want to know the benefits of owning *your* artwork. So make a list of them—right now! A benefit generally saves time, energy or money while appealing to the ego. Right color, right size, joyous feeling, the artist is collected by a loyal following, confidence due to critics saying good things about the artist, nicely framed with high-quality materials. All are benefits of owning a piece of your work.

BENEFITS OF OWNING MY ART:

Never ask a question of a potential client that can be answered with a simple "Yes" or "No."

165

ATTRACTING AND KEEPING CLIENTS

As a salesperson, have your objective be not only to make sales but also to meet and keep clients. Remember, your clients should be for a lifetime. Each individual you meet is important and deserving of your highest regard. Treat everyone with dignity.

Telling is not selling

One of the most effective ways to complete a sale is to engage in a dialogue with the potential client in which you ask questions that will lead to a buying decision. Salespersons not trained in selling art usually try to tell their clients about the works they represent.

My experience has taught me that clients might politely listen for a minute or so, but as the representative continues to talk, they become less and less interested. By telling, you will end up losing their attention and a sale.

People don't like to be told. They would rather tell you! The way to get your clients really interested in owning what you have to sell them—art—is to ask them questions so that they can tell you their thoughts. The more they tell you, the more interested they will become.

Giving more than is expected

To be successful in the business of selling art, think of ways to develop a loyal clientele—collectors who will buy from you again and again. One way to do that is to give your clients more than they expect. It could be a poster, a large postcard featuring one of your works, an invitation to a private showing, a print, a small sketch, a book that features your works, etc. You have all sorts of things around your studio that you could make into a thank-you gift for your clients—something that your clients will appreciate. Gone are the days when you make a sale and the next day forget to whom you sold. Your best clients will become good friends and loyal collectors. Your best clients will also become your best publicity agents for finding new clients to increase your sales.

Tone of voice

Your tone of voice has a profound influence on the mood and rapport that you will have with your clients. Ask your good friends to comment on your tone of voice. Do you speak too loudly or too softly? Does your voice sound harsh? Do you speak too fast or too slowly?

Learn to be aware of the tone of voice. Find out if it has the effect of making people feel relaxed. One way to become more aware of this is to set up a tape recorder and record conversations with a friend. Play it back, listening to your voice.

This article was excerpted from Chapter 3 of *SELLING ART 101* by Robert Regis Dvorák, available at www.artmarketing.com.

Follow up a short time after a sale is made with a friendly call to your client. Yes! He's *your* client now. He's moved up the ladder to #1 code on your mailing list. Call to see if all is going well with his purchase. Tell him briefly about your new paintings. Ask him if he needs any more work for his office, or if he has a friend who's been looking for art. It's a little hard at first to be forward like this. Make it friendly. Try it! He likes you. He likes your work. He bought from you. He's happy. Now you are connecting again emotionally so he won't forget you.

▸ After you make this call, send the client (whether he has given you a referral or not) a brief letter, 3-5 business cards, your flier/postcard/color photocopy of your newest piece and perhaps a discount coupon toward his next purchase.

▸ If the sale has been made to a business, you might stop in some time to see "how my baby's doing." You might meet some employees and leave your business card on the front desk with the receptionist. Casually—no pressure. Send annual cards to the buyer and perhaps one to the office staff.

REFERRALS

Don't forget to ask for a referral. Many art world professionals are glad to refer you to someone they know. Ask!

When you do receive a referral, be sure to follow up. A referral call is an easy call to make. Someone sent you and that recipient doesn't want to be impolite when an associate has recommended you. So when you introduce yourself, be sure to state who sent you. "Hi, Mr. Thomas. My name is . . . and I was referred by Sally Parker of Time Inc, to call you about my artwork. She thought you might be interested in reviewing my portfolio for a possible show in your corporate gallery."

Learn to chat with people. If they say something interesting on the phone, such as where they are calling from, what they did on the weekend, ask them something more. People love that intimacy.

Whatever the outcome, make sure you drop a thank-you note to Sally Parker for her referral. Include a couple of your business cards. Only hint for her to pass them out. If you actually make a sale to a referral, write another note of thanks and include a coupon for a discount on one of your paintings, such as, "Thanks again for your assistance in making my career a success. I hung a piece in Mr. Thomas' office yesterday. As a thank-you for your patronage, I would like to offer you a discount of 10% on a purchase from my collection. Why don't you come by my studio sometime? I can help you decide what piece might be best in your office. Prints are now available of some of my works (flier enclosed)." Small, personal offerings will help bring successful sales.

FOLLOW-UP

Persistence is what makes a good salesperson. An outstanding salesperson contacts a prospect an average of three times, usually within a three-to-six-month period. The outstanding seller makes five to seven contacts each day.

There is no way around investing time and energy in your prospective clients.

167

CONNECT WITH THE BUYER

Open Studios at Hunter's Point in San Francisco (where Open Studios originated) was a bit better than my highest expectations. I'd heard about it for years. Over 300 artists show their work, all within walking distance of each other. Parking is easy. The event even has a food bar. You can hang out all day (or even all weekend), meet friends, view art, chat with the artists, sit in the sun, and enjoy the fantastic views of the Bay. The place is bustling like an anthill all day.

Every studio I went into had a great presentation. All were clean and orderly and easy to navigate. About 50% of the artists had prices on their pieces (not enough for my needs). I think some of them thought they were a gallery venue and could get away without exposing prices. I don't know what their logic is.

I asked an artist the price of a triptych on the entryway wall. It was my favorite piece of those I had seen all day. She said, standing behind her protective desk with her husband by her side, "The price is on the painting." I went outside to search for the price, but couldn't find it anywhere—not on the wall, not on the side (I failed to look on the bottom side of the piece)! I realized right then what a poor presentation this artist had given me. Here she has a potential client who is asking a price! She doesn't even escort me out to the piece, to tell me something about it, or about herself, or about her artwork in general. Such an opportunity, down the drain! Not only that, but I can't find the price! Right action would be to take me out to the piece and chat with me. See how I react to the price. Ask me where I would be hanging it (as if I had already bought it). Tell me a story about when she was painting it, or what it means for her. Get me emotionally involved. Eventually tell me she can put a red dot on it and reserve it for me (not pressuring me to buy it). See how I react. If I say the price is way too high, she can lead me to another piece; after all, this is a triptych. Certainly if I have my eye on such a large piece and am asking the price, I must have a large house and a bit of money to spend. Perhaps she can split the triptych cost into three payments; will that make it easier for me? Perhaps she can deliver it to my house in her van, as it wouldn't fit in my car. There are so many options when someone asks the price of a piece, or asks a question about a piece! Don't let these types of opportunities flow down the drain! Artists must be ready to start the emotional connection and the sale. Starting the conversation, i.e., emotional contact, is essential for an art sale. Ingrain the attitude, "All viewers are there to own a piece." Your attitude about selling will change. Choosing the right piece becomes the problem, not whether they will buy.

LEASE/RENTAL PROGRAMS

One of the most frequent programs I "sold" as a rep, especially to businesses, was that of the lease. A lease is not really different from a rental, except that it lasts longer than a one-month period. Suggesting a lease made it easier for me to get my foot in the door of almost any small business. It also created a flow of income, both for the artist and for myself. To my surprise, many individual company employees began to lease for their homes. I never had one piece damaged or stolen.

The consumer enjoys supporting local artists in a way he can afford but may think he can't afford an original at $3500. A quarterly fee may be within his cash flow. Of course, you want to lease to people you feel comfortable with. Lease options work like this:

▸ The client chooses a piece he wishes to lease for a three-month period, with possible renewal of up to one year (or whatever you decide is reasonable).

▸ Setup charge $_____.

▸ The piece is leased according to its selling price, usually at 2% per month of the selling price. (2% x 3 months + setup fee)

Lease payments can go toward its purchase:

▸ All lease money paid for the first 12 months can be applied toward the purchase price, or

▸ 60% of the lease fee will be deducted from the sale if artwork is purchased. (In this case, you might have a slightly lower lease fee per quarter and no setup charge.)

Make sure you have a clear agreement signed by the leaser:

▸ The company will be liable for damage or theft, to the full price of the piece.

▸ Provide a standard "Care for Artwork" sheet.

▸ Restrict where the art is displayed.

▸ Guard against risk of bankruptcy of your work by noting that it is not owned by the business, only leased.

In the Renaissance era, a patron was not an unusual possibility for an artist. In our time, artists have neglected to attempt this method of support.

SPECIAL SALES PROGRAMS

It was a surprise for me to find that about 80% of the people I met had never before "lived with an original painting." When they spent time with their original, they would always rave about the beauty, many ending up buying it.

Listen to your clients. Chat with them at your openings. Find out what they like or want—perhaps a new size of painting, a new medium (giclée), help hanging their artwork. Personalize, personalize, personalize.

LEASE/RENTAL AGREEMENT

Renter's Name _____

Address _____

City/State/Zip _____

Telephone _____

Start Date of Rental _____ Date Due _____ Rental Fee _____

Title _____

Medium _____ Sale Price _____

Artist/Agent Name _____

Address _____

City/State/Zip _____

Telephone _____

This agreement is subject to the terms and conditions below.

Renter Signature _____

Artist Signature _____

TERMS AND CONDITIONS OF LEASE

1. Rental period is 3 months. Paintings may be re-rented successively for one year, at which time they must be purchased or returned. Rental fees may be applied to purchase price. Renter agrees to handle carefully and return on due date or pay overdue charge of $4 per day. Rental and renewal fees are payable in advance.

2. Renter shall be responsible during rental term for loss of or damage to said property from whatever cause, including fire and theft. Frame may not be painted or altered. Painting may not be painted or altered. Painting may not be transferred to another person's care.

3. At the expiration, termination or default of this Rental Agreement, Renter agrees to return said property to artist in original condition.

THE PATRON PROGRAM

Find a person who likes your artwork, such as a former purchaser. Ask if he would like to participate in your career by making a $100 per-month commitment toward a new piece of artwork. He continues to pay $100 per month until he can afford a piece of your work. During that time, he can visit your studio, and if he sees any work-in-progress he would like to purchase (other than a commission), he can claim it as his future piece. When his monthly payments equal the piece's price, he can take it home. He also has the option of speeding up payments to pay for the piece at any time. Draw up a user-friendly contract to clarify all the details of your patronage program.

Buying art is an emotional process. Give your potential buyers a reason to own your art. Show them the passion with which you create. Tell them your story for them to repeat to their friends. When you have an inexperienced buyer at hand, you need to remember that he will be pressured by friends (and his own attitude) to rationalize the amount of money he spent on this purchase. The first question from a friend or family member often is: How much did that cost? They will need to back up their spending with some kind of reasoning: The artist had a review in a national magazine, the artist has sold works to X (some famous person), the artist's work is in a museum, or simply, the artist has a passionate story.

COUPONS

Send a coupon to former clients to entice them back. Why not give them a 10% discount on their second painting to lure them back, or a free print with their next purchase?

GIFT CERTIFICATES

Promote this idea around the holidays. Don't have a cutoff date. Make sure your name and address and telephone number are on the certificate so it's easy to contact you. Use note cards from the stationery store. Keep track of these in a notebook.

ACTION PLAN

- ❑ Attend an outdoor show to study sales techniques.
- ❑ Go to a gallery to study sales techniques.
- ❑ Start getting referrals.
- ❑ Draw up a lease program and agreement.
- ❑ Draw up a patron program and agreement.
- ❑ Make coupons and certificates for future clients.

RECOMMENDED READING

Guerrilla Selling by Jay Conrad Levinson

Selling Art 101 by Robert Regis Dvorák

Think and Grow Rich by Napoleon Hill

Ziglar on Selling by Zig Ziglar

Chapter 15
Advertising

Ad placement

Artist directories

Internet advertising

A master-passion is the love of news.
George Crabbe

AD PLACEMENT

The golden rule of
advertising is repetition.

It's said that it takes the average consumer nine exposures before an ad or product is remembered. Whenever you plan to advertise, you must follow the golden rule and do it a minimum of three times in the same magazine or newspaper.

Another rule to remember is the 25-25-50 rule. In a group of 100 people, 25 will like you, 25 will dislike you and 50 won't care. Don't waste your time on the 25 who don't like you or the 50 who don't care. Concentrate all your promotional activities on the 25 who already like you.

The approach to advertising for an individual artist is different from many other types of businesses. Selling original artwork directly through an ad is generally difficult. Galleries that advertise in magazines such as *ArtNews* and *Art in America* need megabucks in their budget. These galleries are thinking of long-term promotion and the gallery's general reputation, not just the individual show they are promoting. Galleries that don't represent well-recognized artists can't afford to advertise in these expensive venues.

Advertising in your local newspaper or magazine does not generally bring a lot of sales. People do not buy art through an advertisement unless the artist is already known to them. If your aim is not sales but notoriety, leading to sales later, then advertising could be a way to go.

One big-name artist analyzes the effectiveness of his magazine advertising in this manner: If he generates enough income just to pay for the ads themselves, the ad is worthwhile. He gains exposure and, soon, word-of-mouth will reap profits. People have seen his ad so many times that it's finally sinking in. He looks well established; people gain respect. That's when his ad really begins to work. If you start to advertise, you must be willing to make a long-term investment. Otherwise your money is, essentially, lost.

One artist rented a billboard for two months in his small town. He painted on it for four hours daily. By the time he was done, everyone in town knew his name and his style. Not only had they seen it on the billboard, but he had major write-ups in the local press as well as national papers. Galleries called him. He took a risk and it worked!

Another innovative artist put her art images on a software program that plays them as a screen saver. Though she is selling this, giving it away to customers and potential customers would be a good promo idea too.

ARTIST DIRECTORIES

These advertising venues display a typical piece of an artist's work, along with contact info, giving artists exposure to fine-art professionals they otherwise could never reach.

DIRECTORIES

Living Artists
ArtNetwork, PO Box 1360, Nevada City, CA 95959 (800) 383 0677
www.artmarketing.com/Ency
A high-gloss biannual publication advertising artists' work. Complimentary copies are sent to 7000 art world professionals such as reps, consultants, dealers, galleries, museum curators and private collectors. Jury fee to apply. Advertising ranges from $325 up. A contest is conducted for cover image.

New American Paintings
Open Studio Press, Steven Zevitas, 450 Harrison Ave #304, Boston, MA 02118 (617) 778 5265 www.newamericanpaintings.com
A series of six regional books, published annually, showcasing fine artists. Sold in the magazine racks of bookstores as well as to subscribers. Juried fee to apply; no fee if accepted.

Guidebook of Art
Art of the West, 15612 Highway 7 #235, Minnetonka, MN 55345
(800) 937 9194 www.aotw.com
One issue per year (Jan-Feb) showcasing artists. Listings start at $650.

Art Collectors Edition
Wildlife Art, PO Box 22439, Egan, MN 55122-0439 (800) 221 6547
www.wildlifeartmag.com
One issue per year showcasing artists. Prices start at $500+.

Direct Art Magazine
123 Warren St, Hudson, NY 12534 (518) 828 2343 www.slowart.com
Artist Tim Slowinski is owner of Limner Gallery and publishes an artist directory annually, distributed to a wide range of bookstores, as well as to New York City galleries, collectors and museum stores. Competition to participate.

Sourcebook
The Guild (877) 223 4600 www.guild.com
This company has a variety of resources for advertising to art world professionals and the trade.

If you place an ad in one of these directories, check to see if you can get reprints of your page. A reprint is an exact duplicate of your piece in the book/magazine, usually blank on the reverse side.

INTERNET ADVERTISING

Use your site as another version of your portfolio.

Trying to draw viewers to your web site via advertising on the web can be costly for artists. You have a lot of competition and millions and millions of viewers. I think artists are better off doing the research online: search for corporate art consultants, galleries carrying your style of art, galleries in a particular geographic area, etc. Add to that research via the phone, and you will gather people to add to your e-mail list for future broadcasts.

There are a few ways to draw those "extra" individuals—private collectors, corporate art consultants, etc.—you cannot locate on your own but who might be looking for you:

- Have reciprocal links with an appropriate site: If your art is full of tulips, try to link with tulip sellers.

- For lots more detailed information on how to promote your art on the Internet read *Internet 101* available at www.artmarketing.com.

- Advertise with Google "key words." You will end up paying "per click", i.e., when someone sees your small ad and visits your site. This can be effective and, if you study how to do it, could bring you the right new customers.

META TAGS

Hidden from view within every page on the Internet is a group of "meta tags"—keywords, description and title. Search engines can see the meta tags and use them to categorize your site.

Making sure these meta tags have the correct words is an art form in itself and can make all the difference in the world to someone finding you. One time I had a professional web designer redo our home page. They never bothered to put in meta tags (or use the ones we had previously). For six months we were not listed on search engines! So you need to ask and verify that your designer has included appropriate meta tags and keywords.

KEYWORDS

Keywords are also what search engines use to find and list your site. When thinking of keywords to use to promote your work, try to think the way someone searching for your type of art would think. A collector might be interested in vibrant colors, abstract expressionism, a living artist, price range, etc. These words are what you want to list in your keyword section.

TIPS

→ Find out what other artists are using for their keywords. When on their site, click "View" on the navigator bar, then go to "Page Source." You will be able to see keywords they use on any page!

→ Because the word "painting" is so generic (as well as gallery, artwork, artist), a search done using just the word "painting" will pull up millions of sites. Use words that are not generic—for example, spiritual art, shamanic art, three-dimensional painting, earth works, sublime art, sculptural ceramics, etc.

→ Don't repeat words in the keyword section. You can have variations on each word, such as art, artist, artists, arts, art world, artwork, etc, but do not put artist, artist, artist.

→ When using a phrase such as "commissioned portraits," the keywords should read: commission, commissioned portrait, portrait, portraits, commissions, commissioned portraits. You want the plurals because if someone searches for commissioned portraits and you have only commissioned portrait, it will not pull it up.

→ Separate keywords by commas. No spaces are necessary.

→ Have your first and last name together as well as separate: ivo david, ivo, david.

→ Put all keywords in lowercase.

DESCRIPTIONS FOR PAGES

In the description section of your meta tags, you will be writing in sentence format a summary of your site. Pull out some words from your keyword section and use those in your description. You can have several sentences within the description. This description is what shows up when your site is retrieved in a search.

TITLES FOR PAGES

Be very specific with the title on each of your pages. The title plays an important role in the process that determines where your page shows up on a search engine. The title page is the first thing the spider of a search engine looks at. A title should be helpful to visitors, but also useful to search engines. Use no more than five words; the shorter and more concise the title, the better the search engines respond.

ACTION PLAN

❑ Review national artist directories for possible advertising to art professionals you would not otherwise reach.

❑ Investigate the experiences of other artists who have advertised on the Internet.

❑ Brainstorm some effective advertising possibilities.

❑ Identify art publications from your own area.

❑ Take an article written by an artist in an art publication, locate their web site and learn what you can from this information.

❑ Find an artist's web site who is creating something similar to you. Study how she sets up her site.

RECOMMENDED READING

Body Language by Roberta Smith

Customers for Life by Carl Sewell & Paul B Brown

The Seven Habits of Highly Effective People by Stephen R Covey

Teaching the Elephant to Dance by James A Belasco

Chapter 16

Pitching the Press

Press releases

Formatting a press release

Storyline

Meeting the press

National publicity

Everyone gets 15 minutes of fame.
Andy Warhol

PRESS RELEASES

Andy Warhol clearly understood the power of publicity. Carmen Miranda made great use of its power. This power, however, is often overlooked by artists. Artists must learn to understand the importance of "courting the press." To be the feature attraction in a positive article in your local newspaper says to the public that you are accepted. It imbeds confidence in potential buyers.

A press release is the most common source of communication with a magazine or newspaper editor. Publicity you receive from a press release is free. It will get your name out to the public.

Whenever there is a special event in your artistic career, notify the local art critics and newspapers about it. What is a special event?

In-person signing

Exhibition

Winning a prize

Receipt of a public or private commission

Tie-in with a local charity

Donation of artwork to a nonprofit organization

Teaching a course at a college

Giving a class, workshop or seminar

New method of painting you've discovered

Book you've written

Sale to a famous person

Grant award

This type of press release might lead to a review of your work by a critic, an article, or a brief blurb excerpted directly from your press release. If you do receive a review from an editor or critic, more likely than not it will be a favorable one, one which you can add to your portfolio, one that a gallery owner will notice.

Your "pitch" to the press—the press release—needs to be innovative and imaginative. Editors are bombarded by hundreds of press releases every week. Most editors complain about how incredibly b-o-r-i-n-g press releases are. You want to make your press release stand out in someone's memory.

It's okay to use gimmicks, but don't be thoughtless. You might defeat your purpose. For instance, instead of putting a dab of glitter on a letter, one artist filled her folded sheet of paper with glitter. Editors did not appreciate glitter falling in their laps when they opened the envelope.

Keep the press informed of your activities. Develop story lines to keep your local art editor (or home, house or flower editor) informed of your activities. This pays off in the long run—people start talking, and that's the best advertising.

Choose your publications carefully. Know their audience and the reason for their existence. Study back issues of publications to determine the slant, thus enabling you to understand how your subject matter can best benefit the editorial staff.

CREATE AN INTERESTING TITLE

▸ "Rags to Riches: Five years ago this artist hadn't even sold one piece. Today, his work is in the White House"

▸ "The Marriage of Venus and Mars: Two artists' creativity seems to be more powerful than ones'"

▸ "Warehouse Fire: Artist retrieves litho press and prints, but loses originals"

GIVE AN EXCLUSIVE

Tell an editor with whom you have a special relationship that you will give an exclusive on a story line.

BE COURTEOUS TO YOUR EDITORS

When they are on deadline, they can be very stressed. Before you start "chatting" with an editor, make sure she is not on deadline.

To be known as an artist, you have to put yourself in a position to be seen! You need the public to hear your name over and over again. The aim of the press release is not necessarily to make sales, but to conjure up interest, memory and acceptance of your work, and possible attendance at an exhibit.

FORMATTING A PRESS RELEASE

Keep copies of publicity photos on hand. Remember that storyline you sent your local paper? Well, it resurfaced and they want to do a short story. No time for a photographer to come out and photograph you. He needs the 5x7" sent today!

You want to look professional when you send a press release to an editor, so you're going to imitate the big pros. Follow the outline below.

For Immediate Release - These words are placed in the upper corner of a press release. Do you want this piece to run on March 29? Then note FOR RELEASE ON MARCH 29 at the top. Don't pick a very popular date, however, as there might be too much competition. Most releases say "FOR IMMEDIATE RELEASE" without a specific date.

Contact Person - Underneath "FOR IMMEDIATE RELEASE," put your name (or your publicity agent's name), phone number (even though it's on your letterhead), and, if necessary, the time of day to call. Make it as easy for the editor as you can.

Headline - You must think of a good, catchy title for your release. Make it clear and enticing. All caps and centered.

Body Copy - The 5 W's:

> **Who** - State your business name and/or personal name.
>
> **What** - Is it an opening, an exhibition, an open studio? Can you quote someone or give a testimonial from a celebrity? People love to read testimonials.
>
> **When** - State the exact hours, day of week, month, year.
>
> **Why** - The main topic of your press release: Why are you holding this event, for example?
>
> **Where** - State the exact address, city, state, zip code, telephone number and directions to an event, if necessary.

Place the symbol "# # #" at the end of your release to indicate that there is no more copy. If there is a second page, type "MORE" and continue on a second page. If you do use a second page, type "22222" (five repetitions of the number 2) at the top. You may add a note to the editor after # # # such as "Free photo upon request."

TIPS

→ Double-space with wide margins so the editors can make notes easily.

→ Make it concise—no more than one page. You are more likely to get coverage with a one-page or less press release than a two-page release. A small amount of information is easier to fit somewhere.

→ Have color photos available for magazine publicity.

→ Send B&W photos. Newspapers know their readers love to see pictures. Including a B&W photo will up your chances of getting printed by about 50%. Making it an intriguing photo will get you publicity for sure!

→ Start with local media. Cultivate the same media contacts consistently by sending updates on your career.

→ Read what your target media print. Study the publications to see what is publicized. Then write your own story.

→ Try to get publicity if you are involved with or make a donation to a charity or professional organization.

→ Get on the publicity committee of an art organization or museum. This will help you meet the press.

→ Follow up with phone calls, persistently but not harassingly.

→ Know the names of art editors and reporters.

→ Know the publicity requirements of any given publication.

→ Include correct telephone number and address in the body of the press release copy.

→ Proofread all!

COMMON ERRORS

▸ Using graphics in your press release

▸ Expecting immediate results

▸ Being a pest to the editor

▸ Sending out poorly-edited materials

▸ Exaggerating and using superlatives or too many fancy words

▸ Being intimidated. The editors need your help!

Often an editor will use your press release verbatim to fill a blank spot on his pages.

SAMPLE FORMAT FOR PRESS RELEASE

For immediate release
Contact name
Telephone number

HEADLINE TO HOOK EDITOR AND PUBLIC

Paragraph 1 The 5 W's

Paragraph 2 More details of importance to the public

Paragraph 3 Background info

Paragraph 4 Address info

###

STORYLINE

A more advanced form of a press release is called a storyline or feature story. This type of story needs a hook, or a unique angle of human interest. You need a story that is new, different, and that the general public will be interested in. Is there anything happening in the news that is a hook to what you do? A holiday or anniversary to use as a connection? Write down ideas. Brainstorm for more ideas. Don't stop at just one! Write each idea on a separate piece of paper, adding both conservative and wild ideas until you come up with the hook. These kinds of stories are often carried by large local newspapers in the Sunday edition, so go for it!

▶ One artist created her paintings in her barn, wearing gloves during the long winter months. This somewhat simple, but unusual, story got her front-page coverage in the arts section of her local newspaper.

▶ One artist sent a small bottle of "golden wine" to his local press of seven people. His exhibit was entitled, "The Gold Country." Needless to say, he got a good response! It was also easy to follow up with calls to the editor because everyone remembered his gift and welcomed his calls.

Clippings

When you get press coverage, be sure to save the clippings from the newspaper for your files. Don't, however, include the original newspaper clippings with your portable portfolio. Instead, cut out your article, along with the name of the publication (masthead) and the date. Arrange these clippings on an $8^1/_2$x11″ sheet in a nice layout. You might need to reduce or eliminate part of the newspaper copy; no one reads the entire copy. Make the piece look tidy. Make photocopies for your portfolio. These photocopies are to show those you are trying to impress—a consultant, gallery, collector—that you are well-received by the public, and indeed that you have a public! "I've gotten press! The public accepts me. I am recognized as an artist. My art is good."

If you're going to have a show, you should be doing as much PR as you can—even if your gallery is doing some.

You might want to frame some of your press clippings. Blow them up and mount them on your studio wall. It is impressive when you have an open studio.

A MEMORABLE INVITATION

Promoting an exhibition at the Columbia Museum of Art in South Carolina entitled "BURN, Artists Play with Fire." The box the press release arrived in was intriguing for a few reasons: condition (obviously smashed by the post office machines), size (it was very small at 3x5″), and weight (hardly an ounce). Opening it up was a delicate process. I discovered, wrapped in an $8^1/_2$x11″ paper with a press release, some shredded newspaper. Deeper inside was a little plastic bag full of what looked like charcoal. On the little plastic bag was a label: "This was your invitation...." A memorable invitation, needless to say. The next week a regular invitation arrived.

MEETING THE PRESS

It is infinitely better to send out publicity and not have it used than to not send it out and miss an opportunity for it to be used.

The best place to start meeting the press is right in your own home town. As your career starts, you must become familiar with the editors of your local publications, eventually meeting these editors in person through events that you attend. This will also give you a "rehearsal" period for learning how to deal with the big-time editors.

LIST OF EDITORS

Your list of editors should be compiled in a methodical manner. Knowing the editorial deadlines could be the most important point involved. Monthly and weekly magazines have longer lead times than dailies, so you will need to send them press releases earlier than to daily newspapers. This can easily be noted on your database.

Don't forget to include in your list the specialty publications in your area such as: gallery guides, shopper guides, entertainment guides, neighborhood weeklies, alternative publications, religious newsletters, sports club publications or civic publications. Because their budget and staff are limited, these smaller publications use lots of press releases.

THREE MAILINGS

It is often necessary to send editors and important reviewers three mailings.

- A press release two months before the event

- A personal invitation one month before the event

- A postcard reminder two weeks before the event

PERSONAL WALK-THROUGH

If you are sending a press release for an upcoming exhibit, a reviewer might not want to come to the actual opening. He might want to view your work in a quieter setting—before or after the opening. Some artists suggest that the reviewer contact them for a personal tour of the exhibit. You could note this on your postcard.

A phone call one week before an event can be an added incentive for an editor to respond. Even a message on an answering machine might do the trick. Taking the time to invite the editor or critic personally to your opening or event can better the chances that they review your work by 75%.

PERSISTENCE

Publicity must be constant. As one editor put it, "Think of yourself as the publicity director for a movie star." Persist, persist and then persist some more. When you continually send out new and exciting releases, it tells editors that this person means business! They'll take you more seriously.

FOLLOW-UP

▸ Try to speak to an editor personally.

▸ Try to catch an editor when he is not rushing to meet a deadline. Morning papers should be called mid-morning, afternoon papers mid-afternoon, TV after a broadcast.

▸ If they give you coverage, be sure to call and thank them, send a thank-you note, or both.

Establish a calendar for various press deadlines: daily, weekly, monthly.

I once tried to get one of the artists I represented on a special news sequence. The producer was interested, but he constantly needed to be reminded. (TV is a hectic environment.) Finally, after 10 phone calls, without our being forewarned, a camera crew showed up for six hours one day to film the artist at work in the restaurant where he was restoring the cherub murals on the ceiling. A one-minute spot was on the news that night. Later we used the tape, along with another one the artist had from years before, on a VCR at an exhibit. People were quite impressed to see him on the news.

PR PHOTOS

Providing an outstanding or unusual visual will almost always get you PR. You know the old adage, "a picture is worth a thousand words." How many of us go through the newspaper "reading" the pictures?

Send a newspaper some 5x7″ photos of your artwork. Before sending, you will need to label the backs of the photos. Do not write directly on the back as it might leave marks on the front. Write on a label, then adhere it to the back. Place the title of the photo, your name, medium, date taken, © and name of photographer who shot the photo.

BECOME "THE" ARTIST IN YOUR HOME TOWN

As a "service" to your community, write a quarterly article on art for your local newspaper or tourist magazine. Make sure you appeal to the "commoner," a person who might not know a lot about art, but who finds art and artists intriguing. Keep your articles fun, easy to read and encouraging. Over time this will give you the authority that is needed to become known as "the artist" in town. It will definitely drive traffic to your studio and web site. Couldn't be better publicity! Possible topics:

▸ How to view art more effectively

▸ The importance of art in our schools

▸ Unusual venues to view art (open studios, etc.)

▸ Encourage the spread of original art, not just posters

What happens at a gallery opening? Encourage hesitant participants to attend the local openings. Make sure you do this right before a big gallery opening in town (even if you are not an exhibiting artist), and make sure the gallery owner is aware of your article. Perhaps this will lead to you being part of the gallery stable.

RESOURCES

The Art of Self Promotion
PO Box 23, Hoboken, NJ 07030 (201) 653 0783 www.art-of-self-promotion.com
133 Tips to Promote Yourself and Your Business by Ilise Benun is a 20-page, information-packed guide with easy-to-put-into-action tips.

Publicity Hound's Tips of the Week
www.publicityhound.com
Joan Stewart provides a free e-zine on how to increase your publicity. She also has a free handy checklist, 89 Reasons to Send News Releases that can be downloaded from her web site.

Too many artists jump to regional or national promotion projects without having paid their dues with local promotion. By establishing oneself locally, confidence, clientele and experience are built. When you finally expand regionally or nationally, you will be ready to jump the hurdles that everyone experiences. National promotion is much more complicated, has more intricate politics and needs a great deal more money up-front than local promotion. Every aspect takes a lot longer.

RESEARCH

Look in your library at the most current issues of these publications:

Artist's Market

Gale Directory of Publications

International Yearbook

Media Guide

Bacon's Publicity Checker

Standard Periodical Directory

Editor and Publisher International Yearbook

Working Press of the Nation

Newsletters in Print

Oxbridge Directory of Newsletters

American Art Directory

Keep in mind your particular style, medium and subject matter when looking for a source of national publicity. Are you a painter of tulips? There are tulip societies, and thus magazines, that might be just the right place to start rounding up publicity.

When you learn about appropriate national magazines for your genre of artwork, send the editor a storyline-type press release. The key factor, remember, is the relationship between your subject matter and the needs of these editors.

Editors need news to produce their daily/weekly/monthly publications. Lots of pressure is put on editors to find new and exciting material. If you help an editor by providing him with a storyline, you'll be 100% ahead of the game. You will have a pal for life. Follow up. Remind him. Get to know him. You will get coverage.

NATIONAL PUBLICITY

Almost all artists who are selling nationally began (and are still) selling locally.

Even very famous artists go after publicity whenever they can. Rauschenberg hired a PR firm when he had a retrospective at a museum. The museum had attempted to get him some local PR, but he wanted national PR. He knew that if he spent money on PR, his name would receive more worldwide recognition.

ACTION PLAN

- ❏ Think of some storylines for press releases.
- ❏ Write a press release based on a storyline related to you.
- ❏ Write a press release based on a future exhibition.
- ❏ Compile a list of local press, noting deadlines for sending releases.
- ❏ Send a press release to the local press.
- ❏ Follow up with phone calls.

RECOMMENDED READING

Bullet-Proof News Releases by Kay Borden

Fine Art Publicity by Susan Abbott

The Fine Artist's Guide to Marketing and Self-Promotion by Julius Vitali

Getting Publicity by Tana Fletcher and Julia Rockler

Guerrilla PR by Michael Levine

Guerrilla Publicity by Rich Frishman

How to Get Results with Publicity by Communication Briefing

Marketing Without Money by Nicholas E Bade

The Publicity Manual by Kate Kelly

Writing Effective News Releases by Catherine V McIntyre

The Zen of Hype by Raleigh Pinsky

Chapter 17

Reps and Galleries

All children are artists. The trick is to remain an artist and grow up.
Pablo Picasso

TYPES OF REPS

Those who learn to take care of their own interests usually surpass the achievements of those who turn their affairs over to others.

"Where can I find a rep?" is one of the most common questions I hear from artists. Finding an active art rep can be a dream-come-true for a fine artist. Having a rep, ideally, means that the artist can concentrate on the creation of art instead of dividing time between creation and marketing.

Locating a good rep takes time. Often a rep doesn't want to take on an artist who has no experience working with people, no sales record or no previously acquired reputation.

There are several types of art world professionals who can assist artists in different ways yet often are overlooked by artists. We will define some of them here.

ART REPS

A person who generally takes on no more than five to 10 fine artists and represents their work to specific companies, galleries, publishers, etc. Sometimes a gallery acts in this capacity, or sometimes the wife, relative or friend of an artist. Most artists fantasize about having a rep, yet most do not have one. In the last several years, however, it has become a more recognized profession. It appears that in the near future the fine-art representative will be a better-known figure. For the right person, it is a lucrative and satisfying career. They often get 33-50% commission.

ART CONSULTANTS

Art consultants usually are hired or contracted by businesses or private individuals to help locate and evaluate works of art. They are in touch with a variety of people and need a variety of works. They deal actively in art—it's their livelihood. In today's market they are the most common go-between for the corporate art collection. They could be involved with new buildings, remodelling, large corporations, book publishers, art publishers, museums, private collectors, galleries, developers and planners. They often work with state and federal agencies in the Percentage for the Arts programs. Generally, each consultant has a specialty market with which he deals.

Many art consultants were art history majors in college. They are experienced in the ability to interface with client and artist and know how to orchestrate a project from conception to installation.

They often take 33-50% commission on projects. Sometimes the corporation they are working for pays them a commission; thus they buy from an artist/gallery at full retail for their clients. They make studio visits and monitor payment schedules. If there is a commissioned project, the consultant will see the project through to the end.

Artist consultants

An artist consultant assists artists, sometimes on a one-time basis, with aspects of their career: creating a marketing plan, suggesting venues or geographic areas for sales, organizing their business management, brainstorming new ideas for marketing and sales, etc.

Artist consultants will critique artwork as well as help with marketing plans and suggestions. They generally give private consultations to artists and conduct seminars and workshops.

Brokers

A person who connects a buyer and seller, perhaps at a trade show, through former connections, etc. This person does a lot of networking. Could even be an auction house. Commission varies from 15-50%.

Dealers

Sometimes a gallery owner, but may have many connections in the art world, buys and sells works privately. Commission is usually in the 40-50% range.

Managers

Managers are often paid by the hour. They might do a specific type of job for the artist: bookkeeping, managing contracts, writing contracts or grant proposals, or a variety of these, including public relations.

Publicists

Usually hired by the hour or project for promotion of a specific exhibition or museum opening. Often well-known artists will hire such an agency.

Coaches

Similar to a sports coach, these advisors stand by your side, helping you reach new goals faster, empower creativity, overcome obstacles and take action for success.

The Art of Becoming Visible
Susan Ann Darley, PO Box 1024, Sierra Madre, CA 91025 (616) 355 2753
www.empoweringartists.com

Geoffrey Gorman
2013 Kiva Rd, Santa Fe, NM 87505 (505) 982 4016
www.artistcube.com
He helps artists to define their business vision, set realistic goals, and develop structures that will support them throughout their career.

Artist Career Training for Entrepreneurial Artists
101 First St #103, Los Altos, CA 94022-2750 (650) 917 1225
www.artistcareertraining.com
Aletta de Wal helps fine artists make a better living at sellingtheir art through personal consultations, professionally designed educational programs and practical independent study products.

Molly Gordon
PO Box 195, Suquahim, WA 98392-0195 (360) 633 4397
www.authenticpromotion.com
Receive a free 32-page e-book, *Authentic Promotion: Building Purposeful Prosperity in a Professional Practice* (download at web site)

INTERIOR DESIGNERS

Many artists don't consider interior designers to be buyers of art or reps of artwork. Many love art, have an eye for it, and if they like and appreciate your art, could be just the right people to get your career going. I know several artists who work exclusively with interior designers. You might think it's always a case of matching a painting to someone's furniture—but this is just another myth. Check out interior design shows or home shows in your area. Many artists exhibit at these and make connections with designers as well as individuals interested in art.

The International Interior Design Association
 www.iida.org
Connecting with an active interior designer could bring you many sales. Interior designers must meet an increasing demand for original art in commercial and residential buildings.

American Society of Interior Designers
608 Massachusetts Ave NE, Washington, DC 20002 (202) 546 3480
www.asid.org
May have a current list of projects and firms specializing in commercial buildings. Call Washington, DC to ask for the number of your regional office of ASID. Various levels of membership are available. Publishes a quarterly magazine for members called ICON @ $12 per issue.

Some artists have given talks at ASID luncheons to introduce their artwork to the local chapter.

When professionals—like those just listed—work with you, they expect you to be professional. They want artwork finished on time and in accordance with any agreement. Of course, the more you are asking for your work, the more tolerant they seem to be toward your idiosyncrasies. Once you show you mean business by performing well and on time, they are more likely to call upon you again.

When and if you do find a good rep, you will deal with her via legal agreements. Don't think it's going to be a breeze. Pressures inevitably come when you are working in a new situation.

There is a lot of competition to win over reps and consultants. You must outshine other artists, not only in your artwork but in your professionalism:

▸ Begin with a telephone call to introduce yourself.

▸ Ask if you can send some samples of your work. Be sure to send something they will remember—something outstanding.

▸ Follow up with a friendly call to find out their response to your work. You must create rapport with each consultant.

▸ Be sure to add their names to your mailing list so that you send them notices of future exhibitions. They want to see that you are active.

WORK AS A TEAM

Even if a rep is handling your art deals, you will want to keep tabs on what is going on in the art world. So study, research and help your rep.

One artist I know sells his pieces for up to $25,000. He does have a gallery affiliation—a very well-known gallery in New York City. I asked him why he stays with a gallery that neither sells his work nor gives him a show. He stated, "It sounds good to be listed with a gallery which has prestige, but I'd rather sell my own work because I make more money. I want them around, though, for when I become famous and too busy to sell my own work. Then they will want to give me a show."

LOCATING REPS

Ask for references from other artists. Talk to several reps to get a feel for who they are and what they do. Find out their philosophy. Did they write a book or magazine articles? If they have, read them. Make sure agreements are finalized in writing. If they promise you too much, don't believe it.

ArtNetwork
www.artmarketing.com
Mailing lists of reps, consultants, dealers, brokers and corporate art consultants

APPROACHING REPS

"Should I go with this publisher, rep or gallery?" If you don't trust your dealer or gallery, you should never start working with them. Trust your heart and do your research. Go with your gut feeling. You might be wrong, but it's all you really have to go on. If you have any odd feelings about developing a new relationship with anyone in the artworld, don't do it!

Chicago Artists' Coalition
www.caconline.org
Has a list of Chicago-area reps and consultants, as well as other publications and a monthly newspaper for members

SITES TO REFERENCE

www.bob-baker.com
Articles on marketing and promotion

www.artbusinessacademy.com
Workshops for the "marketing-challenged" artist

www.art-support.com
An especially good site for photographers: portfolio guidelines, copyright info and more

www.wildlife-fantasy.com
Rebecca Kemp has a great site that promotes her artwork. It also has lots of articles to help other artists promote theirs.

You might not realize how few people walk through any given gallery in one year. Do you know how many people who like art have never been in a gallery? Start asking and you'll be surprised. Most people find galleries overbearing, stiff and snobby and don't feel comfortable being in one, let alone looking at the art and considering buying. So you're missing a huge hunk of the market if you think galleries are the only way to go.

Artists often approach galleries before their time. Most art dealers want to represent artists who have already achieved critical recognition and have a substantial number of clients.

I advise artists to search for possible galleries in a reserved manner. They are generally listed last on any of my recommendations for possible venues to show work. Unless you are the number-one person represented by the gallery, there are many drawbacks.

Galleries often don't seem to respect artists. Some pay them late, do not repair damaged artwork before returning it, and sometimes do not even return work to the artist. I cannot tell you the number of stories like this I have heard about galleries. Of course, there are some great gallery owners out there, too, but I've only heard a few stories about them.

A gallery can only promote a small number of artists at any given time. They want to promote artists whose work is the easiest to sell. If you don't fall into that category, they might just be storing your work rather than attempting to sell it.

MYTHS ABOUT GALLERIES

- ▸ Galleries make or break an artist.
- ▸ You must be represented by a gallery to be a real artist.
- ▸ Gallery owners are good businesspeople.
- ▸ Gallery owners are organized.

COMMISSIONS

So you've found the right gallery, but they want 50% of the cost of sales? Wow! You didn't know they took that much.

Remember that Open Studio you put on? Or that group show you held? Remember the cost? Generally, a gallery owner has even more costs due to higher rent, more upscale clientele, etc. So if you cringe at a 50% commission, don't even approach a gallery.

THE GALLERY SCENE

If you're an artist looking for a gallery to carry your work, you need to think creatively. What is it that will set your work apart from all the other artists searching for a gallery?

197

Your goal in sending a portfolio to a gallery is simply to get the director to your studio to view your work.

THE GALLERY SEARCH

Make a list of 20 local galleries to review. When you visit the galleries, jot down all the information you can about each one. From your research, decide what gallery you want to be in.

Focus on galleries that have proven track records and carry work compatible with your own. When it comes down to the final choice, you want to know that the gallery is going to invest in your career. If you get the gallery to commit financially—buying work, framing, spending time on an exhibit, sending press releases, etc.—you know you have a good gallery.

FACTORS TO INVESTIGATE

▶ Styles the gallery carries

▶ The price range and the career status of the artists they represent. You don't want it to be too far out of the range you are presently selling in. If they have very established artists selling for $15,000 and you are just beginning to approach galleries, is this going to work? Probably not. Generally, you have to have a similar price range.

▶ Customer service you receive as a visitor to the gallery

▶ Mood, atmosphere, lighting

▶ Location, foot traffic

▶ Verify the reliability of a gallery through the Better Business Bureau, Chamber of Commerce or Artists Equity Association in your area. Check the Better Business Bureau to see if any complaints have been filed against the gallery, and see whether they belong to the Chamber of Commerce.

▶ Get references from artists whose work the gallery is currently showing. When you give a gallery your artwork, you either want to receive the work back or the money for it!

▶ Make connections with the gallery by getting on their mailing list and attending openings. Remember, you're going to choose the gallery and sell yourself, your work and your story to them. When you know you've found the right gallery for your work, court them. Send them cards, attend openings, etc. It will take persistence—but we've already verified that persistence pays off. Ideally, a gallery owner will have seen your work in local exhibits over the past years and will know about you.

▶ When a gallery takes you on, they should give you a solo show within a year and buy at least one of your artworks. What are you there for otherwise? They are investing in you!

A good way to meet gallery owners is through charity balls or fundraising events. Gallery owners are bombarded by artists introducing themselves over the phone or in person. Show that you are involved in your community. Introducing yourself inconspicuously can be the best path to becoming acquainted with a gallery owner, museum curator, etc.

REFERENCE SOURCES

Art in America Annual Guide
575 Broadway, New York, NY 10012 (212) 941 2870
www.artinamericamagazine.com
This directory lists by state (then city): galleries, consultants, museum curators and other art world professionals. It can be found on most magazine stands in the summer months. As a subscriber to their monthly publication, you receive this annual free.

Manhattan Arts
200 E 72nd St #26L, New York, NY 10021 (212) 472 1660
www.manhattanarts.com
The Complete Guide to New York Art Galleries 6th Edition: over 1000 detailed listings.

Collectors Guide to Art of New Mexico
Wingspread Inc, PO Box 13566, Albuquerque, NM 87192 (800) 873 4278
www.collectorsguide.com
A beautiful publication listing galleries and artists in New Mexico

Art Now Gallery Guides
PO Box 5541, Clinton, NJ 08809-5541 (908) 638 5255 www.galleryguide.com
Consolidated international editions as well as regional editions.

APPROACHING A GALLERY

One of the most common complaints we hear from gallery owners is that artists come to them seeking representation before they are sufficiently prepared. Do not approach a gallery under these conditions:

▸ Too little experience—they want maturity in the work

▸ Not high-quality work

▸ No body of work to show—they want to see direction and consistency

▸ Showing work to the wrong genre of gallery, a very common error and waste of time

▸ Artist has not found his voice yet

Never go into a gallery to show your work without an appointment. Although I have heard stories where this technique worked, don't count on it! Count, instead, on points against you.

Chapter 17

Dealing with a gallery is a two-sided affair. You cannot abandon them and leave them totally to their own devices. They need to receive calls and communiques, to know you appreciate them.

After researching diligently, consider in-depth the approach you will take to each gallery. Offer the owner something unique—in quality, style of work and presentation.

- You've done your homework and should know what to show a particular owner.

- You know what your contract should say.

- You're confident, but not overly so. You come from a professional basis of wanting to work in partnership with the gallery owner. It's a win-win situation.

After your initial telephone call, you send a snazzy portfolio, different than anything they've ever seen. Show how your work is set apart from others. Adjust your basic portfolio for each gallery you contact. Be sophisticated in your presentation, as this may be the only introduction you have to the gallery. It must be coherent and consistent. If they cannot perceive quickly and easily what type of work you do, they will return it without even reviewing.

Tips

→ State briefly in your cover letter why you think the gallery is the right place for your work. Did you see an exhibit? Did someone refer you? Follow up with a call to see what the gallery owner thought of your portfolio, and, hopefully, to arrange for a studio visit.

→ Don't ask for a show or suggest that the gallery represent you. Suggest they come to your studio to view your work, even if you live out of town.

→ If you are from out of town, let them know when you will be in their area to bring by some of your pieces.

→ Never send an unlabeled slide or breakable glass slide.

→ Don't wrap slides in cardboard and then tape them shut. Simply put them in a slide sleeve.

→ Enclose a SASE for convenient return of your portfolio. Gallery owners don't like to pay for return of your slides and portfolio unless they've requested it to begin with. Include enough postage and an envelope of sufficient size to fit in all the items that you want back.

→ Give gallery owners four weeks to review your slides and get them back to you. If, by that time, they have not called or returned them in your SASE, call them, but don't be pushy.

MEETING THE GALLERY OWNER

If and when you finally do get an interview, go prepared.

- ▸ Reconfirm your appointment the day before.

- ▸ Arrive ten minutes early so you can relax.

Don't show your work to a subordinate of the gallery owner or manager. This is a waste of time. Take the attitude that you are interviewing the gallery. Do you want to work with them? Don't play the part of the desperate, struggling artist.

ITEMS TO BRING

- ▸ Portfolio and slides, original reviews, exhibit announcements, etc.

- ▸ Price list with retail prices

- ▸ Several original pieces of your work (if not too burdensome). You should be ready to leave these with the gallery owner on consignment. If you do leave any pieces, you must get a signed receipt stating the retail price to the collector, the gallery's commission, and the condition in which work was received. Bring along a consignment receipt in case the gallery owner doesn't volunteer this.

Usually you will not be accepted into a gallery on the first interview; in fact, be suspicious if that happens. Galleries need time to share their review with other gallery owners and sales personnel, see what their schedule allows, and just plain think over your work.

Even if you do get accepted into a gallery, it doesn't mean you're going to have a solo show or any type of show. If it's not in your contract, don't count on it. Artists call me very excited about their acceptance into a gallery, only to find out that they won't be receiving a solo show. Some owners get greedy and don't want the gallery down the block to show your work—so they sign you up without guaranteeing you anything, just to keep you out of the marketplace. Make sure you have a contract you understand and like.

If you are not accepted, ask for referrals. What do you have to lose? Gallery owners around town have lots of information on other gallery situations. They might send you to just the right spot, or tell you that you're not ready and why.

Should you be rejected, send a card of thanks. Maybe a handmade card will grab them and encourage them to rethink you. Be different from the other artists who just take a "no" sitting down. Show them you are still interested.

Make notes after your meeting with any gallery owner. Note your general feeling about the gallery, quality of artwork the gallery carries, price range and subject matters, your general impression of the exterior of the gallery, foot traffic, how long the gallery has been in business, quality and types of shops nearby, etc.

The business relationship between gallery and artist must be based on mutual respect and trust. If this is not the basis, you can count on it failing.

When your art is accepted by a gallery, your job is not over. You have to stay on top of the gallery to keep them promoting you. One gallery or one show isn't going to make or break your career. A career is built upon a series of exhibitions, sales, awards, and commissions.

STUDIO VISITS

If galleries are interested in your work, they will probably want to make a studio visit. If they don't invite themselves, be sure to invite them yourself. Having the gallery owner make a studio visit is better than bringing your work to the gallery. They are now making the effort to come to you and see *all* your work, your history, your story—who you are and what you create—a big coup for you.

- Give simple, clear directions to your studio. If you live in the wilderness, ask them to call you from a nearby, easy-to-find landmark, meet them there, and escort them to your studio.

- Have a tidy studio. You want them to see your work and you, not the dust and clutter you haven't cleaned for months.

- Have some refreshments available.

- Hang your best works in prominent positions. If there is anything you don't want them to see, take it completely out of the studio.

- Allow the gallery owner to conduct the interview. You are not selling at this time; you are simply showing.

- Be prepared for questions such as: your major influences, sources of imagery, medium.

- Don't answer the phone while you have someone in your studio at an appointment.

STUDIO VISIT PREP

Sometimes you have private individuals who come to your studio.

- Limit the time frame of a studio visit to no more than 30-45 minutes. If you overwhelm clients by showing them all your work, you will have tired people in front of you who don't want to buy anything, especially art.

- Ask them what work of yours they are drawn to before they arrive—a particular style, originals, prints, certain series, etc. Have that ready to show.

- Anyone making the effort to visit your studio deserves your total focus. Even if they don't buy on the first visit, you will most likely see a purchase in the future. Do not allow interruptions. Don't back out of your studio visit if you start getting stage fright. This fear goes away. It happens to Broadway performers and the like. Just go with it and overcome it.

A GALLERY PLAN

After talking to several galleries that have been in business for some time, I tried to figure out how much income they need and how much in expenses they incur. By looking at the theoretical calculations below, you, as an artist, will be able to understand more clearly why a gallery needs to receive a 50% commission on its sales. You will understand also why its salespeople must be able to sell a certain number of paintings each month, just like a car dealer, in order to make ends meet. If an artist's work is not selling, then the gallery owner must find another artist's work that will sell. It's that simple.

The following hypothetical gallery has six artists. All of them make a full-time living at creating their artwork and having their gallery, acting as their agent, sell it. In this scenario the gallery owner earns the same wage as the best-paid artist. The other salespeople are making the same wages as the five other artists. The gallery makes a profit of 4% of total sales.

Gallery income

Artist receives $75,000. This artist is more popular than the rest; thus, he creates and sells more than the other five. His retail price on a painting averages $5000. He produces and sells 30 paintings each year. $ 75,000

Five artists sell 10 paintings @ an average of $2000. Each artist makes $50,000 per year (50x$2000@50%) $250,000

Two part-time salespersons @ $25,000 (50,000)

One full-time salesperson at $50,000 (50,000)

Owner's salary at $80,000 (80,000)

Gallery expenses at $10,000 per month: rent $5000, Employee taxes $1000, advertising $1000, supplies/computer $1000, utilities/misc./interest/openings $2000 (120,000)

Profit of 4% of total sales $25,000

If you haven't noticed by now, it's a long road to winning over a gallery owner. Be patient. Many artists finally get into a well-known gallery after 20 years of emerging!

ASK THESE QUESTIONS WHEN A GALLERY SHOWS INTEREST

How long has the gallery been in business?

Does the gallery have a statement of its goals?

Who has shown in the gallery in the past?

Who handles PR for openings?

Who pays for invitations for openings?

Who pays for refreshments for openings?

When will your reception be?

Will your show be advertised?

What are deadlines for press release information?

Do they have insurance for theft, fire, flood, and handling damages?

Who pays for framing, shipping?

What is the commission on your pieces?

How and when will they pay you?

When will the work be selected for the show?

When will the announcements be sent?

When will you need to deliver your work?

What date will the show be hung?

How long will the show hang?

CONTRACTS

Even if you are having only one show at the gallery and you are not being officially represented, you need a contract. Many gallery owners don't want to sign contracts. But you do! Don't ever agree to show your work at a gallery without a contract. You are a businessperson who knows your rights. Have a contract ready. (See Chapter 4).

Make it clear in your gallery contract that it is legal for you to make sales from your studio. You have clients you have dealt with personally for years, and you still want to service their needs. If a gallery can't understand that, they are simply greedy. However, do not undersell the gallery; you sell at the same price.

INVENTORY SHEET

Include an inventory sheet in your agreement. It's not that uncommon that a gallery should suddenly claim bankruptcy, the sheriff close the doors and seize the property. Without a consignment agreement, you could have a big problem retrieving your work. Add to your original consignment agreement as necessary when you bring in new artworks and take away or sell others. A consignment agreement should list the title, medium, size, overall description, perhaps a photo, date left at gallery, name and signature of gallery owner, and your name and signature. (See *Art Office* available at www.artmarketing.com)

One artist in Florida had his work at a gallery that closed its doors suddenly due to bankruptcy, not even informing its artists of the situation. The police came in, claimed all the goods (finding no consignment agreements) and eventually auctioned off the artwork. A restaurant purchased the entire collection of one artist for quite a small sum. The artist didn't know about any of this, as he wasn't doing his part and keeping in contact with the gallery. One day he walked into the restaurant and saw all his paintings on the wall. He was quite excited—a big sale! He called his gallery only to find that they had closed due to bankruptcy. The only way he could recover his work was if you could prove that he had a consignment agreement—which he hadn't bothered to procure. He never got a cent for his pieces!

WORKING WITH A GALLERY

You must comply with the fact that the gallery receives a commission on sales you make from your studio that were referred to you from the gallery, either indirectly or directly. This is called "working with a gallery." If a collector sees your work at a gallery and traces your name through the phone book, solely to get a reduced rate, they will be sadly disappointed. Firstly, your studio price is the same as the gallery, and secondly, you know they found you via the gallery, so you will be giving the gallery their commission and must charge the full price. Can you imagine the gallery owner's surprise when this happens unbeknownst to him and you send the gallery a $1000 check? Maybe they'll finally treat you with more respect!

A consignment agreement states that art shall be held in trust for the artist's benefit and will not be subject to any claim by creditors.

205

CONSIGNMENT RECEIPT

Received from_____ Date _____

Artist name _____

Address_____

City/State/Zip_____

Telephone _____

Title_____Medium_____ Size _____

Description_____ Sale Price _____

1. _____

2. _____

3. _____

4. _____

5. _____

Anticipated pickup date _____

CONDITIONS OF CONSIGNMENT

1. Gallery agrees to insure the above artworks against loss or damage.
2. Artist shall be notified within 10 days of the sale of any artwork and receive name and address of collector with payment within 30 days of sale.
3. Artist shall receive ____ % of the sale price, gallery ____% of the sale price.
4. Artwork is being held in trust.

Dealer Name_____

Address_____

City/State/Zip_____

Telephone _____

Dealer Signature _____

Date _____

Artist Signaure _____

Date _____

UNIVERSITY GALLERIES

Many artists overlook the local college or university gallery scene, thinking it's only for students and alumni. This is far from the truth. University galleries show all types of work from all types of artists. I've known artists receiving five-digit figures for their pieces sold through university galleries.

For many patrons, a university gallery is a much more relaxing atmosphere than the sterile, commercial gallery. University galleries often are open to avant-garde and installation work also. Explore university galleries in your community. Keep your eye on the "Calls for Exhibits" posted in various art newspapers. Attend some of your local college gallery openings.

MUSEUM RENTAL GALLERIES

Many museums across the nation have a division that rents (and sometimes sells) works of emerging artists to their patrons. Check out your local museum to see if it has a rental program you can join.

Portland Art Museum
1219 SW Park Ave, Portland, OR 97205 (503) 276 4292
www.portlandartmuseum.org
Over 2000 original works in various media by local artists

MOMA/San Francisco
Ft Mason, Bldg A, San Francisco, CA 94123 (415) 441 4777
www.sfmoma.org/museumstore/artists_overview.html

FOREIGN GALLERIES

Obtaining a show in a foreign country has been achieved by many emerging artists. Probably the most difficult factor is shipping work to the country and trusting the gallery owner enough to know that it will come back if not sold.

You can approach galleries on your own via mail, e-mail or through their web site, or you can look for foreign galleries' calls for submissions or competitions. You will want to confirm all aspects of any agreement in writing, just as you have done with any US gallery.

▸ FedEx, UPS and DHL all ship overseas. Ask each what their exact requirements are—size limitations, customs costs, taxes, etc. The main thing to remember is that you need to cushion your work well.

▸ Many items for sale are taxable upon entry into a country. If you note "For display only," items most likely will not be taxed. Allow extra time for shipments to pass through customs.

ALTERNATIVE GALLERIES

Never bring your artwork or portfolio to an opening; that would be too intrusive.

RENTAL GALLERIES

You will find many advertisements, especially in major cities, for gallery space to rent. The only time you want to rent space to exhibit is when you have a large customer base in a particular area and need a place to exhibit to them. When you rent a space, you have to do all the work: invitations, PR, refreshments, much like having an open studio.

FOURTH STREET STUDIOS

When I visited the Fourth Street Gallery in Berkeley, California, located in the hub of an upscale shopping area, I was quite impressed. The idea of an "art gym" is invigorating. So much time is spent getting the body in shape and too little time getting the spirit in shape. Not only is the building that houses this gym a beautiful place in which to paint (4200 square feet with 25-foot-high ceilings with skylights), but the location is superb for attracting potential buyers of the art on display.

This is a member-created space (and almost anyone can become a member!) where members can create and sell art (the gallery taking only 20% commission to go towards gallery expenses), and network with fellow artists and the public. It operates on the same principle as a health gym, offering easels, tables and workspace.

One can even visit and paint for the day ($10) or pay a monthly fee of $150 for unlimited usage. Many discounts are given by local stores to members on framing and art supplies. Classes are available, both for members and non-members. Just like at a workout gym, you can store your equipment in a locker.

Many artists have sold several pieces of their work in the gallery, more than paying their dues.

The networking opportunities this facility creates, with its sofas, music and free coffee, is invaluable to artists who tend to hibernate in their workspace. Able to accommodate 75-100 working artists at one time. Open 10-6 daily. 1717D Fourth St, Berkeley, CA 94710

(510) 527-0600 www.fourthstreetstudio.com

The most common way an artist becomes known by a gallery is through the recommendation of a friend.

The Fine Artist Factory
474 S Raymond Ave, Pasadena, CA 91105 (626) 356 0474
www.fineartistfactory.com
Not only can you rent the gallery on a monthly basis in this upscale community, but you can also rent studio space. Seminars and lectures occur at this innovative, well-kept art space; studio rentals are available.

CO-OP GALLERY SPACES

A co-op space or gallery is an exhibition space run by a group of artists. Artists share costs of rent, sales staff, show openings, etc. Some co-op galleries are well-respected and have been around for years. Co-op galleries can be a perfect exhibition venue for emerging artists. Try to locate such a gallery in your area. Look for listings in your local art newspaper.

Opening a gallery as an individual artist is too large a task, so a cooperative gallery, even four artists working together, could create a great venue for sales. To keep the standard high, most co-op galleries jury in new members.

Often, you can join a cooperative gallery even if you don't live in the area. Most co-op galleries require monthly dues and a commitment to sit and sell for a period of time each month.

SOME FAULTS WITH COOPERATIVE GALLERIES

▸ The presentation is often haphazard; with many fingers in the pie this is not too surprising. Hire a manager/curator and make the gallery space look professional.

▸ Display of work often is not done well. Too many pieces are hanging too close together; it feels like they are stuffed in. Having one spectacular piece from each artist (perhaps a few more in the back sales room) would be more impressive. When someone is paying $500-2500 for a work of art, he wants confidence.

▸ Salesmanship often is nonexistent.

▸ Sitters often are unfamiliar with various aspects of the gallery—an artist's work, where the price list is, etc. This unfamiliarity can be disheartening when you're a customer.

ARTIST-RUN GALLERIES

Woman Made Gallery
685 N Milwaukee Ave, Chicago, IL 60622 (312) 738 0400 www.womanmade.org
Founded in 1992, supports women in the arts. Has occasional marketing workshops.

Pleiades Gallery
530 W 25th St #4Fl, New York, NY 10001-5516 (646) 230 0056
www.pleiadesgallery.com
Prestigious artist-run gallery in the heart of Chelsea gallery district. Limited number of memberships are now available. Send SASE for information.

ACTION PLAN

- ❏ Scout for a rep.
- ❏ Make a list of galleries to research in your area.
- ❏ Keep a notebook on the results of this research.
- ❏ Get on the mailing lists of galleries of interest.
- ❏ Check out alternative spaces.

RECOMMENDED READING

The Artist-Gallery Partnership, A Practical Guide to Consigning Art by Tad Crawford and Susan Mellon

Chapter 18
Shows and Fairs

Outdoor shows

Successful presentations

Selling at shows

Open Studios

Ignorance is not innocence, but sin.
Robert Browning

OUTDOOR SHOWS

Outdoor shows, if chosen wisely, can be a great sales venue for the emerging artist.

Working an art show is not necessarily easy, but then what is? Once you get the knack and find the right shows for your own artwork, you will see that they can be fun as well as financially rewarding. In fact, at some point you might be able to hire someone to help you. It is possible to make $1500-9000 and more per weekend. (If you are a smart marketer, there are after-show sales as well.) At the better shows, artworks from $1000-16,000 can sell. I know some artists who sell work priced at $9000 at outdoor shows. In order to receive these high prices, one must have a reputation or have exhibited many years at the same show.

CHOOSING THE RIGHT SHOW

The most important factor in having a successful show is choosing the right one. You will need to do some research:

▸ Attend a show as a consumer to see what is occurring.

▸ Ask artists how it's going

▸ Get their businesscards and follow-up with a call after the show. Be honest. Say you're calling to see if it's worth your while to show at the next one.

Create a calendar of upcoming shows. Start by looking in your area first. If you can't check it out personally, make sure it has a good review in one of the publications listed on the following page.

▸ Are people carrying off packages?

▸ Do artists have red dots on their pieces?

▸ What's the general atmosphere?

▸ Are artists happy? Sales up?

COSTS

Calculate your estimated costs. Are all the expenses going to be covered by the price you are charging for originals?

Booth fee

Motel

Meals

Gas

Materials such as frames, shrink-wrapping, invoices, and business cards

Sales tax reminder: If an out-of-state client buys something and you ship it to him, no sales tax is charged. If this same client takes the piece with him, you must charge sales tax.

What attracts attention at each booth? For example, mono prints priced between $50-250 sold like hotcakes at one show.

What are people buying? (Prints, originals, knickknacks, photographs)

What style of art is being sold?

How much does a booth cost?

How many people are expected to attend?

What kind of sales has this show generated for past exhibitors?

What happens in bad weather?

What protection do you receive for displays left overnight?

Can you demonstrate a creative technique during the show?

Are your prices right for that show?

FINDING A SHOW

Local arts councils and art organizations often sponsor summer shows.

ArtFair SourceBook
(800) 358 2045 (503) 331 0455 www.artfairsourcebook.com
Rates the top 300 art shows in the US

Harris List
(719) 742 3146 www.harrislist.com
Lists and rates top 150 shows. $65 subscription. Consulting services.

Sunshine Artist
(407) 648 7479 www.sunshineartist.com
Each year, this magazine lists the top 100 fine-art shows across the nation (as rated by subscribers).

APPLYING TO SHOWS

As you begin to apply to the art shows of your choice, you might find that the better shows have a lot of competition to get a booth. These shows are also juried (although artists from previous years may be given priority). To improve your odds of being accepted, you must remember that the judges are seeing only your slides or jpgs, not your original work.

▸ Many pieces can look wonderful in person, but on a slide they lose impact. Don't send slides of this type of work.

▸ Mark slides clearly and exactly as the show promoters request. Follow the prospectus instructions verbatim.

Most customers at fine art shows are people who do not like to go into galleries. Many like to have a more personal connection to the artist from whom they are buying.

Look for a show that is referred to as a "fine art show," not a craft fair.

When you decide to apply to any particular show and are accepted, make it a goal to reapply for five consecutive years. You need to show consistency to those same customers walking around each year. Create credibility. If you've researched and chosen your show well, you will see better and better results each year.

- Try to choose slides that show the individuality and originality of your work, selecting subjects that are not frequently portrayed.

- Don't vary your style, medium or color too dramatically. Technical mastery is not what you are trying to show in your slides. You are trying to emphasize overall effect to an audience.

REJECTIONS

If you are rejected, try to find out why.

- Was the number of applicants exceedingly high?

- Was it the quality of your work?

- The quality of your slides?

TRADE SHOWS

A trade show is where people in a particular trade—art, auto, buttons, cosmetics, etc.—set up a booth with products for that trade. There are quite a few upscale art trade shows around the country: ArtExpo LA, ArtExpo NY, Art Chicago, Art Miami, Modernism, as well as others worldwide. Most emerging artists do not exhibit at these shows. The mainstay of the exhibitors are high-end art publishers and galleries.

Sometimes, however, you will find established regional artists who are branching out into national exhibitions. These shows are no small event and need considerable planning and bucks. Booths generally run $2000⁺. Transportation for yourself and your artwork, hotel and dining costs, setup at the show, etc., all add up to big costs.

SCOUTING

As an actively marketing artist, you should attempt to *attend* one of these shows as a *viewer*. You will make observations about marketing, brochures, displays, sales techniques and trends in the marketplace. You will also be able to learn what errors the exhibitors make in their presentations and learn how not to do the same.

Don't be closed to new ideas about where to exhibit. There are shows to sell prints, flowers, garden accessories, home decor, furniture, gifts, and wildlife art, as well as many, many more. Be inventive!

SASE: Self-addressed stamped envelope

THREE INNOVATIVE SHOWS

An artist who loved to paint orchids approached the producer of his local orchid trade show to rent a booth space. When the presenter found out he was an artist, not a grower, he refused to have him participate. The artist was determined, however, and explained to the presenter the possibilities for him. Finally, he was given a "test" booth. The test went off very well. The artist sold many orchid portraits and gained many new clients. He does the show annually now and has one of the most popular booths there. Take a risk! Go for it if you have a good idea.

What is a fine artist doing at an office supply show? He's taking a risk—a risk that turned out to be a good one! One artist decided to reach the business world by sitting at a booth in an office supply and furniture show. He was going to sell prints as well as originals, and possibly try to lease his original work to prospective clients. His main intent was to get names to follow up with after the local show was over. It worked. He became known within the business community in his area. Word gets around fast!

One artist started her career by showing and demonstrating at her local home show. It was a lot of tough work, setting up, sitting there for the entire weekend, dealing with people's comments. She decided that painting would be a good buffer zone for her, so she did demonstrations while the public watched. She's now gone on to bigger and better things.

SUCCESSFUL PRESENTATIONS

When you decide to do a show, don't plan to party or socialize in the evening. You need to eat, rest and relax so you can center your energies for the next day. It does take a lot of energy to spend the entire day "on the floor." Having a winning attitude is a necessity, and it's not easy if you're tired, hungover, or just not feeling confident.

So you've been accepted to the number-one show on your list. Now you actually have to face the crowds. Your presentation could be the most important part of your show.

- Do you need a table and chair?

- What kind of backdrop will you display your work on?

- You will need a sales receipt book, perhaps some change, a large inventory of your work, printed literature, and a method to record the names and addresses of interested browsers.

- Will you be painting on the scene? Some artists find it easier to paint in front of people than to chat with them!

Each show presenter will inform you of what type of equipment you need for exhibiting. Many artists use canopies, not only to protect their paintings but to protect themselves from weather elements. Some bring easels and display their work on them. Generally, you won't have more than a 10x10' area to display your work.

POINTERS

→ Be well-groomed.

→ Arrive during the allotted time. Never break down your display until the show has ended.

→ Make your booth welcoming for people.

→ Design a display that is lightweight and easy to assemble and disassemble. Have a professional-looking booth.

→ If you have assistance from a friend, relative or mate, this lends support and relief. It's important to your mental health to rejuvenate and take breaks. People are hard to deal with. Some are very snooty, sassy, unintelligent, mean, nasty—all the adjectives we can think of. Remember, you are an actor and you are trying to deliver your lines the way you studied them.

→ Take time to eat, but not in the booth. Lots of shows have volunteer relief workers to give artists periodic breaks.

→ Walk the show to check out the competition. Trend-watch.

→ Keep an even keel emotionally and physically.

→ Have a price range of items from $50 up.

→ When pricing your work, write the price large enough on the tag that it is very easy to read. Why would you want to hide a price?

→ Start up a conversation: "Do you collect art?"

→ If you've calculated the price to be $784 . . . list that as the price. Unusual pricing will show intention. If you've calculated the price to be $1034, it might be better to put it at $992 or something below $1000. Experiment and verify.

→ Make yourself available; do not sit in the back of the booth.

→ Do not eat or read in the booth. Your duty is to work the public.

→ Open your booth, i.e., do not have the front of the booth blocked with tables or chairs. Make for easy access in and out.

→ Be sure you have comfortable shoes, fresh breath and a good diet during the show so you will feel your best.

→ Plan to take two days off after the show. Treat yourself to a massage or something relaxing, or you will come to hate doing shows.

→ Wear a name tag.

→ Watch the amount of time you spend with any given person; there are yackers and there are buyers.

→ If two people are working the booth, never interrupt your associate unless requested. Let him do his own job. If you have a comment, save it for later.

→ Read *Selling Art 101* (www.artmarketing.com). Practice some of the scripts. Be prepared to sell!

SHOW SUPPLIES

Lots of business cards	Brochures and giveaways
Guest book or signup sheet	Sales tax certificate
Sales receipt books	Pens
Table and chair	Inventory of work
Change/coins	Care list for clients who purchase
Red dots for sold pieces	Packaging for purchases
Credit card equipment	Calculator

▸ Label your work with price, medium if necessary, and "original" or "limited edition." This clarifies to the customer what he is looking at. Have extra labels nd price tags.

▸ Signs such as "Personal Checks Accepted," "VISA/MC/AmEx Accepted," "Free Local Delivery," etc.

Consider having prints made for ready-made frames for the $75-100 price range.

Sometimes people don't know that they need or want something. It's your job to tell them why they want your art. Unless you know the benefits and believe in them, you won't be able to convince anyone else.

SELLING AT SHOWS

Many people who are buying at these shows might be first-time art buyers, and thus a bit insecure.

Any sales approach could work—but it must be yours, i.e., not phony. You don't have to change your personality. You do have to think about your approach. Watch yourself acting. Isn't all of life a stage? Think of being on stage at your local outdoor fine-art show.

You can gain the confidence of passersby by showing that other people and companies have purchased from you in the past. Create a portfolio you can set on a table for people to look through. Validate yourself and your career. If you have work exhibited in a magazine or book, put that out. If you've given to charity, make it clear, such as "original artwork donated to Wildlife Foundation." People like that. It's also an icebreaker.

You are selling an overall appearance and "story." These locals want to know that you will be back next year. They want to know they are not being ripped off. They want to have their friends over to their home to show them the wonderful artwork they purchased.

DEALING WITH PEOPLE

All people walking by are potential customers. Treat them equally! Use no excuses: She's wearing clothes from K-Mart; she bites her fingernails; she can't have enough money for my artwork; it looks like he's tagging along with his girlfriend. When you start hearing yourself saying these things, it's time to take a break.

Make a list of "lines" you can use and try them out. Study *Selling Art 101* (www.artmarketing.com). Follow the author's suggestions. If they're never successful, then delete them from your repertoire!

When someone is glancing for a while at your pieces, walk up casually and say jokingly, "Which one did you say you wanted shipped to your office?" Look at their reaction. Perhaps you want to add, "Or would you prefer me to deliver it and help hang it for you? I offer a variety of options—just let me know!" Maybe you need to add, "I'm going to be in the area for a couple days between shows because XYZ company is having me help hang a couple pieces and I have one more resident I have to visit." You're telling him that you offer service. He will like that. He will also like that other customers say you're "okay."

GUARANTEE

Let your potential customers know that your work is guaranteed. If the client is not happy with his piece when he arrives home with it, he can return it. Give a time limit for this. If it should happen that someone is disappointed, have him ship the artwork back to you; be sure to instruct him how. Better yet, make an appointment to pick it up. Tell him you will bring some different paintings. Most likely he doesn't have quite enough confidence yet about buying a piece, but you will be able to help instill confidence in his decision. Perhaps there is an outside objection: His wife was surprised that he spent $300 on a painting when she would rather have purchased a dress.

If they don't like your personality, they won't buy your artwork. It's that simple!

One of the best lines I ever heard while perusing an outdoor fine-art show came from the wife of the artist, an artist who did rather large pieces. "How much space do you have on your walls?" I was so shocked by the unusual question that I didn't have an immediate response. I just sort of giggled. She went on to show me some of the smaller pieces she had in the back. This was a good tactic, even though she didn't know what my objections were. In my case they were not size or price—I just didn't like the work that much.

I went to the Sausalito Fine Art Show about three hours after it started on the first day of a three-day event. One of the first booths I came to was a corner booth, set up very nicely, showing pleasantly framed watercolor florals. The most prominent art piece had a red dot on it, indicating that it had sold. I thought, "Gee, already sold! Hmmm." I looked further in the booth, and yet another and still a third had red dots. I was really impressed for only three hours of sales time. These pieces were in the $900-1200 range. I thought that she just placed these red dots on her paintings to make her look popular. But, as I was exploring her booth further, a man dragged his wife up to look at a $900 painting. They chatted a bit and decided within 45 seconds that they would buy the piece. Well, I realized then that this lady was for real. Her pieces had sold.

MERCHANT STATUS

If you are doing business at outdoor shows, it is imperative for you to get merchant status from your local bank. Merchant status means that you will be able to accept credit cards. If you have a long-standing relationship with your bank, it shouldn't be difficult. If you do apply:

▸ List your studio address (hopefully it's different from home) as your place of business.

▸ Tell them you want it for outdoor art shows.

▸ Be aware that between 3-5% of the charge will be taken out as a service fee.

TIPS

→ Be aggressively friendly. If you appear to have shocked someone unpleasantly, back off.

→ A strong advantage can be humor. Humor will break down almost any tense buyer into a more relaxed prospect.

→ Give attention to all, but focus on the most active 20%.

→ Some prospective clients are knowledgeable, while others know nothing about art. Be sensitive to the different levels of development.

→ Do something different: Demonstrate your work, run a contest, have a story!

→ Be yourself. Be prepared to give of yourself.

→ Brace yourself for negative feedback. There's always a percentage of people who will criticize.

→ Stories are fun—and your clients do want to be entertained! Stories should be short and to the point.

→ Information is good: Tell them how a serigraph is made, but make it brief. Other customers need attention. Be aware of when you need to excuse yourself.

→ Watch body language. You want your potential client to open up to you. Get him to unfold those arms.

→ Make eye contact with your customers. They'll trust you more.

→ Pay attention to constructive comments made by potential customers. Don't heed the person who is expressing his vanity.

→ Talk to people on their terms—no buzz words or art slang, just normal talk. If you use slang they don't understand, their ego will deflate.

→ Bring a stack of index cards and have people sign up for a drawing. Give away a print, a mug, a tile. This way you can get their address and e-mail for future communication.

Once the customer has decided to buy, tempt him to go on a buying binge by offering the companion piece at a 10% discount.

CITYWIDE OPEN STUDIOS

Citywide Open Studios, one of the two types of "Open Studios" occurring for artists these days—the type sponsored by a high-profile local art organization— reports excellent sales throughout the U.S.

Find out when Open Studios are happening in your community and attempt to take part. If you don't think you have an appropriate studio, business patrons often let artists set up an exhibition in their facility.

Even though the group sponsoring the Citywide Open Studio might be planning the publicity, you will also need to do a lot of planning to make it a success. Let the press know how your studio will be special during this event. Entice the public to your studio. Send out postcards. Often, the arts organization provides you with some extra postcards they've printed. You can also provide them with your patrons' names for mailings.

PERSONAL OPEN STUDIO

The second type of Open Sudio is when an artist holds one on his own. That means he does the publicity and invites present and potential clients at a particular time on a particular day. One artist I know holds an Open Studio the first Sunday of each month. Review Chapter 7 for assistance in your planning.

ON TOUR

In some communities, you can be listed as part of a cultural attraction. Consider forming a group with other artists who want to advertise specifically to tourists. Perhaps together you can produce a brochure to leave at all the tourist attractions, B&B's, hotels, motels, etc. in town. Contact your local tour bus guides and introduce them to your studio.

TIPS

→ Have excellent road signs if you invite potential clients to your studio/home.

→ If you have children or pets, find a baby-sitter (outside of your studio) for them.

→ Encourage people to sign your guest book so you can continue mailing to them. Have printed material for guests to take with them: a color postcard, business card with image of your work, a bio or statement and your price list, all with your name, address, telephone, and URL on them.

→ Emphasize tax deductions for business buyers. Artworks can often be deducted as office decor if the price is under $5,000.

→ Have a special desk set up for sales purposes with sales invoices, flowers, and a chair on each side for completing the transaction.

OPEN STUDIOS

Check local magazines to see if there is someone who gives organized tours of artists' studios. Sometimes museums do this. Try to become part of your town's art tour.

→ Hire a salesperson; ask your local arts council for a reference; go to a local tourist gallery to find a part-time salesperson who wants to make some extra money; find a friend who's a good salesperson. Hire her for the opening. Make sure you are comfortable with the salesperson's selling style—everyone is different. Educate the salesperson in detail before the event as to options for taking a piece on approval, lease programs, patron programs, and discounts for purchasing two pieces at the same time.

→ Present various sizes and prices of pieces—prints if you have them, both unframed and framed. You want to hit all price ranges. Have one original piece priced high above the others.

→ Put the price on the artwork or on the tag that accompanies it.

→ When a purchase is made and the person plans to pick it up later, put a red-dot sticker on its tag to indicate "sold."

→ Have packaging materials ready in one corner of the room for carry-out purchases (bubble bags, tape, stapler). Perhaps you can get a friend to do this packaging for you.

→ Don't say anything negative about anything!

→ Be strong in all your statements. Create no doubts.

→ Know when to stop talking. When someone is reaching for her checkbook, do not say another word. Let her say the next thing. Silence is golden at this moment. This is extremely hard for even good salespeople to remember!

PRE-EXHIBITION OFFER

One artist uses a pre-exhibition sale offer. When she sends out her first invitation for her show, she entices collectors to come to her studio for a private showing before the actual show date. She offers them a 10% discount. She also lets buyers know that she will be exhibiting the work they purchased throughout the entirety of the show. Thus, when her opening occurs, she will already have sold some pieces. You know how impressive it is to see red "sold" dots on pieces on the opening night of a show!

OPEN STUDIO GIVEAWAY

Get four or five artists together for a group Open Studio show. Share expenses. Plan a four-hour studio opening. With all participants sending out invitations to potential and former clients, you could end up with a turnout of 250 or more.

For many people, an event on Friday after work is convenient, fun and a nice way to start the weekend. Choose the least difficult time for your clients to stop by. Sometimes Sunday afternoons can be great, but when people get to relaxing on a weekend, they might not want to get "decent" and go out! Consider all the possibilities for the best turnout. Perhaps an entire weekend event would be best.

What one group of artists did, rather spontaneously, at one of these group shows was to give away ceramic rats—funny-looking rat heads with comical noses and whiskers—that one of them had made. The artist was tired of storing them in her studio, so she made a sign saying that any sale over $50 (from any of the artists involved) qualified the buyer for a free rat. Every time a sale over $50 happened, an *AOOOGA* horn sounded and everyone cheered. The happy buyer was thrilled to have a gift. Soon all 20 rats were gone, and they were replaced with cat heads holding mice in their mouths.

Like a gallery, you want the level of excitement at your studio to be elevated during an Open Studio event.

▸ Make sure your choice of music is intentional. If you play Brahms lullabies, you might lull people to sleep.

▸ Do not get into a deep conversation with one customer. Many others will be floating through and you will miss them. People love to try to entice artists into a long conversation, but don't fall for it. Learn (and it does take practice) how to gracefully excuse yourself if this situation does happen.

▸ If nothing much is happening during your event, start moving your pieces around on the wall. See which looks best where. Ask some of your visitors. Get them involved. They will love it!

ACTION PLAN

❏ Make a schedule of fine-art outdoor shows to visit this summer.

❏ Decide on two shows to do for the next five years.

❏ Apply to five shows, so if not accepted at the first choices, you have some alternatives.

❏ When accepted, start preparing sketches of the booth and gathering materials necessary to the show.

❏ Plan to visit some upscale art trade shows.

❏ Check out the marketplace for other types of trade shows.

❏ Hold an Open Studio event.

RECOMMENDED READING

Exhibit Marketing by Edward A Chapman Jr

Trade Show Exhibiting by Diane Weintraub

Chapter 19

Locating New Markets

Competitions

Publicly-funded programs

Community involvement

Museums

Religious markets

Animals

Businesses

Architects

Private collectors

Portraits

The superior man is modest in his speech but exceeds in his actions.

Confucius

COMPETITIONS

Prospectus/pros = a brochure that lists the details about a competition, event or show. SASE = self-addressed stamped envelope, sometimes called "sassy" by the uninitiated.

Competitions, both for emerging and established artists, occur quite regularly. Many organizations, galleries and magazines sponsor competitions. A competition can be juried or nonjuried (without any judges involved). Winning a juried competition is a prestigious occurrence. A winner of a competition could receive an exhibit, entry into a book, a monetary award, publicity, an article, sales or other awards.

Entering and winning a juried competition can be a good way to gain public recognition. It can lend prestige and authority to your work. It will also bring your work to the attention of curators, critics, dealers and collectors who visit juried exhibitions.

Dali entered contests from the age of 12—and won most of them.

The sponsoring organization, university, museum or civic group generally charges an entry fee for the competition. Fees go to the production of the show, to the awards being offered, or to pay for the jurors. Jurors sometimes volunteer their time but most commonly are paid a fee.

Being juried into a show can help to start building your resume. It shows gallery owners, consultants and collectors that you are active, that people are reacting to your work, and that you are going somewhere with your career. If you win an award, you can list it under "Awards and Honors." Gallery owners will be impressed by the entries on your resume that were judged by established members of the art profession, so list the juror if you do win a competition.

LOCATING COMPETITIONS

The classified sections of local and national art publications list many competitions, both regional and national. If there are any local competitions of particular interest to you, mark them on your calendar so you can visit them to see the results of the jurying—the year prior to applying. A preview like this will help you prepare for the next year's show. Keep in mind, however, that every juror is somewhat subjective, so styles and subject preferences can change from year to year and juror to juror.

Apply to local shows first. If there is a competition for a specific subject matter or style that you do, then extend your geographic limit. Go national only after you have explored many shows, know a little about the history of any given show, and have won some local competitions.

TIPS

→ Prepare good-quality duplicate slides for sending to competitions.

→ Don't enter every competition. Be selective.

Competition deadlines are often extended. Call to verify.

→ Museum competitions, or competitions with museum curators acting as jurors, can be a good introduction to the museum world for your work.

→ Set a monthly limit on how much you are willing to spend to enter shows. Keep in mind the costs for entry fees, as well as slides, shipping, packing.

→ Read the prospectus carefully. They might not return slides, they might return slides only if you send a SASE, they might only accept works completed in the last two years, etc.

→ Shows that take a commission on sales are good. That way they have initiative to sell!

ASK BEFORE APPLYING

▸ The number of entries the previous year versus the number of works selected

▸ What percentage of last year's works sold?

▸ Is there a sales force on-site at the opening and throughout the exhibition?

▸ How is the show advertised to the buying public?

▸ Who pays for shipping if artwork is accepted?

▸ Who is the juror? Look in *Art in America Annual Guide* if you are not familiar with the juror's name. Perhaps you can find her listed there.

▸ Will printed price lists and information on artists be available to the public?

A jury's decision is based solely on the 35mm or jpg representation of your work. It is imperative that your slides or jpgs show well on a computer screen.

ARTS FOR THE PARKS

"Arts for the Parks" is one of the top juried shows in the nation, with awards totalling $62,000 and a grand prize of $50,000. One hundred pieces are chosen to travel across the country each year. Various museums showcase the exhibit with openings and promotional talks. Most of the 100 pieces are sold—if not prior to the tour, during the tour. The goal of this competition is to enhance public awareness and support of National Parks while showcasing the creative efforts of artists. Call (800) 553 2787 for more information. www.artsfortheparks.com

It is shows like "Arts for the Parks"—ones with notoriety and high monetary awards and sales—that you are ultimately looking for. Not all of them will be this grand (be wary if they sound too good), but you want a show that has sales, awards and plenty of exposure.

Whether you win a competition or not, try to attend the exhibit. Why was your work not selected? Sometimes there is absolutely no way for you to know. Other times you can see that the jurors had a specific idea of what they were looking for, very different from your style of work.

I attended an exhibit at Portland Museum in Oregon. The winners' works were hanging in the gallery. In a small room off to the side, slides were being shown of *all* the entrants' works, whether they were accepted into the show or not. This was very educational. Too bad not all competitions can't have this type of display.

RESOURCE

Juried Art Exhibitions: Ethical Guidelines and Practical Applications
www.caconline.org
A booklet that will help you plan a competition

INSIDE THE JURY PROCESS

A jury seeks a consistent vision or aesthetic in the visual work from an artist. Jurors judge on the basis of originality, craftsmanship, style, composition, inspiration. Samples of your work that are synergistic are the best choice for sending to a competition. They will have a stronger impact. Generally, jurors sit in a darkened room with a note pad. They don't know the title of the piece, nor the artist's name. The juror only sees the artwork. All five pieces from the same artist are projected at the same time. What effect do they have together? Try it with your own slides and see!

→ Keep an inventory of what you send and where. Use a notebook for organizing (see ART OFFICE available at www.artmarketing.com).

→ File applications not yet sent by the due date. This way you won't be sending payments in advance or late.

If you lose every competition you enter, it doesn't necessarily mean you aren't ready for the marketplace. I would suggest a consultation with an artist consultant if this happens; tell her the problem and see if she can find the flaw. Perhaps it is your presentation. Perhaps it is your style or subject matter. She can give you more guidance and, hopefully, direct you to better results.

→ Put yourself in a juror's shoes. If you were reviewing 3000 slides for a show, would you pick one of yours?

→ Look at your slides. Are they clear, sharp, distinct, color-correct, powerful? To outdo 2999 other slides, they have to be all that, as well as innovative, creative, and well-executed. If the piece is out-of-square, it indicates that the artist is not up-to-par on his photography skills. Such a flaw doesn't always eliminate a piece, but when something is awry it will invite more scrutiny. If it is too dark to view without squinting, it might be eliminated in a wisp.

When I review slides for the cover of the LIVING ARTISTS biannual directory, I first eliminate those slides that fail at all or some of the above aspects: boring, topic is seen too often, not powerful, too common, photographed poorly, etc. About 75% get put into this pile. It is that easy to eliminate three-fourths of the slides that come in. The 25% that initially don't get rejected are usually of high quality. It often is very hard to choose the "best" one from the group. So when I do choose the final winners, some of the 25% are really just unlucky—they were very close to winning.

PUBLICLY-FUNDED PROGRAMS

Arts councils are funded by federal, state, county or city government, as well as by private donation. Arts councils were created to bring more art into the general public's view: performing art, visual art, music, etc. It's important to get to know your local arts council's visual art director. Community-wise, they can be helpful to your career, leading to local collectors, possible exhibition venues, recommendations of all sorts, etc. They, of course, want to know that you are a serious artist and have quality work. Arts councils often sponsor seminars, have gallery space available to artists, and keep slide registries, as well as other activities for an artist's benefit.

PERCENTAGE-FOR-THE-ARTS PROGRAM

Most states have a "Percentage for the Arts" program, often managed by the local or state arts council. This is a program that requires a percentage of the construction budget of any new public building to be applied toward art. Sometimes called an "Art in Public Places Program," it is meant to enhance the environment through works of art while creating a relationship between artist and community. Keep current on "Percentage for the Arts Programs" by reading listings in weekly art publications or by calling arts councils directly and asking to be put on their mailing list for such notification.

Selection procedures for "Percentage for the Arts" programs vary. They may include:

- Direct purchase by jury or panel

- Invitational projects. By using a slide registry, the panel selects only one artist to draw up a proposal, and if it is accepted, the artist receives the commission.

- Limited competition. Several artists are invited to compete by drawing up a proposal.

- Open competition

Public Art Review
(651) 641 1128 www.publicartreview.org
A publication about public art

GOVERNMENT BUILDINGS

The Russell Senate Building in Washington, DC sponsors shows. You must get a US Senator to sponsor your work. Call your local US Senator.

SLIDE REGISTRIES

A slide registry is a place where artists' slides are kept on file. Reps, consultants, architects, and designers visit community slide registries to locate artists who do particular types of work for projects they are working on. You can be listed in slide registries outside your local area also. Many consultants find artists from different regions in this manner. Some slide registries are juried, some are not. Some slide registries charge a fee to be listed, some do not. For invitational projects at arts councils, you will want to submit slides of your recent work to selected slide registries.

ART IN EMBASSIES/AIEP

Though many citizens have never heard of it, this program is over 30 years old! Placements are made in US Embassy offices and homes around the world, providing excellent exposure for artwork to various dignitaries, including political, government and state officials. Work must be available for travel for three years but is often purchased at the end of the loan period.

US Department of State
AIEP, 2201 C St NW #B258, Washington, DC 20520-0258 www.state.gov

ART-IN-ARCHITECTURE/AIA

The General Services Administration and the Department of Veterans Affairs, both federal agencies, have Art-in-Architecture programs for their buildings nationwide and maintain their own slide registries.

General Services Administration
AIA, 1800 "F" St NW, Washington, DC 20405 (202) 501 1554 www.gsa.gov

President Clinton was presented with a silkscreen of Roy Lichtenstein's "Composition III" by Friends of Art and Preservation in Embassies/FAPE. The signed and numbered edition of 175 was donated to FAPE and the "Art in the Embassies Program." Prints will be placed in each of the US Embassies worldwide. Can you imagine what publicity over the years this will bring Lichtenstein? Some of these people have never seen or heard of him!

COMMUNITY INVOLVEMENT

These days, many nonprofit organizations and artists work together in their promotion efforts—Sierra Club, Harlem Theatre, KQED TV, local Little League, Brooklyn Art Museum, and many thousands more across the nation. For all parties involved, this becomes a win-win situation. The key is to find the right organization for your style of work. Ultimately you can receive lots of publicity,

CASE IN POINT

An artist called me one day to ask for a short consultation. He wanted to know what I thought of an idea he had to take a painting he had created (which I had never seen) to a meeting of the Brothers of the Temple, an organization similar to the Elks Club. He wanted to raise funds for prints of this piece by having members of the organization buy prints at a special pre-publication price. He thought the members would like his painting enough to participate in this venture. I thought it was an innovative approach. Two weeks later, he called back to report the news. He had arranged to do a sales pitch at their meeting, bringing the original artwork. Not only did the members buy enough pre-publication prints to support his printing, leaving him with several hundred copies more to sell, but they bought the original painting as well. What a coup! I told him to keep up the good work and find another, similar organization, perhaps a few townships away, create another painting, and do the same sales pitch. Take the ball and run with it!

Another artist liked to do historical paintings. She took it upon herself to do a large mural-type painting of her town's history, which she had studied thoroughly. After completing the piece, she decided to try to sell it to her City Council. After much red tape, prints were made by the City Council and sold as a fund-raiser (of which she received a nice royalty), and they eventually bought her piece (due to her lack of experience, without signed agreement) for a price less than what she had thought they originally agreed upon. All in all, though, this venture was a great success. She made a royalty on the prints, got great publicity in the town, sold her original work and had extra prints to sell on her own. Her job then was to go to the next township and propose a similar fund-raising event to them, promoting the success of her first fund-raiser. This time she would make sure she had a signed contract from the start.

Sculptor Richard MacDonald donated a 22-foot monument portraying an Olympic gymnast to the state of Georgia for the 1996 games. He took full advantage of this opportunity and received a lot of free publicity. I'm certain he also got many sales. He is now a much more common name, not only to the American public but to the world. A great investment for the long-term goals of his career!

NONPROFIT WIN-WIN

I constantly advocate to artists, "You don't need a gallery to make it as an artist."

It has been proven to me once again that this philosophy is sound. I was recently told an innovative way to work with nonprofit charitable organizations. Think about the following method, adapt it to your own artwork, your own needs, and then let us know what you cooked up!

Find a nonprofit that you would like to work with, i.e., one whose cause you feel passionate about (cancer research, animal shelter, AIDS, whales, the rain forest, etc.). Since you will be networking amongst their most active constituents, it is important that you learn a little history about the organization as well as its mission statement.

After studying the organization's history, prepare a simple outline in writing. Eventually you will be proposing this well-thought-out idea to someone at the organization, or you might be sending the proposal in writing. Brainstorm with yourself, friends and family about your various ideas and get their feedback, especially on your first proposal.

PROPOSE A FUND-RAISING EVENT

Most charitable foundations have an annual or semiannual fund-raiser. You will offer to help raise funds by auctioning a painting, selling prints and having a gala gallery event. You propose that they buy a painting of yours to auction, giving them a 50% discount off your retail price. Chances are they will sell it for the retail amount, and hopefully more. Along with offering the organization one of your beautiful originals, you can offer them the onetime right to reproduce a print of it for a fee. Of course this fee will depend on the number of prints they plan to produce; thus, you will need to know the size of the organization's membership. You would include the image's usage for their postcard or invitation free of charge, of course, promoting your work's image too!

If, for instance, they are a 5000-member organization, perhaps they have 500 active members. This is the type of information you will need to find out in order to make a valid proposal to them. If the above stats are correct, they could easily estimate to sell 100 posters, perhaps 200-300 or more depending on the price. Perhaps they will plan to use it as a giveaway for new members in the following year. Let's say they plan to print 500 posters. They plan to sell them for $25. You have also suggested they print 10% as limited-edition giclées—50 signed and numbered giclées at $250. That's a total of $25,000 income value. You should request approximately 10% of that or $2500 for reproduction rights.

The fund-raising event could be a Sunday afternoon tea with strawberries and cream and a gallery exhibit costing each participant $25-50; it could be a sit-down dinner at $250 a seat. They should calculate and manage this part of the event by themselves, from past experience. In essence, that part of the event should already have a 50% profit margin.

Consider in your proposal what they have succeeded with in the past and who their constituents are—that is, what they can afford and what they would like. One of the main draws of your offering is the auction and your gallery show. After all, they will be receiving 50% of all your sales from the exhibition, and if anyone buys afterwards from their organization, you can offer them the same percentage. This is, after all, what galleries take for a commission. In this situation, you become the boss and have a lot more power (and more responsibilities), you know where and by whom your painting was purchased, and you get paid on time because you see to it that nothing is delivered until it is paid for in full—although you can use a layaway plan or patron plan. If your paintings sell for $1200-$3000 and you sell four paintings, that could be $10,000—$5K for you and $5K for them.

You will have a guest book out and will meet many potential patrons, patrons who could, logically, be long-time customers (and donors to the organization)!

Profits for you from this event could be $10,500 . . . possibly more if your sales are higher. Hire a salesperson for the evening. Better yet, get an experienced volunteer from the organization!

Other expenses they encounter are normal to their annual fund-raising: printing envelopes and invitation cards, decorating, etc. Income from entry ticket sales will offset those expenses. In essence, the gallery show is an added benefit and profit.

You will want to put some legwork into the project—help with organization and setup to make the event spectacular. Before you make your final proposal to them, make sure you do some research:

▸ How much money do they usually raise?

▸ How much do they ideally want to raise?

▸ What kind of event do they normally have?

▸ How many members do they presently have? How many are active?

Answers to these questions will determine what you ultimately offer them regarding the cost of your original, how many prints to run, and how much money they have the potential to make. Be sure to show them actual profit possibilities. And show them you are there to help!

DONATIONS TO AUCTIONS

At some point in your career, you will probably be asked to donate a piece of artwork to a particular charity for an auction fund-raiser. Auctions have been taking place for decades—a great fund-raiser for an organization. But what about the artist who is donating?

The first few inquiries you receive for a donation will pump up your ego. When you become known for giving in your community, you might receive as many as five calls a month for donations. At some point you will have to set limits.

Require the organization to:

▸ Set a bottom limit on your auction price. If it doesn't sell for that minimum, you receive it back.

▸ Inform you of the price it sold for as well as the buyer's name and address.

▸ Pay for framing and transportation.

▸ Give you 50% commission on the auction sale price.

MUSEUMS

Museums are looking for innovative exhibits. They often "rent" travelling exhibits.

Museums are looking for quality work. In the last years, their budgets have shrunk. They can no longer afford to buy consistently the number-one, superstar artists. They are looking for emerging artists they can afford, whose worth will grow with time.

You can approach a museum to sell a piece, donate a piece or have an exhibit. You need to be well-prepared if you approach them as an emerging artist. Do you have a really great idea for an exhibition? Smaller museums are much more open to emerging artists. To approach a museum, write a brief letter of introduction to the appropriate curator. Include with your letter your resume, as well as promotional materials, announcements from solo shows, and six to 10 photo prints or slides of your work.

If you are thinking of approaching a museum for an exhibit, remember that they are not places that sell; they just exhibit artwork. Exhibiting work in a museum, however, can be a great boost to your career. Your credibility will increase tenfold. Receptions are usually held for patrons of the museum; you, of course, will attend and introduce yourself to these patrons. You will meet curators and other museum staff as well.

Many museums have annual competitions for emerging artists. These could be your best bet for introduction. Some museums have rental galleries (see page 209). This is an excellent way to find clients also.

To locate museums out of your area, ask your librarian for a museum directory. If you have a specialty market (wildlife, horses, florals, historical), look for this type of museum. Contact the curator by phone with your idea for an exhibit. He will most likely ask you to follow up by sending your portfolio.

DONATIONS TO MUSEUMS

Storing artwork has become a costly venture for most museums. Many do not want an unknown artist to approach them about possible donations of his work. If you are becoming well-known in a particular area of the country, however, you might try to donate a work to a museum there.

If and when you do donate a piece, make the most of it.

▸ Ask the curator if you can have a formal unveiling.

▸ Invite the press to the event.

▸ Be sure to list that you are in the museum collection on your resume.

You'll need to draw up a donation contract if you give a piece to a museum. Make it clear that you still own the reproduction rights.

You can also try to persuade one of your collectors to buy a work and donate it. He can then deduct the full market value from his income tax.

REFERENCES

Official Museum Directory

Museum Store Association

Museums of the World

International Directory of the Arts

Become a member of your local museum and volunteer your time.

One artist donated a piece to a large museum in the South. They gave her artwork a special unveiling. The museum got the press to come, and they did several grand stories on her work. Her piece has since been rotated to different spots, but for some time it was at the central entrance to the museum. Her next step was to make prints and sell them to the gift shop, as well as around town. Her originals became much easier to get into galleries at that point. She had become known locally.

One artist I know has his photographs traveling to many museums all over the country. He solicits museums with a well-prepared press kit. He is paid to exhibit and the museum packages and ships his work to the next museum on the list. He also sells cards and posters of his work. The museum gets a cut of these products. It's a win-win situation.

One artist wanted to have a traveling exhibit of her work, which she volunteered free to any museum that would accept it. She only asked that they pay for transportation and her personal expenses for attending the opening. She would also give demonstrations of her work for several days during the exhibition. Her mailing was so successful that she actually had to refuse some museums that wanted to be on her tour!

RELIGIOUS MARKETS

Try renting a studio space in a church. This is a great connection as well as a practical idea—many churches have extra space, need the money, and want to assist artists. Perhaps you can even trade a piece of artwork for the rent.

Churches have traditionally been patrons to the arts. Churches and synagogues utilize and display many works of art: murals, mosaics, stained-glass windows, sculptures, tapestries, paintings, etc. The most active churches have separate foundations through which they can attract grants for art programming.

You do not need to be a member of a church or faith to create a work of art that is appropriate for them. You do, however, need to know that particular denomination's use of signs and symbols. Various colors also symbolize particular festivals and other celebration periods for individual denominations. The architectural style of the church, synagogue, space, and the preference of the people involved will determine the size, colors, and media of artwork—the same as if you were selling to any other art market.

Contact your local churches. If you can show examples of previous liturgical commissions, it would be quite helpful. If you have none, make some preliminary sketches of possibilities.

Memorials are often purchased by churches, so it is useful if they have your information on file. You can also:

▸ Contact architects who are building or restoring churches.

▸ Contact new churches being constructed in the area.

▸ Contact the regional headquarters of various denominations to find out about new churches being built that might need artwork.

RESOURCES

The Spertus Prize
618 S Michigan Ave, Chicago, IL 60605 (312) 322 1700
www.spertus.edu/spertus_prize
A biennial competition for the creation of Jewish ceremonial art. $10,000 award.

Christians in the Visual Arts
(978) 867 4124 www.civa.org
They have an annual conference, which features exhibits of art as well as workshops. They also have field trips, a newsletter and an artist directory.

ANIMALS

Animal lovers crave portraits of their pets. Take advantage of this by displaying your animal portraiture in a veterinary office.

One artist-entrepreneur had a vision and made it come true. An animal portraitist, he created the nonprofit "Canine Companies for Independence," which brings physical assistance to children and adults who have lost the full use of their arms or legs. This nonprofit provides dogs that have been trained for two years to perform simple, everyday tasks that most of us take for granted. He combined forces with a leading store and direct mail marketer and now advertises pet portraits through this company—giving some of his proceeds to his organization.

ANIMAL SHOWS

International Exhibition on Animals in Art

Veterinary Medicine Library, Sue Laubiere, Louisianna State University, Skip Bertman Dr, Baton Rouge, LA 70803 (225) 578 9793 www.vetmed.lsu.edu
Held in mid-March, this competition exhibits all media. Cash awards. 15% commission. One entry will appear on cover of *Journal of the American Veterinary Medical Association.*

Birds in Art

Leigh Yawkey Woodson Art Museum, 700 N 12th St, Wausau, WI 54403
(715) 845 7010 www.lywam.org

STAMPS

Most states have annual fish, duck, wildlife, and conservation stamp competitions. Contact the Game, Fish and Wildlife Department in any state.

Federal Duck Stamp Competition

Federal Duck Stamp Program, 4401 N Fairfax Dr, MBSP 4070, Arlington, VA 22203-1622 (703) 358 2000 www.fws.gov/duckstamp
Held annually

Conservation Stamp Competition, Sale and Show

Wyoming Game and Fish Dept, 5400 Bishop Blvd, Cheyenne, WY 82006
(800) LIV WILD www.gf.state.wy.us/services/publications/stamp

BUSINESSES

Many corporations consider their support of the arts to be part of their public relations. They are not necessarily measuring their return on the dollar.

Most companies need artwork for their walls. Advertising agencies and upscale office complexes are good places to scout around. Find out who the contact people are in the given business and call them to make an appointment. If they are hesitant to buy, suggest to them the possibility of renting or leasing. For many small businessowners, paying $100 per month for a nice painting is much more feasible than purchasing for $5,000. The executives are often overworked and busy, so be patient if they put you off. Banks and institutions sometimes have unused wall space. Approach the banks with the idea of selling them a series of local scenes, originals or prints. Be sure to offer their employees some kind of deal as well. If buying is not on their agenda, try to procure an exhibit to get some publicity and new buyers.

Corporations may aid the artist in several ways:

▸ By selling works in a corporate gallery

▸ By donating or loaning supplies and equipment

▸ By purchasing works directly from the artist

▸ By establishing a foundation that follows the federal rules for grants and awards to individuals

▸ By leasing artwork

To receive a commission from a corporation, you don't necessarily have to be well-known. Art consultants work with many emerging artists to acquire artworks for corporations, for decorative purposes in their meeting rooms, foyers, etc. Working with an art consultant is one of the best ways to connect to the larger corporations. A mailing list of corporate art consultants is available at www.artmarketing.com.

RESTAURANTS AND CAFES

Eating establishments have decorative needs. Watch for new ownerships and keep your eyes open for buildings under construction. Contact the architect or contractor for the name of the person in charge of the art budget.

If and when you do get a show at a good-quality restaurant, have a brief meeting (with the owner's permission) with the waiters and waitresses to inform and inspire them about your work. Offer them a 10% commission when they sell a piece for you (again, with owner's permission).

Volunteer to bring art into the lives of hospital patients by having an exhibit, perhaps in a specific department. You can locate medical facilities nationwide in reference directories at libraries.

Try to get the restaurant owners to note your exhibit in their newspaper ads. Make sure that it's okay to label your pieces with the price and that you can leave business cards and price sheets/brochures on the front counter.

SCRAPS

Originally created for art teachers, scrap recycle centers are located in almost every major city. They are nonprofit organizations that have formed to gather materials from businesses that they might have thrown out, to organize and make it available to schools as well as the public. A small fee is charged for taking home any of the materials, and I do mean small. You can find buttons, tiles, glass, paper, envelopes, chalk—just about anything related to art and art making. To find a location near you, go to www.artmarketing.com/scrapsdirectory.html. Have fun!

MEDICAL FACILITIES

There is a trend to humanize hospitals. Prints are often the format desired, as they are less expensive and, if damaged, won't be such a loss. Approach the right person at the facility and be patient for the right time.

NURTUREART ARTIST REGISTRY

NurtureArt is a New York City-based nonprofit that seeks to establish visual artists as capable of providing for themselves solely through the sale of their work. It also has an Adopt-an-Artist Program through which individuals commit money, materials, or services to a particular artist or group of artists, as a patron would have in previous centuries. Artists may also participate in Muse Fuse, NurtureArt's voluntary association for peer support and networking. To apply to the registry, send a resume with exhibition history, education, employment history, art-related skills, awards and grants, and contact information; an artist's statement focusing on short- and long-term aesthetic objectives; any promotional material such as reviews from the last five years, exhibition invitations, and catalogs; and one slide sheet with your most recent and available work. Label each slide: top, your name, title, medium, size (in inches) and date of creation. Items will not be returned. Selection is made by a jury of specialists such as gallery directors, museum curators, art dealers, authors, journalists and critics. No fees or dues are charged. Do not send oversized, thick envelopes or heavy binders; a portfolio must fit in a standard-size file drawer. Hard copies of materials are required, and links to web sites are not an acceptable substitution. NurtureArt does not guarantee artists inclusion in any exhibition. Contact NurtureArt, 55 Bogart St, Brooklyn, NY 11026. (718) 782 7755 www.nurtureart.org

Some businesses to try are accountants, chiropractors, dentists, doctors, engineers, hotels, insurance companies, lawyers, stockbrokers, therapists, veterinarians.

ORGANIZATIONS FOR DISABLED ARTISTS

There are many facilities across the country that enable disabled artists by providing them with art supplies and instruction. Many of these facilities have galleries where they can sell their work.

Art Ability

Gair Weilbacher, 524 Valley View Rd, Merion Station, PA 19066
(610) 660 9137 www.mainlinehealth.org/br/article_9417.asp
This exhibition is held mid-November. Work is reviewed by slide and if accepted, by original work. Cash prizes are awarded.

VSA

818 Connecticut Ave NW #600, Washington, DC 20006 (800) 933 8721
(202) 628 2800 www.vsaarts.org

Creative Growth Center

355 24th St, Oakland, CA 94612 (510) 836 2340 www.creativegrowth.org
When you go to an opening at this facility, you arrive early and wait in a line that goes around the block—it's that darn popular!

HOTELS

Go to exclusive hotels to see if they need artwork. You might find a gallery there, too, that you didn't even know existed! One good magazine to reference is *Prestige, The Magazine of Small Luxury Hotels*. Look for other reference magazines with the help of your librarian.

COUNTRY CLUBS

Country clubs need art for their club rooms, ballrooms, gift shops and dining facilities. If you create golf art, they are the perfect place for you to exhibit. Country clubs can attract a good clientele even if golf art isn't your genre. They will sometimes rent out facilities for a show and let you use their mailing list of members. One artist in Florida has a show each year at his local country club. Each year he sells out. Can't beat that—and he's not a golf artist!

STORES

Consider selling to frame stores, art shops, print shops, department stores (gift departments), gift stores, etc. Maybe an upscale boutique would be a good place to display and sell your work. Find out if your work is appropriate and call the prospect to set an appointment.

Bring order blanks, brochures, and samples of work. Many stores will want artwork on consignment. Be sure to have a signed consignment agreement if you do leave artwork.

One artist made a great deal with his prints of a local basketball coach when he connected with a car dealership. The company bought all the prints and used them as a sale giveaway to the buyer of each used car.

Another artist created a series of greeting cards and got her images on the front cover of a national azalea publication. She sold out the entire printing.

Yet another artist connected with the local correctional system in his town and is doing a series of murals on the jail walls.

ARCHITECTS

Some art sales to corporations can be commissioned through architects. To find architectural firms that are involved in current building and renovating projects, ask your public librarian for local publications that list new construction in your section of the city or county.

▸ Dodge Reports is a publication of McGraw-Hill. These reports list new construction plans, describe their scale, and note the architect in charge. A subscription is very expensive—\$2000[+]. For this reason, not many libraries subscribe. Find someone in an architectural firm or construction company who subscribes, and arrange to read them at his office.

▸ Call the regional branch of the American Institute of Architects/AIA or your local Chamber of Commerce and ask for a list of architects in your area who specialize in commercial buildings.

▸ Make your own list of architects by looking for building sites. They generally display signs naming the architects.

▸ Speak or display at an architects' gathering or luncheon.

▸ Be listed in your local arts council's slide registry, where architects visit to locate artists for their projects.

BUILDING MANAGEMENT COMPANIES

These large businesses construct and manage buildings and often decorate their lobbies with paintings and sculpture. They frequently know which of their tenants are interested in buying artwork for their offices. They might need to furnish a model home or apartment, so introduce them to your rental/lease program.

REAL ESTATE BROKERS

Businesses and private individuals tend to buy art when they relocate. Real estate agents can tell you who is moving where and whether their clients may be prospective buyers.

International Facility Management Association
1 E Greenway Plz #1100, Houston, TX 77046-0194 (713) 623 4362
www.ifma.org
A nonprofit organization dedicated to serving facility management professionals, many of whom are decision-makers for purchasing art for corporate facilities.

One enterprising artist put together a package deal that her local real estate company couldn't resist. She discovered that as a promotional tool, when a salesperson closed a sale, he usually gave the buyer an inexpensive print to hang in the new house or office. She put together several medium- and small-sized framed prints and sold them for under $50 each to the real estate company. It worked so well that the artist and her husband took a booth at the state real estate convention and are now selling to real estate companies regionally.

Another artist teamed up with a sculptor and showed work in several new homes during a builder's opening.

PRIVATE COLLECTORS

You will compile your own list of collectors over the years. It will include all the people who have shown interest in your art and all the people who have purchased from you. Collectors are amazing. They can spend thousands of dollars within minutes.

Don't ever give the names of your private collectors to anyone—and don't expect that anyone will ever give you their collectors' names either. You will find that these private collectors are usually your best patrons. They love your work and thus sell it to their friends for you—especially if you make it clear that you are a full-time artist. It makes them feel good to patronize an artist. Someday they might give you an opening in their home or business. Court these private collectors. Mail to them at least twice a year—better yet, each quarter. Don't lose contact with them, and, of course, with your artwork that they own.

One artist living in Florida showcased her work in *LIVING ARTISTS* (WWW.ARTMARKETING.COM). She was surprised to receive a call one day from a collector in Texas. He had fallen in love with her piece in the ninth edition. Within two weeks, he flew into Miami just to view the painting and to verify that it looked like the picture in the book. He left Miami the next morning, having paid the artist for the piece as well as for shipping to Texas. There was no indecision on the collector's part—just pure and simple love. When someone falls in love with your painting, it is truly the biggest compliment in the world. "It all happened so quickly. It was such an exciting event," says the artist. She went on to say that this was the most unusual, dreamlike experience that she has ever encountered in all her years of marketing her art.

COMMISSIONS

Commissions are works of art produced specifically for a given individual, corporation, interior designer, arts council or business. Interior designers, consultants, and architects often require commissioned work—a specific order for a specific product. Some artists don't like to do commissions. For others, commissions create the right challenge and offer a new direction for their work. Decide whether you can and want to do this type of work.

- Sign a written agreement for any commission you schedule.

- Make sure the contract includes an advance on funds for the cost of materials and part of your time.

PORTRAITS

Artists who do portrait commissions often receive word-of-mouth referrals.

Whether you work through a portrait broker or as your own agent, be sure to get your contract in writing. The terms of a portrait commission are similar to other types of commissions. You will note what medium you will be using, what size, propose the scale of the figure (full or head), specify if it will have an abstract or detailed background, set a completion schedule, etc. Don't neglect to include charges for a preparatory study based on a preliminary sitting or photo session. Before you start this preliminary sitting, be sure to collect the first one-third of your commission.

PORTRAIT ORGANIZATIONS

A Stroke of Genius
www.portraitartist.com

American Society of Portrait Artists
PO Box 230216, Montgomery, AL 36106 (800) 62A SOPA www.asopa.com

Portrait Society of America
PO Box 11272, Tallahassee, FL 32302 (877) 772 4321 www.portraitsociety.org

Portrait Society of Atlanta
www.portraitsocietyofatlanta.org

Society of Portrait Sculptors
www.portrait-sculpture.org

Be clear on how you handle commissions. If you don't like being directed by a client, don't do them—you'll only get into trouble.

ACTION PLAN

- ❑ Identify three possible business venues where you could display your work.
- ❑ Brainstorm some creative ways to approach new markets.

RECOMMENDED READING

Artist's Market edited by Northlight Books

Chapter 20

Alternatives to Sales

Grants

Residencies

Moonlighting

Publishing and licensing

*"Where shall I begin, your Majesty?" he asked. "Begin at the beginning,"
the King said, gravely, "and go on till you come to the end: then stop."*

Alice's Adventures in Wonderland, Lewis Carroll

GRANTS

Grants should not be thought of as a primary source of income. In most cases, they are intended to assist an artist while she is becoming known.

In this chapter, opportunities—other than the direct sale of artwork—for supporting yourself will be covered. Not all these ideas work for all artists. Explore this chapter and see what might work best for you.

A grant is a gift of money, sometimes called a scholarship or fellowship. A grant does not require repayment. An individual, company or foundation sponsors a grant for a specific purpose or reason. Except for the research and writing time you need to spend, you have nothing to lose by applying. Most grants don't even require a final product.

RESEARCHING GRANTS

You'll need to have persistence, stamina and resourcefulness in your search. If you don't research a grant thoroughly before you apply, you're wasting your time and energy. Your aim is to find a grant that specifically fits your needs and your artwork.

Foundation libraries carry books specifically on grants. They are the best place to search for grant possibilities. Your local library might also be able to help you find publications that list grants available to artists. Books on grants will give you details on eligibility, deadlines, and requirements. Many grants are restricted to a certain ethnic background, geographic location, or religion; some are for study, some for travel, etc. Your local art paper and most national art magazines carry listings of available grants also.

FOUNDATION CENTER LIBRARIES

1627 K St NW #300, Washington DC 20006-1708	(202) 331 1400
50 Hurt Plz #150, Atlanta, GA 30303-2914	(404) 880 0094
1422 Euclid Ave #1600, Cleveland, OH 44115-2001	(216) 861 1933
312 Sutter St #606, San Francisco, CA 94108-4314	(415) 397 0902
79 5th Ave, New York, NY 10003-3076	(212) 620 4230

www.foundationcenter.org

New York University Libraries
70 Washington Sq S, New York, NY 10012 (212) 998 2500
www.library.nyu.edu/research/art/grants.html

RESEARCH POINTERS

▸ Keep your eye on the grants for individuals (i.e., not corporations). The Foundation Center's Guide to Funding for Individuals is a good place to start.

▸ If the fund's name and the last name of the principal officer are the same, chances are it's a family foundation. They generally are smaller and more difficult to contact.

▸ The foundation library will have tax reports from each foundation. Check the IRS 990 Form of the awarded grant giver you're interested in to see whom they gave grants to last year. Maybe their friends or family? Are they all from one geographic area, a certain age group, male/female?

▸ Each funding organization will have different deadlines. Note these on your business calendar.

Call the funder that seems to fit your qualifications best and ask for an application. If you have any questions that arise during your research, ask them. You are trying to eliminate grantors—yes, eliminate. That way, your final list will be very specific and your chances will be much greater of receiving an award. Put these funders on your mailing list. Send them cards of your openings and exhibitions and press releases. You will be cultivating future possibilities.

Once you've narrowed down to a list of three to five appropriate grants for which to apply, you will need to fill out forms and paperwork. Applying for a grant does not have to be torture! Following a few guidelines will help you along your way. Read the application packet carefully. Rethink whether this is the grant for you. When you have decided that it is, your proposal writing starts.

GRANT WRITING

A grant proposal generally contains these parts:

Project Summary - One to two sentences that include the monetary amount of your request. Be specific about timeframe and amounts of money. Establish credibility and qualifications. For example "The allotment of $5,000 will be used in 2008 to print a catalog to be used for the Hoyt Museum exhibit."

The Problem or Need - The problem that receiving funds will resolve, as in "I wish to make the most of having received a solo-exhibition at the Hoyt Museum in 2008. A catalog is the best possible manner. By receiving the grant for $5000, I will be able to print a quality catalog of my works, which will be sent to museum patrons, present customers and local art collectors."

The Objectives - The nature of the project. "The project is to include compilation and printing of a catalog of current works for my Hoyt Museum solo exhibit in June 2008."

The Method - How and by whom it will be done, as in, "Projected quote from designer through printer for 10,000 catalogs is $5000."

All aspects must be covered in detail and with certainty. Every word counts. You must write concisely and clearly. No rambling. Be direct. No lies. Write and rewrite this proposal, leaving a lapse of time to weed out unnecessary words. You want to make sure that you have communicated why your idea is especially worthy of funding.

GRANT-WRITING TIPS

→ Try to reach the head of the appropriate funding source.

→ Know for whom you are writing this. Who are the people on the committee?

→ Find out if the grantor's mandates match your qualifications. You don't want to apply to a grantor who wants to support minorities if you don't qualify.

→ Usually a grant application will require you to limit your request to a defined space. Therefore, you need to make it as concise as possible. It should answer the who, what, when, where, why, and how of the funding request. If a question does not apply to you, write "N/A" or "Not Applicable." They will know then that you haven't overlooked a question.

→ Don't philosophize. Be specific and clear in your request. If the panel can't decipher your concept, you'll be eliminated from consideration.

→ Phrase your request so that they don't have to read and reread to achieve clarity.

→ Don't use jargon.

→ Follow directions precisely; keep your application neat, clean, and easy to read. Most grant guidelines request specific information in a specific format. Comply with all requests in the order requested. If a request is made for three letters of support, don't send five. If an applicant is not willing to follow directions in submitting an application, the grantor may question the applicant's ability to account for grant monies.

→ Your application should be computer-generated. Use bold, italic and indentations to emphasize certain ideas. Be sure to have someone proofread the manuscript for typos.

→ Don't include promises that you can't keep.

→ Make your numerical calculations clear, correct and easy-to-follow.

→ Indicate what you hope to do and where the money is going.

→ When itemizing your expenses, don't forget an artist's fee. You should be compensated for your time, not just for the material cost of the project.

→ Send no extraneous material. Make it as easy as possible for the reviewer to "like" your request.

→ Be positive. A chip on your shoulder will not get you a grant.

→ If asked for work samples, send your best.

GRANT WRITERS

You can hire a grant writer if you don't want to write the application yourself. Some grant writers will also do preliminary research for your particular needs. They can save you hours of research time. They can provide you with assistance and inspiration and advise you on slide selection. They should be able to match your work with the foundations that will fund it. Many are, essentially, a grant coach.

LOCATING GRANT WRITERS

Call one of the foundation libraries.

Look in your local art paper in the classified section.

Ask your local arts council.

Contact a local Lawyers for the Arts organization. They often hold seminars on grant writing.

MEETING WITH JURORS OF GRANTS

If you've passed the written proposal, the next step is meeting with the jury panel in person.

▸ Arrive early. Relax. Breathe deeply.

▸ Before your meeting, learn their names. Research their vocations and interests. Determine the key person(s).

▸ Plan your agenda to include three to five goals and key points, as well as an opening and summary. Thank them for the opportunity.

▸ State your objective and purpose, considering what they want to know.

▸ Conduct an interactive dialogue—no monologues. Establish eye contact. Their questions and your answers should comprise at least one-third of the presentation.

▸ Don't become defensive over objections that might be raised. If need be, ask for clarification of their question or concern.

▸ Remember, you are not selling anything; you are explaining a project you would love to be able to accomplish.

You are not only writing this grant for the funding foundation, but you are writing it for yourself. You will come to understand your artwork and aims much more clearly once you have gone through this process. It often inspires new ideas and brings into your consciousness latent thoughts.

REPORTING GRANTS TO THE IRS

Most grants must be included in your annual income tax return. Only grants that meet one of the following criteria may be tax-free:

▸ Recipient is selected without any action on his part.

▸ Recipient is not required to render services as a condition to receive money.

▸ Amount of the award is transferred to a tax-exempt government organization.

Try to find out before you apply if the grant is taxable. If it is, see if you can split the monies received—50% in one year and 50% in the next. Additionally, for your own personal accounting, it might be best to have monthly payments transferred to your checking account so you don't spend it all at once.

REGIONAL ARTS ORGANIZATIONS

Arts Midwest
2908 Hennepin Ave #200, Minneapolis, MN 55408 (612) 341 0755
www.artsmidwest.org

Mid-Atlantic Arts Foundation
201 N Charles St #401 Baltimore, MD 21201 (410) 539 6656
www.midatlanticarts.org

Southern Arts Federation
1800 Peachtree St NE #808, Atlanta, GA 30309 (404) 874 7244
www.southarts.org

Western States Arts Federation/WESTAF
1743 Wazee St #300, Denver, CO 80202 (303) 629 1166
www.westaf.org

National Endowment for the Arts/NEA
1201 16th St NW, Washington, DC 20036-3290 (202) 822 7974
www.nea.org

Send a thank-you note if you are awarded a grant, to all levels of the foundation—the president, the secretary whom you spoke to many times on the phone, etc. You will continue to send them cards and press releases—they are one of your best clients. If someone you've come to know goes to another agency, be sure to send her postcards and press releases to her new address.

TARGETING THE RIGHT FOUNDATIONS

By Hanna Ullman

Almost every artist needs money to work, buy materials, rent a new work space, take time off from a job or go abroad. One can find hundreds of grants for individual artists—often restricted, however, by geographic areas, age requirements, etc. Some foundations give grants based on merit only; other grants are made based on merit and financial need. Only a handful of foundations give grant money to individual artists with few or no restrictions.

Decide what yype of funding you need

There are, basically, five types of funding for artists:

- Small grants (under $5000): for upcoming projects or to complete a body of work in process
- Large grants ($5000-50,000): to provide living expenses so that one can be free from the demands of a full-time job
- Travel grants: relating to or necessitated by your artwork
- Artists' colonies or residencies: time to work, often with expenses paid. You must be willing to relocate temporarily to have the tremendous benefit of being part of a community of artists.
- Public art projects

Research the right foundation

This involves knowing where to look and what kind of grant you need. Check your local or state arts council or peruse the better art newsletters. One of the best sources of free, targeted information is the incredibly well-run Visual Artist's Hotline, now organized by the New York Foundation for the Arts at (800) 232 2789 www.nyfa.org. The Foundation Center, a grant library, is another good source of information and has offices in San Francisco, New York and other major cities. You can go there to peruse books on grants for just about anything. You will find the book *FOUNDATION GRANTS TO INDIVIDUALS*—it is not just for artists but for all individuals.

Grant writers

The most difficult aspect of getting funding, for most artists, is finding the right foundation. Good grant writers will provide you with specific listings immediately. They will also provide you with assistance and inspiration during the writing of your proposal, and even advise on the selection of your slides. They will be able to tell you what the various foundations are looking for and match your work to the foundations most likely to fund it. They will be able to show you how to apply for grants reserved for organizations only, even if you are an individual. In short, they should act as a coach for you, perfecting your proposal and presentation until you bring out the absolute best in your work and make a compelling argument for its funding.

If your work is worthy and your efforts persistent, you will, indeed, end up with the funding you deserve. The results could change your life.

Hanna Ullman is a grant writer. She is also a painter and has been awarded five major grants, beginning with a Fulbright to Italy. Her MFA is from Columbia University.

RESIDENCIES

Artists send excellent reports on the stimulating and rewarding time they've had when attending a retreat or residency.

Residencies, art colonies, art communities and retreats are places that provide opportunities of space, free of distractions, so an artist can focus on a specific undertaking in a serene and creatively supportive environment. They also provide a congenial atmosphere for the exchange of ideas with other artists. Many are free via a grant award. Some require a nominal fee.

TIPS

→ Contact your local or state arts council for more details about specific opportunities.

→ Order a mailing list of over 200 grants and residencies; available on peel-and-stick labels. You could mail a postcard to each, requesting information. (www.artmarketing.com)

→ Watch the listings in the back of your local or national art newspaper/magazine for deadlines.

RESIDENCIES TO CONTACT

Millay Colony for the Arts
www.millaycolony.org

Bemis Center
724 S 12th St, Omaha, NE 68102-3202 (402) 341 7130 www.bemiscenter.org
125,000-sq-ft facility in the heart of Omaha housing artist studios and living spaces. Stipends range from $500-1000 per month, as well as living and studio space.

George Sugarman Foundation Inc
448 Ignacio Blvd #329, Novato, CA 94949 www.georgesugarman.com
Annual grants ranging from $1000 to $2500 for painters and sculptors

Jentel Artists
130 Lower Piney Creek Rd, Banner, WY 82832 (307) 737 2311 www.jentelarts.org

Guggenheim Foundation
(212) 687 4470 www.gfng/broch.html

Robert Mapplethorpe Foundation
www.mapplethorpe.org

Light Work
316 Waverly Ave, Syracuse, NY 13210-2437 (315) 443 1300 www.lightwork.org
Photographers' retreat

RESOURCES

Americans for the Arts

1 E 53rd St, New York, NY 10022-4201 (800) 321 4510 ext 225 (212) 223 2787
www.americansforthearts.org
Books on funding

Mailing lists of grants

www.artmarketing.com/ML

Mailing list of grants and residencies that comes on peel-and-stick labels

TRAVEL PROGRAMS

A number of opportunities exist for artists to travel and study abroad, with the assistance of a fellowship or scholarship to cover full or partial expenses.

American Academy in Rome

(212) 751 7200 www.aarome.org
Advanced research and independent study in the arts for 30 residential fellowships, ranging from six months to two years with $10,000-20,000 stipends and free room and board.

Fulbright Fellowships

(202) 687 4470 www.fulbrightonline.org
Fulbright grants provide funding for a year of study and training overseas.

MOONLIGHTING

Wayne Thiebaud, a world-renowned artist, was a teacher for 30 years at UC Davis in California.

Besides selling your artwork, you may need to augment your income through some activity, hopefully art-related. This can lead to good connections and a supportive and nurturing artistic environment, and, possibly, clients for your artwork.

▸ Teach art at a college, through an adult education program, art organization, craft shop, art store, YWCA.

▸ Work at an art museum.

▸ Be a judge or juror for a show.

▸ Write a column for a local art paper.

▸ Organize a lecture or slide show.

▸ Start a local art newsletter.

▸ Work at a gallery or framing gallery.

▸ Work at an art supply store.

NON-ART JOBS

Alternatively, you may wish to work in a non-art-related job, saving your art energy for your personal work—waitress, typist, or bank teller. Working half days can get you in gear to go to your studio and work diligently in your off hours. You will value your time much more than someone who has all day free. I have seen artists get very confused and bored when they have all day to create. They really don't know how to do that. Being creative all day isn't easy.

INTERNSHIPS

Internships occur mostly in art organizations or museums. An intern may assist a director in a museum, in an art organization, or even another artist. Not only are you learning the trade, but you are meeting people, including potential clients. Some interns actually get paid.

Volunteering your time can connect you with local arts councils, art organizations, museums, etc. These groups have access to gallery space, slide registries, job banks, studios, credit unions and technical assistance. The more people who know you are an artist, the more chances for commission referrals.

BARTERING

Bartering is an age-old concept. Today, many small and large firms are successfully bartering for products they need. In fact, some of these companies have bartering departments.

PUBLISHING AND LICENSING

Putting your work in print form is another way you can add to your income. If you've studied the print market at all and think that it is one of the directions you want to venture with your business, read on.

The publishing industry is one of the biggest in the art market. Millions of dollars' worth of prints, cards, posters, etc., are purchased each year by consumers. If you think your work would do well in this marketplace, you will need to learn all the ins-and-outs of the market. It is easy to get ripped off if you are not educated.

LICENSING

Licensing agents are people who work as a go-between for artists and manufacturers. They locate artwork to be embossed onto shower curtains, sheets, pillows, Kleenex boxes, and a myriad of other products.

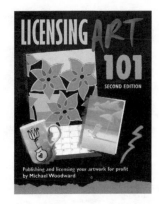

In *Licensing Art 101, Publishing and Licensing your Artwork for Profit*, author Michael Woodward, a 25-year veteran in the industry, teaches artists how to increase their income by licensing their art. Reaching the licensing industry takes special knowledge. He gives you advice and insight as you flip through the pages—assistance from an expert. The first part of the book has information about conducting business with the publishing and licensing industry; the second part lists contacts in the industry with over 300 names, addresses, telephone numbers, and URLs as well as types of art each company is looking for. You'll learn about negotiating fees, how to approach various markets, targeting your presentation, trade shows, licensing agents, protecting your rights, self-publishing and more. With over 200 pages, this topic takes an entire book of its own. You can find it in stores or at www.artmarketing.com.

ACTION PLAN

- ❏ Decide whether or not to apply for a grant.
- ❏ Research an art retreat for vacation.
- ❏ Investigate the publishing and licensing industry.

RECOMMENDED READING

Artists' and Writers' Colonies by Gail Hellund Bower

Artist Communities: A Directory of Residencies in the United States That Offer Time and Space for Creativity

Individual's Guide to Grants by Judith Margolin

Money for Visual Artists by Suzanne Niemeyer

Opportunities in Visual Arts Careers by Mark Salmon

Chapter 21

Marketing Plans

A personal plan

Setting goals

Marketing ideas

Long-term goals

Short-term goals

No one ever regarded the first of January with indifference.
Charles Lamb

A PERSONAL PLAN

Each January, set one or two major goals for the coming year.

Congratulations! You've made it to the last chapter in this book! Or have you? Have you skipped to here? Have you read all the previous chapters? If not, you can still go ahead and read this chapter. Hopefully it will entice you to go back and study (not just read, but read and *do*) the previous words. If you don't go back and do some of the legwork, chances are you will be compromising your marketing plan.

BUSINESS PLAN

A business plan is a requirement in any business if there is to be hope of success. Without a plan, results will be erratic at best. A business plan is your personal road map to success. The professional artist cannot afford to be complacent about a plan.

Developing a marketing plan does not have to be an overwhelming task. It does take thinking and soul-searching—sitting down in a quiet mode and concentrating on your business. You will need to write down your thoughts so you can view them more concretely, putting them into an understandable order so you can follow them step-by-step.

CREATING A PLAN THAT FLIES

You must have realistic goals, taking into consideration your cashflow and time constraints. Do not compare your marketing plan with someone else's; this is ludicrous. If you have only four hours a week to market, you cannot compare yourself to the person who is devoting 20 hours a week to the same task.

Any business must be thought about over the long term. There is no short-term business unless that business doesn't have a plan. You must have a good overview of what your aims are, although they will certainly change over time.

Try to understand why you must devote some time to this project of a business plan.

- ▸ Concentrating with conviction on a particular direction, one often attracts that which one is aiming at.

- ▸ A plan will help you diagnose difficulties you need to overcome in order to reach your final destination.

- ▸ A plan helps you budget better by anticipating the future.

To develop a plan, you must know your target market and your budget, understand the benefits of your product and be aware of techniques to reach your particular market. All of these areas have been covered in the previous chapters. Hopefully you have dedicated some time and serious thinking to these ideas and are ready to proceed.

FIVE FACTORS FOR SUCCESS

These five factors came about by studying successful artists' approaches to daily tasks. As you make your goal-setting chart, keep these five factors in mind.

1. Continually contacting people

Make it a goal to call four people a day—whether they be new prospects or current clients. It's guaranteed that not only will you become quite good on the phone, but your business will flourish. Clients are the mainstay of any business. To call four people a day could take 15 minutes. Don't have long conversations; in fact, they should be short, with a specific goal in mind. You could ask for referrals, invite the person to visit a future opening or exhibit, invite him to your studio to see your new series of work, thank someone for a recent purchase. Be creative! Add to this list of four phone calls four post cards per day, and you have eight contacts a day, to get a total of 40 contacts a week! If you try this for two months (320 contacts or follow-ups), you will be amazed at how your sales increase.

2. Follow-up

Not only do successful artists follow up after they send out a package of slides, but they follow up even if they receive a rejection. This means that they send out a postcard with one of their images on it, a photo print, announcement of an exhibition, whatever it is—at least every six to 12 months to all prospective clients, galleries and former purchasers. The rule in direct marketing is: You must contact people three times before they respond! As an artist, you won't have a huge mailing list; it will be quite intimate, perhaps 100-400, so the cost to do a mailing is not overwhelming. E-mail broadcasts can be used as well.

3. Innovative marketing

Successful artists are always thinking of innovative ways to market. They are willing to take a risk if they feel a new idea might work. For instance, new places to exhibit—an orchid show, an interior designer show, a real estate show, a music conference, a sci-fi convention—whatever they think might work for them! Presentation is always consistent and top-notch, of course.

4. Press coverage

Successful artists consistently receive press coverage. Although she might not get direct sales from this press coverage, a successful artist knows that in the long run it means many people see her name, artwork and progression over the years. This means a lot to potential buyers. It also means that the newspaper/magazine approves of you. Name recognition is of the greatest importance in any business.

5. Long-term goals

All the successful artists I know have had long-term goals. This means they did not make it overnight. They planned and strategized to get where they are today. They never gave up. They knew their target, and they knew there would be down periods, as in all businesses. Goals are the mainstay of any business.

SETTING GOALS

It is said that 90% of businesses that don't have a formal written plan fail. Do you want to be among this 90%? If you don't have a destination, how will you know when you get there?

There are different theories about setting goals. You need to see what approach works best for the type of person you are.

Some people advocate setting targets that you can easily reach so you won't fail. This type of goal might limit your possibilities. How do you know you can do more if you don't try?

Others recommend setting goals that are a bit beyond what you think you can accomplish. This type of goal could drive you to be more creative, pushing you into new territory and risks, or it could make you feel like a failure.

TIPS FOR DAILY SUCCESS

→ Focus on top-priority tasks every day. If you are able to accomplish your number-one task, then you've had a productive day. Strive for a balance between quality and quantity.

→ Use a weekly and daily to-do list. Cross out tasks that you've completed on your daily list. If need be, stamp "completed" on it. That really gives one a feeling of accomplishment.

→ Imagine yourself in your role as art entrepreneur and you will be more prepared mentally to succeed.

Goal-setting is not something you can just sit and think about. You must write down your ideas. Brainstorm and see what new ideas you can come up with.

Let's think about general goals and directions for your art business, and then about particular aims as steps to reach those goals. You can use the ideas you've already read about. On the following pages are some aims to consider. Add some of your own.

Dedicate as much time to marketing as you do to your creating art each week—remember the 50/50 theory?

Write down every idea you have. Make a file section called Ideas for future reference and creativity. One file of ideas on the business of art, one on the creation of art, one for wild marketing ideas, etc.

Set aside a specific day and time each week for marketing.

Create your own work space.

Don't consider an artwork finished until it is titled, framed, signed and copyrighted.

Start collecting names for your mailing list.

Call five to 10 art world professionals each week.

Organize a solo exhibit.

Spend one day visiting local galleries.

Subscribe to an art publication for one year and read it.

Decide on your company name, design your logo and print your business cards and stationery.

Enter a competition.

Attend an outdoor show to check it out for possible sales next year.

Sponsor a community event.

Host a studio party.

Conduct a client survey to see what products your clients would like.

Donate time to some charity. Let people know you are an artist.

Barter your art for services.

Enlarge your Yellow Page ad.

Support your statewide arts organization by buying an art license plate. Put something related to your business name on it.

Make a special offer to your clientele.

Try to get an interview on your local radio station.

What interior designer could you take to lunch?

To what local business could you lease your artwork?

In what cafe could you hang your paintings?

MARKETING IDEAS

My own ideas:

The biggest step in becoming successful is to start working your plan!

In what competition could you apply to be?

Give out coupons with your next Christmas card.

What special offer could you make on a postcard to your clients?

What storyline can you create for the local art writer?

For what special seasonal event can you open your studio?

What art idea could you write a story about?

What previous client would be able to give you a useful referral?

What "stunt" can you think up to give yourself some publicity?

What sign could you put on your car to advertise your work?

What bumper sticker could you create to give to your clients?

Go to the arts council's next open house.

Create an e-mail newsletter to send to clients.

Which one of your pieces would make the best greeting card?

Which one of your pieces would make the best Christmas card?

How much would it cost to put up a billboard at the entrance to town?

Look into exposing your work through the Internet.

Create an unusual, catchy name for your new group of paintings.

Find a marketing mentor. Treat him to lunch.

Apply to the next local art fair.

Start saying, "I am an artist."

Refer business to one of your clients.

Have a private studio showing for your favorite clients.

See if a client would be willing to have an "art party."

Have your answering machine say something memorable (but brief!).

Analyze your pricing policy to see if you can improve it.

Provide a specialized service that no other artist provides.

Get a phone number that spells out something (or figure out what your current one spells).

Create an office space.

Create your life by knowing what you want.

Be friendly with a competitor.

Place your artwork in model home displays.

Advertise in regional or local magazines.

Work with a local chapter of American Society of Interior Designers: You could give a talk at one of their meetings.

Contact your local International Furnishings and Design Association chapter affiliation.

Take a booth at a home show.

Place a display of your work at the local library, associated with the talk you will give.

Smile at everyone today.

Find a Realtor's office that will let you exhibit. They have a lot of new homeowners walking through their facility. Offer the agent who sells a piece a 30-50% commission.

Create a gift certificate form.

Ask for written testimonials from your favorite buyers.

Check out your local doctor, veterinarian, optometrist, emergency room, hospital, medical facilities office. These venues can prove to be excellent choices and often do have a budget for "decoration." If they are not in the position to buy, offer a lease.

Connect with your American Institute of Architects local chapter; ask to advertise in their newsletter.

LONG-TERM GOALS

Long-term goals need to be revised annually. They will change periodically as your business grows and you learn.

FIFTH-YEAR GOALS

1. Get accepted into a San Francisco gallery as one of their stable of artists.

2. Net $35,000.

3. Exhibit at ArtExpo.

4. Get printed by an established publisher.

FOURTH-YEAR GOALS

1. Invite 200 people to my Open Studio.

2. Donate a piece of artwork to charity; use this opportunity for new contacts.

3. Net $25,000.

4. Exhibit at three fine art fairs.

THIRD-YEAR GOALS

1. Have a mailing list of 30 purchasers as well as 200 possible purchasers.

2. Net $15,000. Go part-time on my regular job

3. Investigate art publishers.

4. Exhibit at an art show.

SECOND-YEAR GOALS

1. Invite 100 people to my Open Studio.

2. Advertise in the Yellow Pages.

3. Net $10,000 this year.

4. Research corporate art consultants.

FIRST-YEAR GOALS

1. Become a legal business.

2. Prepare an outstanding portfolio.

3. Find an interior designer with whom to work.

4. Hold an exhibit at my studio.

STEPS TO REACH GOAL 1

1. Decide on company name/logo.

2. Design business cards/stationery.

3. Get business license/sales tax permit.

4. Market 10 hours a week.

STEPS TO REACH GOAL 2

1. Take slides of all artwork and label them.

2. Prepare a resume.

3. Plan my web site's overall appearance.

4. Hire a designer and learn what I can from him.

STEPS TO REACH GOAL 3

1. Call five interior designers.

2. Get an appointment with an interior designer.

3. Study *Decor, Art Business News, Interior Designer Magazine*.

4. Explore a merchandise mart.

STEPS TO REACH GOAL 4

1. Create a 12-month plan for your Open Studio.

2. Frame work.

3. Find a salesperson.

4. Get studio in order: clean, paint, scrub!

SHORT-TERM GOALS

Once you have set in writing your strategies, take out your annual planning calendar and break them down to the month, then week, then day. Give yourself time to accomplish each task, but not too much time!

FIVE-YEAR GOALS

FIFTH-YEAR GOALS

1. _____

2. _____

3. _____

4. _____

FOURTH-YEAR GOALS

1. _____

2. _____

3. _____

4. _____

THIRD-YEAR GOALS

1. _____

2. _____

3. _____

4. _____

SECOND-YEAR GOALS

1. _____

2. _____

3. _____

4. _____

TWELVE-MONTH GOALS

1. _____

2. _____

3. _____

4. _____

STEPS TO REACH GOAL 1

1. _____

2. _____

3. _____

4. _____

STEPS TO REACH GOAL 2

1. _____

2. _____

3. _____

4. _____

STEPS TO REACH GOAL 3

1. _____

2. _____

3. _____

4. _____

STEPS TO REACH GOAL 4

1. _____

2. _____

3. _____

4. _____

ACTION PLAN

❏ Keep files for all your ideas.

❏ Note three main goals for years two through five.

❏ List five main goals for next year.

❏ Break down these goals into five steps each.

❏ Update a marketing plan each quarter.

RECOMMENDED READING

The 90-Minute Hour by Jay Conrad Levinson

Business Plan for Dummies by Paul Tiffany

Swim with the Sharks without Being Eaten Alive by Harvey Mackaey

Time Management for Busy People by Roberta Roesch

Time Management for Dummies by Jeffrey J Mayer

Your Business Plan by Dennis J Sargent and Maynard N Chambers

Bold type = Companies, shows and organizations

Italic type = Publications and videos

Bold type = Companies, shows and organizations

Italic type = Publications and videos

Bold type = Companies, shows and organizations

Italic type = Publications and videos

Bold type = Companies, shows and organizations

ART WORLD MAILING LISTS

Artists (46,000 names) . $100 per 1000

Architects (650 names) . $60

Art Councils (640 names) . $60

Art Museums (1000 names) . $85

Art Museum Store Buyers (550 names) . $75

Art Organizations (1800 names) . $110

Art Publications (700 names) . $75

Art Publishers (1150 names) . $95

Art Supply Stores (800 names) . $65

Book Publishers (325 names) . $50

Calendar Publishers (100 names) . $50

College Art Departments (2500 names) . $130

Corporate Art Consultants (175 names) . $50

Corporations Collecting Art (475 names) . $60

Corporations Collecting Photography (125 names) $50

Galleries (5500 nationwide names) . $400

Galleries Carrying Photography (320 names) . $50

Galleries/New York (750) (more city/state selections online) $75

Greeting Card Publishers (640 names) . $70

Greeting Card Reps (300) . $50

Interior Designers (600 names) . $55

Licensing Contacts (200 names) . $50

Public Libraries (1500 names) . $110

Reps, Consultants, Dealers, Brokers (1600 names) $125

All lists can be rented for onetime use and may not be copied, duplicated or reproduced in any form. Lists have been seeded to detect unauthorized usage. Reorder of same lists within a 12-month period qualifies for 25% discount. Lists cannot be returned or exchanged.

Formats/Coding
All domestic names are provided in zip code sequence on three-up pressure-sensitive—peel-and-stick—labels (these are not e-mail lists).

Shipping
Please allow one week for processing your order once your payment has been received. Lists are then sent Priority Mail and take an additional 2-4 days. Orders sent without shipping costs will be delayed. Shipping is $5 per order.

Guarantee
Each list is guaranteed 95% deliverable. We will refund 37¢ per piece for undeliverable mail in excess of 5% if returned to us within 90 days of order. We mail to each company/person on our list a minimum of once per year. Our business thrives on responses to our mailings, so we keep our lists as up-to-date and clean as we possibly can.

ArtNetwork
PO Box 1360, Nevada City, CA 95959-1360
530·470·0862 800·383·0677 www.artmarketing.com

LOCAL PROMO MAILING LISTS

Promote your open studio or exhibition by inviting local art professionals.
Our local promotion lists include the following eight categories:

Art publishers * **Galleries** * **Consultants, reps and dealers** * **Architects**
Interior designers * **Museum curators** * **Corporations collecting art** * **College gallery directors**

Some examples of counts follow. More geographic areas are listed on-line at www.artmarketing.com. Call or e-mail for a quote for your specific needs.

California	2700 names	$200
Northern California	1350 names	$115
Southern California	1350 names	$115
San Diego	200 names	$50
Los Angeles	525 names	$75
San Francisco Bay Area	725 names	$85
San Francisco	350 names	$55
New York City	1200 names	$115
New England	1000 names	$100
Boston	210 names	$50
Chicago	300 names	$50
Illinois	500 names	$65
Florida	600 names	$75
Georgia	245 names	$50
Hawaii	90 names	$40
Michigan	300 names	$55
Mid-Atlantic	650 names	$80
Minnesota	225 names	$50
New Jersey	350 names	$55
New Mexico	350 names	$55
Ohio	250 names	$50
Oregon	275 names	$50
Seattle	225 names	$50
Texas	600 names	$70

ArtNetwork
PO Box 1360, Nevada City, CA 95959-1360 530·470·0862 800·383·0677

ONLINE GALLERY

NOT READY TO SPEND HUNDREDS OF DOLLARS TO HAVE A WEB SITE BUILT?

Take advantage of ArtNetwork's low-cost, high-exposure home pages. Our two-year plan is economical and allows you to have a professional "spot" on the web to call home.

Our 20 years' experience within the art world has made our site popular among thousands of art professionals. We contact these professionals annually via direct mail—they know us and the quality of artists we work with.

A home page with ArtNetwork will include five reproductions of your artwork (you can get a double page of 10 pieces if you like). Each artwork clicks onto an enlarged rendition, approximately three times the size. Two hundred words of copy (whatever you want to say) are also allowed on your main page, as in above layout.

Artmarketing.com receives between 400,000-500,000 hits per month—an average of 1500 users a day (and rising each quarter). The gallery is the second-most visited area on our site.

▸ We pay for clicks on Google for a variety of art genres: abstract, equine, nature, environmental, whimsical and many more.

▸ We publicize our site to art publishers, gallery owners, museum curators, consultants, architects, interior designers and more! Your home page on our site will be seen by important members of the art world.

TO SHOWCASE YOUR WORK ONLINE, GO TO WWW.ARTMARKETING.COM/ADS

ArtNetwork
PO Box 1360, Nevada City, CA 95959-1360 530·470·0862 800·383·0677

BUSINESS BOOKS FOR ARTISTS

Licensing Art 101: Selling Reproduction Rights for Profit

Expose your artwork to potential clients in the art publishing and licensing industry. You will learn how to deal with this vast marketplace and how to increase your income by licensing your art. Contains names, addresses, telephone numbers and web sites of licensing professionals and agents.

Negotiating fees * How to approach various markets * Targeting your presentation
Trade shows * Licensing agents * Protecting your rights

Selling Art 101: The Art of Creative Selling

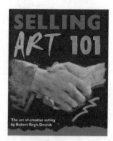

This book teaches artists, art representatives and gallery sales personnel powerful and effective selling methods. It provides easy-to-approach techniques that will save years of frustration. The information in this book, combined with the right attitude, will take sales to new heights.

Closing secrets * Getting referrals * Telephone techniques * Prospecting clients
14 power words * Studio selling * How to use emotions * Finding and keeping clients
Developing rapport with clients * Goal setting * Overcoming objections

Internet 101: With a Special Guide to Selling Art on eBay

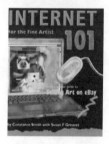

This user-friendly guide explains exhibiting, promoting and selling artwork on-line. It also teaches in detail how one artist made $30,000 selling her art on eBay.

Internet lingo * E-mail communication shortcuts * Doing business via e-mail * Meta tags
Creative research on the web * Acquiring a URL * Designing your art site
Basic promotional techniques for attracting clients to your site * Pay-per-click advertising
Search engines * Tracking visitors * Reference sources

A Gallery without Walls: Selling Art in Alternative Venues

This book will lead you to a greater understanding of how to select and then reserve the best space to exhibit your work. It will also teach you how to promote your artwork on a limited budget.

The Sacred Sales Spot * Themed events * The Red Dot Syndrome
Finding alternative venues * Art Teas * Making a penny scream
Promotion on a shoestring

Art Office: 80⁺ Forms, Charts, Legal Documents

This book contains 80+ forms that provide artists with a wide selection of charts, sample letters, legal documents and business plans . . . all for photocopying. Organize your office's administrative and planning functions. Reduce routine paperwork and increase time for your art creation.

12-month planning calendar * Sales agreement * Form VA * Model release
Phone-zone sheet * Checklist for a juried show * Slide reference sheet
Bill of sale * Competition record * Customer-client record * Pricing worksheet

ArtNetwork
PO Box 1360, Nevada City, CA 95959-1360
530·470·0862 800·383·0677 www.artmarketing.com

WWW.ARTMARKETING.COM

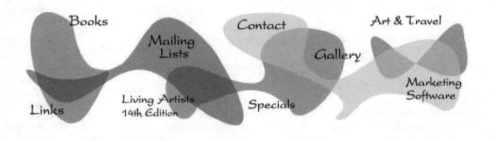

Books

Mailing
Lists

Contact

Art & Travel

Gallery

Marketing
Software

Links

Living Artists
14th Edition

Specials